D0862368

LET THERE BE LIGHT
The Mysterious Journey of Cosmic Creativity

LET THERE BE LIGHT

The Mysterious Journey of Cosmic Creativity

HENRYK SKOLIMOWSKI

wisdom
tree

© Henryk Skolimowski, 2010

First published 2010

All rights reserved. No part of this book may be reproduced, stored in a retrieval system or transmitted in any form or by any means — electronic, mechanical, photocopying, recording or otherwise — without the prior permission of the author and the publisher.

ISBN: 978-81-8328-152-2

Published by
Wisdom Tree,
4779/23, Ansari Road,
Darya Ganj, New Delhi-2
Ph.: 23247966/67/68
wisdomtreebooks@gmail.com

Printed in India at Print Perfect

CONTENTS

THE EPIPHANY OF LIGHT

We are living in a strange universe. One of the outstanding physicists of the twentieth century has said that the Universe is not only stranger than we imagine, but also stranger than we can imagine. It would be desirable if we find the right key to the Universe. We have tried various combinations. We have not succeeded yet. It does not mean that we are doomed. But only that we have to try again — more ingeniously, more imaginatively, with more illuminating and deeper insights.

Human beings are curious, resourceful, creative. We shall try again and again until we find a right idiom for cooperation with the Universe. It is important that we find a key to the whole story. This book is one attempt in this direction. Working on various disconnected parts has led us nowhere; worse still, it has led us to dangerous cul de sacs.

The key to the new story is Light itself, but Light conceived in an altogether new way. Before I start spelling out the new story, I will share with the reader some glimpses of it. These glimpses (which immediately follow) give a taste of the story.

Any new story which is a worthwhile reading must have some surprises and shocks. For if it is truly a new story, it must be out of the ordinary, thus a bit startling and perhaps even astonishing. I plead with the reader for little patience until he gets the real taste of the story.

A New Journey

The Universe wants to reveal itself to us. But we have been slow to answer its calling. We have lived in a state of atrophy. This is not a right condition for the sparks of the Universe. We are the ambers of the energy of the Universe — shining particles of the light of the Cosmos. Because the Universe is us, it is realising itself through us. We are rediscovering Light, while Light is rediscovering itself through us.

To discover the Universe anew, we need to come much closer to it, and not be continually separated by alienating scientific theories. We need to go much deeper to its underlying foundations, and not be satisfied with the superficial physical surface of it.

We need to rediscover the Universe and ourselves through the rediscovery of Light. Light is really close to us and intimate in its manifold manifestations. Light is also the key to the understanding of the profound wholeness of the Universe amidst its dazzling diversity.

The rediscovery of Light is a strange journey. We already know the land we are going to travel. Yet it will become a new land after we have travelled it. A new journey to the source of Light, which is Light itself, becomes a return to our Primordial Home, which we left aeons ago and which becomes more and more familiar as we re-remember it during the journey. The time past becomes the time present and time future as we observe the transformations of Light from amoebas to gods. The revealing nature of the new journey makes us aware that the age of science is coming to an end and that the era of Light is beginning.

The Universe has created human intelligence to celebrate itself. The Universe does not want its intelligence to be dwarfed or maimed. We need to create a new story of the Universe in which human intelligence naturally follows from the nature of the Cosmos. The Cosmos must be seen as the roots of this intelligence, while human intelligence should be easily perceived as its blossoming flower. The new story has been in the air for some time. We shall try to articulate it, or at least provide its first rudimentary outline.

LIGHT IS GENESIS. GENESIS IS LIGHT

Of all the things in the life of the Cosmos, genesis is most important. The nature of the source determines the nature of the rest. The source is always a bit mysterious. It explains everything. But it cannot be explained. We cannot ask what was before the origin, simply because the origin is the beginning of everything.

We can ask however what kind of source was capable of generating life and thought and gods. We shall propose and argue that Light is the beginning of it all. Thus Light is the source of all sources.

Light is genesis. Genesis is Light. This is the simplest and the most profound hypothesis. And it rings true in our intuitions. The primordial awe and delight with the sun and Light were common to all our early ancestors. To truly know our cosmic nature, we have to excavate our cosmic origins. We should not be afraid of our cosmic roots. We are after all cosmic beings.

THE GENIUS OF LIGHT

At the beginning was Light. All that exists is made of Light. Light has evolved. The first stroke of the genius of Light was to invent Photosynthesis, which enabled the vegetable world to be nourished by Light. Animals who eat leafy forms of life are themselves condensed forms of Light. Carnivorous creatures,

which eat grazing animals, are even more condensed forms of Light. We are continually nourished by Light.

Then Light made another enormous leap. With a stroke of another genius it created Logosynthesis, which generated self-conscious thought, out of which came art and knowledge. Light started to shine with the power of symbols. All forms of knowledge and all objects of art are forms of Light. They nourish our minds.

We are continually nourished by Light.

Then the genius of Light struck the third time. It created Theosynthesis, which generated religious icons, divinities, gods and religions. All divine beings and entities are made of a most sublime light. The Light of Theosynthesis nourishes our souls.

We are continually nourished by Light.

Light is universal and all pervading. It provides the womb, sustenance and nourishment for all there is. It is the Universal Mother.

LIGHT AS THE UNIVERSAL MOTHER

We respond to Light so naturally because Light is the source. Light is the Universal Mother. It feeds our body. It feeds our mind. It feeds our soul. Being in the embrace of Light is so natural because it pervades all and sustains all. In fact we have always so perceived it in our deepest intuitions. We have always been natural worshippers of Light.

Yet, during the last 5,000 years of human history, we have been persuaded otherwise. We were led away from the source. The time has come to return to the source. The time has come to embrace Light in active forms of reverence. It is entirely right to worship the source. It feels so natural to return to the Mother. This return to the source, deep down, is healing and sustaining, which is another evidence that Light is so primordial.

Seeing all through the perspective of Light gives us a new power, the power of seeing the whole canvas of existence as

woven with the threads of Light. This is a new vision. But it is a new vision with a difference. It not only furnishes our mind with new perspectives, but makes us luminous beings. Embracing any new vision is an act of courage which requires a lot of strength, determination and perseverance. But who would not be prepared to sacrifice a lot in order to become a luminous being?

A NEW VISION

A new vision of Light is not an arbitrary perspective. It is an indispensable prerequisite for the survival of humanity and for the continuation of life, which transcends violence, selfishness and stupidity. The existing forms of knowledge and of ethics do not inform us how to overcome present obstacles, pitfalls and impediments. They do not even understand the nature of these impediments. Hence we grope in confusion and semi-darkness.

The new vision of Light clearly shows the way. It invites us to go to the source — Light itself. Then with the sword of Light cut the knots of darkness. Subsequently with the ethics of abundance, we abolish injustice, then inequity and violence. Then with the increase of our inner light, we transcend further — while following the path of our inner bliss.

Nobody ever said that an important work of a cosmic nature would be easy. But the glory of a great work overshadows its toils and tears.

PREGNANT WITH LIGHT

The whole Universe is pregnant with Light; humans are pregnant with Light — each of us individually and the whole human race. Light is a great equaliser. It makes every being in this universe a vessel of its creation. Light is both Mother and Father. And we are, each of us, Father and Mother simultaneously.

Light is continually birthing. And it is birthing through us all. We are the vessels of Light and the bearers of new light.

A new poem created, a new baby born are equally children of Light. The question, which is more important, is not important. The important thing is creation.

Birthing is the joy of the pregnant Universe. Birthing is the joy of a pregnant poet. Birthing is the joy of a pregnant mother. Birthing is the joy of the transcending power of the Universe, which delights in its fruit — until it reaches its Omega Point.

RELIGIONS AS FILTERS

Organised religions are filters. From the enormous potency of Light, they filter out only some of its aspects. They enshrine these aspects as attributes of God, and subsequently express these attributes in the language of dogmas. This language becomes sacred and taboo and whoever questions this language is ostracised or punished. These religious filters ultimately become a monopoly on Light, on truth, and on spiritual teachings. Through these monopolies, churches and religions exert an enormous power on people. This spiritual power is not benign, but controlling, and in defending their respective monopolies, different religions are prepared to go to war with each other.

For this reason, the original meaning of Big Light — as generous, all giving and impartial — is lost. And the images of God are tarnished and sullied.

RELIGIOUS FILTERS AND BIG LIGHT

No religion can behold the wholeness of Light. And no religion can access Big Light directly. Therefore, each religion appropriates a part of this light. Each religion filters this light through its respective filter. The name of this filter is the name of the given religion. The character of this filter determines the character of a religion.

All products of human culture, religion and knowledge are filtered, thus structured to be accessible to humans.

The understanding of the variety of filters enables us to understand the variety of religions, cultures and forms of knowledge. Each legitimately structures a given domain of Light. And each must be respected as a miracle of human understanding.

No religion is absolute and complete. No God is absolute and complete.

All religions should be respectful of each other because each of them expresses part of the divinity of Light. No religion should claim superiority over the other, for each is bound by the limitations of its filters.

INSTITUTIONAL RELIGIONS AND SCIENCE

Institutional religions came on the wave of the Big Light, then became exclusive vehicles of the sacred. They vested all divinity in individual gods, which were located up, in the skies. The sky-gods replaced the earth gods of Matriarchy, which was identified with all living nature. They monopolised the sacred, establishing themselves as sole religious guardians. This monopoly became, in time, a religious tyranny, so that even the mystics, who were the clearest embodiment of the divine, were persecuted and even exterminated. The divine light became obscured and darkened. This was a tragedy of epic proportions.

With the passing of time, religious orthodoxies, especially in the West, began to wane. Science became dominant and triumphant. It established itself as a new orthodoxy. It monopolised dominant symbols and language itself.

Through its language, science has ruled and dominated. It declared that all spirituality and divinity are invalid. This was another tragedy of epic proportions. For science is not truth but only a set of filters — of a rather crude, coarse and materialist kind. As the result of the oppression by science, seeing people have gone into the space of silence.

The call of spiritual light in us is inexorable. This call will never abandon us. For Light is stronger than any orthodoxy, whether religious or secular.

THE MYSTIC

The Big Light is beyond the reach of religious institutions. Only the mystic can experience Big Light. He has survived the blazing encounter with Light. He has been smouldered but not scorched.

The mystic goes beyond filters and religious structures — directly to Light itself. For this reason he is not liked by religions, often mistrusted and sometimes persecuted. The mystic knows but cannot convey the meaning of Light. His knowledge is beyond words and human understanding. He is utterly lonely. But he lives in the space of bliss.

We admire the mystic, but are apprehensive of him. We envy the grace in which he lives. There are hidden ambers in us, which respond to the Light which the mystic has encountered. The mystic is surrounded by the aura of great peace and silence, which is beyond knowing and saying.

Only on exceptional occasions can the mystic utter the words which connect our mind with the Big Light. Thus Meister Eckart spoke:

"My eye with which God sees me
Is the eye with which I see him
My eye and his eye are one."

THE ETHICS OF LIGHT

The enduring ethics must be in congruence with and fitting into the laws of the Cosmos. These laws, in one way or another, recapitulate the thrust and elan of Light unfolding. Human ethics must, therefore, accept and embody the elan of the abundance of Light. Light is always giving. Thus human ethics must be based on giving and not hoarding.

Other ethical principles which are latent in the na┆
Light, and which must become principles of human eth┆
generosity, sharing, solidarity and love. But furthermo
ethics of Light must include: harmony, transcendence, spiritual
well-being and beauty. Why harmony? Because generosity
and sharing are meant to increase the overall larger harmony.
Why transcendence? Because the overall harmony is not one
of immediate satisfaction but a transcendent quest for spiritual
self-realisation. The eight principles of cosmic ethics (ethics in
congruence with the Cosmos law) are as follows:

- Giving
- Generosity
- Sharing
- Solidarity
- Love
- Harmony
- Transcendence
- Spiritual quest

The forms of ethics, which ignore the mentioned principles
(the ethics of war and destruction) are unnatural and pathological,
because war is unnatural to the quests of human life and to the
quests of Light itself. The ethics of Light, which we also call cosmic
ethics, is natural, intuitive and rational. The cosmic ethics is based
on a deeper reading of the structure of the Cosmos, which is in the
image of Light unfolding. It is not based on any religion or divine
revelation. Yet, we call it divine because of the overall divinity of
the unfolding of Light, which this ethics embodies and reflects.

THE STARRY HEAVEN UPON YOU

The starry heaven upon you and the moral law within you,
declared Immanuel Kant, thereby separating physical knowledge
from ethics. Ethics follows from the inner moral imperative, which

is the sovereignty of the individual. Thus ethics was saved from the tyranny of mechanistic thinking. This solution was welcomed by many thinking people during the last two centuries.

But the time has arrived to examine this solution deeper. With the ascent of the ethics of Light we can now declare: the starry heaven upon you, therefore the moral law within you. The two realms are not separated but are actually bound together by a deep but subtle bond.

Because of the inexhaustible generosity of Light, altruistic human ethics can be declared to be a cosmic law. The inner moral imperative of sharing and love simply follows from the structure of the universe in which abundance and generosity prevail.

In the ultimate reckoning, we can see that the starry heaven participates in the process of creating human ethics. The starry heaven makes us aware that the bonds of human solidarity are but a reflection of the bonds of cosmic solidarity. The human order of things must ultimately mirror the cosmic order of things. As in the heaven so on the earth.

The starry heaven upon you ultimately spells out the moral law within you.

THE IMPERATIVE OF CREATIVITY

We were born to create. To be human is to be alive. To be alive is to be creative. Our creativity expresses our status as human beings. The agonies of creativity are sometimes enormous. But the glories of creativity exceed its agonies.

We create because we must, because the Cosmos creates through us. We create because life loves novelty and genius. Life expresses itself through new unfoldings, which are new creative acts. Moreover, life, which unfolds on its way to self-realisation, is a process of continuous transcendence through ceaseless acts of creativity.

Creativity is so odd and yet so normal. Seemingly, it is unnecessary. Comprehended in depth, it is essential to the life process and to the entire elan of the Cosmos. Thus life is carried through the mysterious forces of creativity.

In human experience, creativity is felt both as impossible and as divine. The more creative we are, the closer we come to divinity. The less creative we are, the more repetitious, stagnant and moronic we become. Decay and boredom are opposite to blossoming and radiance.

The human condition is blessed because we were divined to be creative, and caught in the creative web of the Cosmos to such a degree that we cannot leave it without leaving the elan of life altogether. This condition we call blessed and not cursed because through it we self-realise ourselves and contribute to the self-realisation of the Cosmos.

We are but significant extension of the creativity of the Cosmos. Significant not in terms of the volume of creativity, but through its uniqueness. Because of the great intensity and clarity of the creative act among humans, we have become more aware of it than other creative agents. Through continuous reflection on the creative act, we have been able to understand the essence of the creative act. The understanding of creativity in art has become the paradigm of understanding of all forms of creativity in the Cosmos. Thus the pivotal nature of human creativity stands revealed — as the matrix of understanding of all creativity.

This is a rather extraordinary situation. Because we were given powers and sensitivities to articulate the essence of the creative act, we have made the Cosmos aware of how creative it is itself. This way of putting it may seem arrogant at first. However, it is not so after a closer scrutiny. To be aware of its subtler features, the Cosmos had to create subtle forms of consciousness. To be aware of its own thinking, the Cosmos had to create thinking beings. Through our thinking and self-reflection, the Cosmos is

reflecting upon itself and its nature. We are a singular form of the creativity of the Cosmos, whose destiny was to reveal the nature of the creativity of the Cosmos — so that the Cosmos can rejoice in its own creativity.

UNITED IN LIGHT

When life in your part of the world becomes disturbed and ugly, look up and reach for the stars! Return to Light. In Light you will find a renewal. In Light you will find your centre — for your centre is rooted in Light; in Light you will find right understanding — all understanding stems from Light; in Light you will find the right values — for Light ethics is giving, solidarity and love; in Light you will find your practical path of right purpose and clear meaning; in Light you will find your deity — for Light is the ground of all gods and religions. Light shines through all healthy spiritual traditions.

Let us unite in Light — in the times of strife and in times of elation. For Light has been the source of our life and of our divine inspirations.

THINGS TO REMEMBER

The Universe is home for all humans. We should feel comfortable in it. The whole Cosmos is a friendly place — not a cold machine but a loving, warm, compassionate habitat.

The world is a sanctuary. We are the shepherds of being. Man is not wolf to other men. We say: *Homo homini Deus est* — man is god to other men.

Hope is a natural condition of living. It is the spring eternal. We must never abandon it for through hope and love we redeem the world.

A new story of the Universe justifies the greatness and nobility of the human. We need to go to the source, to the source

of all sources and then see with new eyes that the Universe is of grandeur, of beauty, of generosity, of infinite giving and ultimately, of love.

At the beginning was Light. Light — pure, triumphant, overwhelming in its unity and possibilities. Out of this Light came everything that we call Cosmos, Universe and Life. The whole story of the Universe is the story of the evolving Light which is intertwined with Love. Love is not accidental but essential to the story of the Universe. Equally essential is thinking, art and sacred symbols.

The story of the Universe is enthralling, fascinating, mysterious and yet simple. We need to have the eyes to see the beauty and the genius of life, as it incessantly re-creates and transforms itself.

The meaning of life is simple. This meaning is the loom around which everything that exists is woven. Light is the divine denominator which unites us all. We are truly one — because we are all made of Light. This unity is tremendously reassuring and a source of hope and optimism. If we need one single and sure beacon of hope, it is Light.

CHAPTER 1

LIGHT AS ENLIGHTENMENT AND AS NOURISHMENT

TO EAT OR NOT TO EAT IS NOT THE QUESTION

We are slowly emerging out of the 'mechanistic slumber' and opening our eyes to the miraculous possibilities of the world. During the past century, so many strange things happened and so many strange discoveries were made that we should not be surprised at anything. British physicist J.B.S. Haldane said that the world is not only stranger than we imagine, but also stranger than we can imagine (actually, he used the term 'queerer'). This strangeness of the world is a part of its nature. It may even be a part of its 'rationality'. Now, part of our rationality vis-à-vis the world's is our capacity to be surprised and delighted with it; as well as delighted with all creation.

We are living in a universe which is full of wonder and delight. Gloom is not the essence of the world. This attitude of

enchantment with the world may enable us to accept the world's miraculous possibilities. That does not mean the acceptance of everything or anything come what may. Cheap sensations and pornographic dirt are not miraculous possibilities of the world, but exactly that — sensations and dirt. Of late, people are increasingly talking about the Era of Light. This is a very felicitous expression. We are rediscovering anew the epoch of Light. I say, rediscovering because the Era of Light has been with us for the last several billion years — maybe from the beginning of the Universe.

The reason is simple. *Everything is Light.* Everything emerged out of Light. Each and every aspect of the Universe is a part of the process of the transformation of Light. Everything around us is part of the great journey of the self-realisation of the Cosmos of which we are a part.

The understanding of this great process of self-realisation is an aspect of the great mystery in which we are participating. The new insights into the nature of Light are tantamount to opening our eyes to the wonders and delights of this incredible Cosmos. These new insights also hint that in future, we might be able to live on Light alone and be literally nourished by it. When we think of it, it is amazing that some people in the past (and also in the present) have been able to live on Light alone. So the world might indeed be 'queerer than we can imagine'.

This problem, however, needs to be approached with due care and fastidiousness in order to avoid the haphazard derivation that all of us will be able to eat Light alone in the near future. A deeper reflection would inform us that there is nothing extraordinary in the proposition that we can be nourished by Light. Actually we have been doing that since the beginning of organic life. We need to treat with caution the meaning of the phrase 'being nourished by Light'. We need to understand this term within the perspective of evolution.

Before we do that, let us observe that for some thousands of years, Hindu yogis have known the process of treating Light as nourishment through appropriate spiritual exercises, which enable the human organism such a level of fine-tuning and harmony with the forces and energies of the Cosmos that he is capable of bypassing the need of ordinary food in favour of Light alone. If and when we master to live by Light alone, we shall then be freed from the tyranny of work. We shall be freed from the tyranny of illnesses, of medicines, of insurance; from the tyranny of the system, which contends that what is not measured in millimetres or inches, and sold in pennies or cents is not important.

Admittedly, it took the Hindu yogis several hundred years to understand this process. The main point is that this process is *possible and available*. The countless examples of Hindu yogis — as well as of Western people of the present times who do not call themselves yogis — give credence to our assertion. For people of unfulfilled consciousness, who lack the appropriate preparation and exercises, training is essential to enable them to use prana or any kind of subtle energy as their main nourishment. Indeed, this process is possible. But not easy.

Almost all illuminati, the enlightened people, emphasised that the crux of the matter is spiritual practice. Even the Buddha refused to make miracles although he possessed the powers that would enable him to do so. He thought that creating the right conditions for spiritual work for all beings was more important than spectacular occasions. Through spiritual practice, we achieve a subtle balance of the psyche and the consciousness, which leads to a great inner peace. Out of this great inner peace emerges a deeper understanding of oneself, as well as understanding of the place of love in the human world and in the Universe at large. The practice of this love leads to a joy of the spirit and the harmony of the body which makes us 'Light', and this unites us with the great energies of the Cosmos.

This state of weightlessness and incredible lightness of being enables us to connect ourselves with the subtle chains of energy not available to ordinary humans. This lightness of being also enables us to develop and cultivate a whole range of new perceptions, sensitivities and powers of which we did not dream or were only dimly aware of. And through these powers and sensitivities we see deeper and clearer as well as achieve things out-of-the-ordinary, such as being nourished by prana. These out-of-the-ordinary achievements are not the aim of spiritual practices, but only the consequences of highly tuned minds and souls. Just as an athlete trains vigorously for years in order to perform well, we need to train our spiritual faculties — our soul and mind — to achieve the extraordinary.

'To eat or not to eat' is not the question. 'To be or not to be', is the question. 'To be' means to live consciously a life connected with the Cosmos and the other lives and to follow spiritual paths which empower one to achieve the extraordinary. 'Not to be' means to live in the half-darkness of one's own egoism and not to discover the spiritual path — the road to the extraordinary.

PHOTOSYNTHESIS AS AN ACT OF THE GENIUS OF LIGHT

Now, a few words about the history of evolution. There is no doubt that we are being nourished by Light and other fantastic energies of Nature and the Cosmos, for such is the structure and nature of the Cosmos. Some of these energies are recognised, others are barely perceptible.

We are quite aware of the relationship of Light to plants, or rather of plants to Light. Photosynthesis was an act of genius of Light to facilitate the path for future life. Photosynthesis is the clearest example of how Light nourishes, of how Light is transformed into life. Once plants showed the way, everything became easier — for

the whole life. Indeed the whole life — which has become ever more versatile and differentiated; then sophisticated, thinking, reflective, brooding — is but transformation of Light.

Even if no form of life other than plants had ever emerged on the surface of the earth — through the act of photosynthesis — this would have been a sufficient evidence of the genius of life. But life did improve upon itself. Plants were living entities but they never had the faculty to think. The Cosmos, then, created thinking beings, through whom it could think reflectively, chart its own destiny and its journey of self-realisation. Therefore, the 'higher' forms of evolution were created. Every creation of evolution is 'high and mighty'. The conventional term 'higher' being used here only indicates the creatures, with more refined faculties, that came next.

Let us clearly see the chain of events. With the breakthrough process of photosynthesis, plants came into being, being nourished by Light. Then came the herbivorous animals, creatures feeding on plants. They indirectly, by consuming plants which were nourished by Light, consumed Light. Then the carnivorous animals arrived, creatures feeding on the herbivorous animals. They also indirectly consumed Light. The question here is: are the carnivorous animals on a 'higher' level of evolutionary development? In many ways, they are. Tigers are more intelligent than plants. But at a certain point, we need to look at the whole biological situation differently. Not only who is faster and more rapacious, but how life has chosen to augment its prowess and acumen by developing the moral dimension in human beings. Tigers do not have ethics. Human beings do. 'To eat or not to eat' (other animals) is never a moral problem for tigers. Tigers possess a different consciousness than we do. They may be faster and stronger than humans. But by developing ethics and moral sensitivity, we know that brute strength is not all there is.

Precisely, by developing moral sensitivity and ethics we could create compassion, justice and fairness in human society. Because of this, we are superior to wild animals. The world is a sanctuary and we are its custodians. We can and must take care of the world because of our sense of responsibility — the moral responsibility for all there is.

Evolution made various experiments in order to see which were the best ways leading to more intensive life, more versatile life, to the life of increased self-realisation. First emerged rather gentle animals and then more rapacious ones who ate other animals. The appearance of the latter signified the intensification of life in some aspects. The life of gentle animals was rather lazy. The life of rapacious animals was more accelerated, intensive and aggressive.

This contributed to the acceleration of the pulse of life of other animals, which had to be watchful and alert. In this fashion, the rhythm and tempo of life in general became accelerated. Tigers must be fast, decisive, skillful. They could not have any sentiments towards the victim; they could just leap and kill the prey. There is a poetry peculiar to tigers. Maybe it is a rapacious kind of poetry. Looking at the human race at present, I wonder whether we have not inherited much of the tiger nature. I hope not. But in some of us, there are more than traces of the tiger — a hidden nostalgia for the past aggressive glory, which allowed us to kill with impunity and without any pangs of moral conscience.

But evolution went on, beyond tigers and dinosaurs. Especially beyond dinosaurs, who were exceptionally brutal, without any intelligence and skills, without any 'poetry'. With their brutal force they destroyed everything obstructing their path and ruled the planet. Evolution ended the experiment, which meant the end of dinosaurs. The path was to cultivate intelligence and sensitivities to safeguard against excessive aggression.

However, traces of the nature of dinosaurs were imbibed by the succeeding species.

The intensification of life, therefore, had diverse consequences — like the sharpening of skills, increased efficiency and mobility, tuning and quickening the reflex. At the same time, it generated the instinct of exerting power over others, aggression and various forms of tyranny.

As already said, through the course of evolution, intelligence was cultivated. Following this was the cultivation of the sense of ethics, which enabled us to distinguish good from evil. The primary task of ethical values and ethical sensitivities has been to increase human capacities to act for the good beyond one's own. Tigers do not possess ethical intelligence although they are very intelligent beasts. Similarly other animals also do not possess the ethical sense which could enable them to rise above their biological condition, and reach for the Light and the sense of reality, which we call sacred or divine.

Let us now look at the unfolding journey of Light and of evolution, which led to two great syntheses, beyond and above photosynthesis.

LOGOSYNTHESIS — ANOTHER STROKE OF THE GENIUS OF LIGHT

The new chapter of evolution, spanning the last several thousand years, does not consist in increasing our physical attributes, as previously, but in the intensification of the thought process. This has been the intensification of Logos as we might say, using the Greek term.

As evolution unveiled itself further, through the intensification of Logos-consciousness, humans went further still and began to consecrate the world and create religions and gods. And that was the work of yet another great synthesis.

'Logosynthesis' was the second bold venture of Light, leading life to the higher stages of self-realisation. The transformation of Light into consciousness and reflective faculty was an expression of a genius of no lesser dimension than the transformation of Light through photosynthesis, into plants. There is the sense of something tremendous and mysterious in the spectacle of evolution when, of the various biological and physiological impulses, there emerges a lucid understanding — self-conscious and reflective.

Logos means not only the mind, or the abstract brain. Logos is the thinking substance of the Cosmos, in which we participate. Logos also meant the understanding of the underlying laws of life, of thinking, of art, of political institutions. This divine capacity to think led to ethics, and to religions; also to sanctifying and worshipping certain entities as divine beings — which was the creation of gods.

Creative thinking is the source of it all. True enough, sometimes it leads to anomalies, pathologies and even becomes an instrument of evil and crime. Treacherous and envious thinking has done a lot of harm to human beings and to the world. This is not the kind of thinking we mean by 'creative thinking'. By 'creative' we mean thinking which is a blessing to the human condition and the source of infinite good. Creative thinking led to the upsurge of art, and to flowering of human creativity. The creative Cosmos, on the way to its stupendous self-realisation, had to use extraordinary means in order to transform itself from cosmic dust to the genius of Mozart. We think of the genius of Mozart as dazzling. Yet we are somehow dim to realise how much more dazzling the genius of Light itself is, namely, to create life; and then to create the Mozarts and Bachs; the Zarathustras and Buddhas; and other celestial beings in the human form. In a nutshell — it led to the creation of new worlds around humans. Let us be mindful that every world view, every picture of the world, every branch of cosmology are the creations of human logos. Finally, Logos led to

the creation of transcendental realms in which dwell the
energies and divine beings. A new synthesis had taken pl
'Theosynthesis' (from the Greek word 'theos' meani
was the next expression of the genius of Light, which propelled
life to new heights. Logosynthesis brought life to the realm of
reflective thinking. Theosynthesis brought life, and especially
human life, to the sacred realm, to the sphere of divine beings
and sacred energies. That was another triumph of the genius of
Light, namely to show that life does not end with thinking, let
alone with eating.

The transcendence into the sphere of the sacred was the next
miracle of existence. Nevertheless, the phenomena initiated during
the prior stages of evolution remained intact. Photosynthesis
retained its validity; so did Logosynthesis. But new dimensions
of existence were added to reality, therefore to our thinking,
therefore to human life. Man began interpreting the sacred and
emulating it. Viewed from another perspective, the whole reality
around human beings was endowed with sacred dimensions.

We should be very conscious of the fact that without the
sacred Universe — as the background and the source of it all —
there is no ground for the sacred dimension of human existence.
Our being is a part and an aspect of a larger being. And this being
(which has acquired a sacred dimension) must include humans
and their thinking for its sustenance. In brief, we can say that
Light's journey of self-realisation is consonant with the journey of
self-realisation of man. For all is Light. The transformations of the
Cosmos and of humans are the transformations of Light.

On its way to self-realisation, Light had to create thinking
beings and then sacred beings. Through these beings and their
ethical and spiritual sensitivities, Light could reflect upon itself and
continue its ascent to self-realisation. We are indispensable actors
in this great cosmic drama. It is all very simple, but breathtaking
in its beauty.

Through the act of Theosynthesis, the Cosmos, which essentially means Light, was able to create beings endowed with exceptional powers and subtle spiritual sensitivities. This act of Theosynthesis enabled the rise of monks, saints, pilgrims, yogis who have been cultivating spiritual life.

These extraordinary ambassadors of the sacred, through special exercises of body, mind and spirit, enlarge the sphere of sacred experience, whereby they enlarge the realm of human possibilities, and simultaneously liberate humans from biological and emotional limitations. In this context, we should clearly see that monks are doing the cosmic work. For example, the Tibetan monks show us that it is possible to survive amidst the snow in frosty weather (half naked or naked) and not feel cold. Hindu yogis show us that one can be 'buried' in a grave for several days, and then, after being dug out, come to oneself and lead a normal life. Again Hindu yogis, and also others show us that one can abstain from eating for months and longer (by consuming prana and other forms of subtle energy) and live normally, without conventional nourishment.

When Light has achieved this stage of its development, which in the human universe is called spiritual enlightenment, it is then capable of amazing achievements. These achievements are amazing, but only in the conventional system of thinking.

It should be also added that when I state that the human being has become a sacred being, endowed with new psychic and spiritual powers, I am not talking about every single person. I only insist that new possibilities of human life have been created; and given to us in *potentio*. It takes a big leap of transcendence to make the potential the actual. We are at the threshold of a new chapter of evolution. The circle is closing. After the physical, biological and intellectual evolution, through acquiring spiritual powers, we shall be able to create new worlds, and altogether new possibilities of living.

THE AWESOME JOURNEY OF LIGHT

YOUR ROLE IN THE SELF-REALISATION OF THE COSMOS

Every step brings Light. Walk in beauty, walk in Light. The two are synonymous. Your entire being is surrounded with Light, saturated with Light, fused with Light, is a manifestation of Light with all its colours.

It is simple to perceive. All is Light. Therefore you are Light. In you Light has found its vessel, form and expression. In you it has discovered the ways of modulating itself and maturing; the paths of self-transcendence. You are being formed by Light and Light is the source of everything. But Light itself matures and evolves — exactly through you and other sentient beings. The sensitivities and dispositions, powers and abilities which Light and evolution form and sharpen — in their turn serve as ladders

for further evolution in the *mysterium tremendum* process of self-realisation of Light. In this process you are only a link, but a very important link. You and Light are one. You are this Light. This Light is you — in all its five dimensions. But you need to take care of these various forms of Light. You need to provide suitable sanctuaries for them to dwell in you.

Through you and the whole of humankind, through the divine abilities of human knowing, Light has understood the process of self-realisation and became conscious of it. Human thinking, with all its limitations, is part and parcel of the thinking Cosmos. As Light aims for the divine, you are the means. You must be fully aware that in the process of self-realisation, you are a participant too. Nurturing the seed of the spiritual and the divine is an essential task in your life.

THE INCOMPLETENESS OF TRADITIONAL SCIENCE

Science is a great achievement of humankind. Science, which is to say classical science of the West, based on physics, has attempted to explain 'everything'. Today, there are abundant theories for everything in physics. But there is a serious problem with the Standard Models of physics explaining 'everything'. And there will be problems forever. The reason is that classical physics, as well as physics of sub-elementary particles have, with their constricting perspectives, so dwarfed the Universe of their discourse that they have found themselves in a prison.

As the result of narrowing the perspective and the whole discourse, a certain 'disinfection' of language has occurred. The consequence of this was the elimination of contents, which do not possess any physical connotation. All in all, the language and theories of physics comprise only a limited part of the

whole Cosmos. Alas, this part has been pushed on us as if it were the most important knowledge of the Universe.

Physics, in spite of its astounding revelations, carries the irrevocable sin of reductionism. With its Standard Models and Grand Unified Theories (GUTs), it attempts to 'reduce' the richness of the Cosmos to physical parameters, to some particles — elementary and sub-elementary — to be described by the language of physics. Actually there are many competing Standard Models. And if this is the case, it simply means that there is no Standard Model.

Moreover, it appears that what is most important for the most advanced theories of present physics is the coding, or their expression in the form of mathematical equations. What these mathematical equations finally designate (beyond their consistency or semi-consistency) is a very good question. It would appear that the *mathematical physicists*, themselves, are not very certain what these equations signify beyond their coherence and consistency.

The objection is not trivial. What we barter is the opportunity to experience the nature of the Cosmos — its beauty and grandeur. The GUTs or Standard Models simply dwarf the Universe in order to fit it into a set of mathematical equations. For all the mathematical dexterity of present physicists, the Universe would not oblige and would not want to fit into the *procrustean bed of equations*.

We salute these brilliant *mathematical physicists* for their prowess and enormous inventiveness. But, beyond the mathematical is the metaphysical which is much more encompassing. Rather, the mathematical is at one tiny end of the spectrum of metaphysics. Taking into account the whole gamut of metaphysical models, it is just one sample.

AN ALTERNATIVE WAY OF EXPLAINING THE COSMOS

As a result of the increasing fragmentation of science and its increasingly incomprehensible models, some thinkers have recognised the need to compose a holistic view of the Cosmos. They defy the GUTs models, the atomistic and numerical models, which try to breakdown everything to particles.

The holistic models create a niche for the metaphysical imagination instead of the mathematical one. These new holistic models, not surprisingly, feature the 'whole', not the component 'bricks.' This holistic approach also vouches for the wholeness of human understanding. The new models do not hesitate to insist that the human mind, through which we explore the Cosmos, is part of a *larger cosmic mind*.

Once this perspective is accepted, the path becomes clearer and more comprehensible. For we can then surmise that not only is the human mind a part of a larger cosmic mind, but that even we are a part of the mind through which the Cosmos thinks. And, if so, then our minds were created to understand the Cosmos. Therefore, they were created in order to feel comfortable in the Cosmos. The purpose of the human mind is to interpret the Cosmos in terms which are accessible to humans. The knowledge, which is created by people and for people should be understandable for people at large.

The theories, which describe the Cosmos in a way which is incomprehensible to the ordinary man can be deemed only as an expression of alienation of human reason and not its greatest feat. Therefore, with a due humility, we shall have the courage — born of necessity — to suggest a new model of the Cosmos, which is accessible to human reason. This model has the ambition to explain the odyssey of Light and the Cosmos in their

evolutionary unfolding. It is only through the evolution of Light that we can understand the nature of the Universe and our place in it. We are essential actors in the development of evolutionary intelligence. The stupendous journey of Light is also the stupendous journey of the human mind.

The model proposed, much like all models drafted by humans, contains some anthropocentric elements. In the final analysis, the proposed model is cosmic, not anthropocentric, because it attempts to reconstruct the unfolding of the Cosmos — including us as its inherent part.

The great Newton categorically announced: *Hypotheses non fingo* (I propose no hypothesis). This was meant to mean that Newton proposed nothing but truths. But even his unshakable convictions turned out to be only dreams. Seen from the historical perspective, the *absolute truths* are but *approximate hypotheses*.

Given to us are only hypotheses, not absolute truths. But one hypothesis is not equal to another. Hypotheses concerning only the physical aspects of the world must be limiting. Hypotheses which keep in regard the evolution of the whole Cosmos go beyond the parameters and language of physics. We are tireless in emphasising this point because once we accept a limited and limiting language, we cripple our comprehension and put a straight jacket on the entire reality.

To understand the nature of the Cosmos we must understand the nature of Light. This is our central supposition. The understanding of the nature of Light leads us to comprehend the metamorphoses which have occurred in the nature of Cosmos over several billion years. We are searching for the simplest hypothesis because only such a hypothesis would have the chance to come close to the truth. We are searching for a hypothesis integrating all human experience and knowledge, which registers everything from the elementary form of Light to the metamorphosed form, called God. Everything in the Cosmos is connected to

form a unity. All is derived from Light, contains Light, is made up of Light. There could not be a hypothesis simpler than that. And none seems to be more far reaching.

The simplest hypothesis of evolution attempts to explain in what manner, by what ways and means, Light in its evolutionary development has been changing its form. It has been doubling upon itself, acquiring new characteristics and generating new forms of existence in the process. These new forms of existence have been unique but woven together by Light as the common genesis. They bear the elements of the previous stages of the existence of the Cosmos.

Thus, Light is the leitmotif running through the whole stupendous drama of the becoming of the Cosmos, all its forms of existence, all its rivers and tributaries. Light welds them together and gives them the power and reason for existence.

There is no element more universal than Light. Being present everywhere and in everything, it interconnects them. The beginning of the Universe was the beginning of Light. The end of the Universe will be the end of Light. Expressed otherwise: the end of Light will be the end of the Universe. Light is absolutely fundamental in the whole structure of existence; as well as in the structure of our life; as well as the nature of phenomena which are most important for us: knowledge, art, love, divinity.

In a nutshell, we are proposing that the evolution of the Cosmos has happened through four major metamorphoses of Light as pure potency (of everything that was to become). Each of these metamorphoses was unpredictable. Yet, each contained its own genius. Each represents transcendence of the previous state of existence of the Cosmos and of Light. Each of these metamorphoses changed the nature of the Universe.

Out of these four metamorphoses, the four main cycles emerged:

- Light as matter
- Light as life
- Light as creativity of life
- Light as divinity of life

The transition of Light to matter is accepted but not fully understood. The transformation of energy into matter was a metamorphosis of a genius, not just a simple transition. The emergence of matter was one of the great creative jumps of the Cosmos. Western science has deflated the subject and made it banal. In a curious way we know 'too much' about the physical structure of the world. This knowledge has paralysed us. It prevents us from seeing other aspects of the self-emergence of the Cosmos, and our role in it.

So much has been written on the subject: physics explains it all, that we think that we understand. But we don't. Physics only repeats its dogmas and assumptions. But does not explain in depth. I don't want to be drawn in the spider web of physics and its cognitive gambits. For this reason, I do not wish to discuss with physicists the nature of their exaggerated claims, because this subtly contributes to the peculiar corruption of our mental and cognitive faculties through the precepts and language (of physics) which is arid, limited and simply distorts reality. Instead I shall move to the next acts of the creativity of the Cosmos in its eternal alchemical cauldron.

FROM LIGHT TO LIFE

Louis Khan, an American architect, has written with an extraordinary incisiveness: "Light did not know how great it was until it hit a white wall." A very creative revelation. But Khan left the expression incomplete. We need to add: "Light did not know how great it was until it created the human eye capable of seeing the greatness of Light reflected on a white wall."

The white wall shining with the beauty of unsullied Light is great indeed. But, the radiance of an idol of Shiva or of the Buddha would render the white shining wall pale in comparison. The light on the white wall is only expressing its potency. It is the first anticipation of what it wants to become in order to make of itself something truly great in the future.

Now, let us see how Light transformed its nature. The first leap forward occurred when Light transformed itself into matter. Then, Light made another leap. It doubled upon itself to create 'life'. It was a momentous occasion, in the evolution of the Cosmos, when Light broke with a thunder to become life. This was the beginning of the journey from pure Light on its way to divinity.

Pure Light, unseen and unperceived, is the first dimension. In itself it is nothing but *pure potency*. Light could have stayed in its first dimension and that would have been a miracle by itself. But then, Light moved to a new level, the second dimension. The transition from Light to matter has been well covered in science. So I shall not dwell on this subject.

Then Light initiated a new transition. It conceived of and gave birth to life. When Light became life, it acquired the third dimension. This extraordinary condensation of Light was brought about through photosynthesis, which enabled the transformation of Light into plants. It was a particular genius of Light to coalesce and embody itself as plants of the earth. These plants prepared the ground for other forms of life. However, the journey of Light did not end here.

LOGOSYNTHESIS AND THE CREATIVITY OF THE COSMOS

We have discussed so far the first three dimensions of Light: original Light — the pure potency of everything; then Light as matter; then Light as life.

After a brief interlude, Light continued the journey. It crystallised itself into forms of life, which were endowed with intelligence and creative abilities. This was the transition from the third to the fourth dimension, from mere biological life to life endowed with self-consciousness, reflection and creativity.

The genius of Light struck again. This time, through what I call Logosynthesis. Thus, Light doubled upon itself once again and created forms of existence of extraordinary characteristics — absent in the previous existence of the Cosmos. The Light of Lucid Logos was born. This stretch of the journey of Light bore extraordinary fruits: of philosophy, wisdom, knowledge, science, ethics, and also art. These consequences of Lucid Logos, were the manifestations or the mirror of the inner life of human, the expressions of the aspirations of human race growing. Philosophy and art emerged as main domains of the symbolic transformation of man and the world.

Art is not just an ability to fashion clay figurines of animals or early goddesses and then fire them. It is much more than chiselling into marble or granite monumental shapes of the pharaohs, which are inspiring by their gigantic shapes and inner powers. It is above all a symbolic journey: from formless clay to icons; and then to transcendental dimensions of reality, which these icons represent.

Through art we have been able to endow the surrounding reality with transcendent dimensions and attributes. Without art, we would not have been able to read the Cosmos in depth; we would have been doomed to live and react on the surface — through our senses and impressions only. This would have been a superficial life. And continually blurred as we would not have had Lucid Logos to fashion and read the symbols of art and knowledge to render reality in potent and immensely fascinating forms.

Through the various forms of art, we have discovered many fascinating aspects of reality which reveal to us new visions of the world. We usually say: we have 'discovered' these new deeper aspects of reality. Is that correct? Has art simply 'unveiled' to us what was hidden in the ready forms? Or was the process a bit more complex — participatory and co-creative? What do I mean by that? Let us realise that we co-create with the creative Cosmos. Light does create new folds of reality, new forms of the world. Yet not by itself alone! It does so by the parallel creation of new states of consciousness and new sensitivities in humans — through which new forms come into being. It is beautiful and mysterious that these new states of consciousness are the work of the same Light which embodies itself in us, and other sentient beings, in order to manifest itself — in the process of self-realisation. It is by the like that the like is recognised. The *Light of Logos* had to be 'ignited' in us before we could discover the existence of this Logos outside our minds.

In the fourth dimension (the 'period' of Logosynthesis), Light revealed itself with new and breathtaking attributes of the Cosmos and life itself. The evolution enabled perceiving the whole existence with new depths, new horizons, new astonishments. We must see very clearly what an important role Logosynthesis has played in this whole creative spectacle.

Looking from merely the logical point of view, we can see that creativity does not seem to be a necessary component of the existence of the Cosmos. The Cosmos could have existed without creativity. So it would seem. The same could be said about the phenomenon of human life. But no! Without creativity there would be no Cosmos as an evolutionary 'phenomenon'. Without creativity the human would have been a 'blurred blot'. Creativity is the essence of evolution; the essence of very form of existence in both the Cosmos and the human world.

When Light became creativity, it manifested its fourth dimension. The triumph of *homo creativus* heralded the fourth dimension of Light. The inspiration for art was only one of the expressions of the *creative urge* of Light. The same urge also gave birth to flourishing of all forms of knowledge, including science and other forms of imaginative and creative thinking. However, the odyssey of Light did not end at this stage. It moved to the next cycle.

THE SACRALISATION OF THE COSMOS

In due time, Light doubled upon itself one more time. It created its fifth dimension, the realm of the divine. This process I call Theosynthesis. The divine mind and the capacity of the divine consciousness to create sacred symbols were part of this Theosynthesis.

The fifth dimension signifies the divinity of Light. With the ultimate leap, Light as creativity led to Light as divinity. It is in this period that the idea of gods and religions was created. With articulation, through the period of Logosynthesis, the sense of the Divine started pouring in, which culminated in Theosynthesis. Great, inspired creativity came to be identified with the voice of and the presence of God.

With Light acquiring the fifth dimension, the anticipation regarding the divinity and sanctity of the Universe came to full bloom. Institutional religions emerged. Special characteristics and attributes came to be associated with gods. Images of gods were sculpted. And then, around the new symbols and images, complex theologies were formulated. Thereafter, controversies arose and religious wars started to establish the precedence of one God over the other. In a nutshell, this was the period of the birth of the 'idea' of gods — who later came to be credited for the creation of everything. And also usurped for themselves the power

to control everything. It is quite clear from this discussion that the emergence of gods and religions was a historical phenomenon.

In due time, religions became shapers of our spiritual identity — sometimes benign, sometimes not so benign. Along with religions, gods were created — sometimes revealing the Big Light (while being its translucent manifestations); sometimes obscuring the Big Light — while attempting to enslave us as their servants.

The real human story is inherently connected with the fourth and fifth dimensions of Light. It is the story of the evolution of human culture, of human religions and spiritualities. It is only within these dimensions that we can truly understand the vicissitudes and dramas of human becoming.

We all know how mighty is the power of Logos, although it is devoid of physical prowess. Sacred beings and symbols possess even greater power. For this reason, religious wars are most dangerous and so destructive. Also for this reason, the individuals endowed with spiritual energies possess great powers. Such is the case with saints, secluded hermits and even spiritual crazies. They can be a great blessing, but also a great danger.

Each image of God and each manner of interpreting the divine is an expression of Light and a supreme handiwork of Light. Gods are not subjective realms or figments of human imagination. They are real realms upon themselves. They represent the eons of evolution. They are consequences of the great synthesis of Light. The higher we climb the ladder of the sacred, the greater becomes the potency of those beings, who are endowed with spiritual Light.

All the five stages of Light are connected; one is leading to another; the higher dimensions 'always' incorporate the lower ones. This is an evolutionary perspective. It is homogenous,

cogent, potent and truly powerful. It makes sense. It is simple. Ultimately the most profound things must be explained simply.

The dynamic picture here presented is simple. We go upward on the spiral of becoming. We do so without any falls from grace; without any twisted explanations that we were once in heaven; then were thrown out of it for an insignificant transgression (we wanted to taste the fruit from the tree of knowledge); and then we started a divine ascent — amidst suffering and pain.

This is a fable for immature minds. We have now matured. And we need a story for mature minds. Such a story is being developed in this volume. We are not trying to be offensive or irreligious. We are only trying to see the true picture of the evolving Light. We are trying to release Light from the *prison of images* of traditional religions. We are trying to restore Light as primordial, everlasting and all-embracing. Such a picture is religious par excellence. Nobody who appreciates the greatness and majesty of Light can be accused of being irreligious for this appreciation includes what is of essence in all religions.

LIGHT AS THE JOY OF LIFE

JOY AS THE FIRST MANIFESTATION OF THE DIVINE

Between Photosynthesis and Logosynthesis, hundreds of millions of years passed. Life was not idle in this period; neither was Light. In order to bring out new qualities and shine with new radiance, slowly but surely, new shapes of life and of Light were formed, articulated and refined.

Logosynthesis is a resplendent meteor. It can be easily perceived and grasped; as well as defined and sanctified. True to its nature, it defines itself; and because of its nature it easily sanctifies itself. It is renowned for its ability to comprehend. In the evolution of life and of the Cosmos, there was never before so much clarity, self-awareness and assurance about the nature of life and of the world.

As the sense of awareness and consciousness grew and refined itself, something else also emerged. This was the joy of life. This joy of life, as a collective term designating the entire evolution, was a sense of elation of being alive, a sense of celebration of the various gifts of life. By 'recalling' this joy in our own life, we can easily empathise with the joy of all creation in its evolutionary development. By growing in various capacities and sensitivities, all of life — in us and before us — has felt freer, more complete, more daring and more delighted with the possibilities of existence.

By watching the spectacle of unfolding possibilities, the very act of existence appears as an act of joy. This joy is at the same time experienced as freedom of life. Life remains no longer immobilised. It dances, sings and expresses its delights in various forms of joy. The consciousness of these new beings — coming to life — makes them fuller, more mature, and more aware of the freedom of their existence. These beings do not vegetate. They do not apologise for their existence. They sing through their being. Life is a positive phenomenon, naturally 'gravitating' towards Joy. Pessimism and gloom are against the nature of life itself; and of course against the nature of Joy. Joy is a spontaneous form of freedom; freedom is an attribute of Joy. Right Logos means the right understanding of these potencies, which are important not only for the biological but also the spiritual life. Right Logos is tantamount to foresight, which becomes reverential, delightful and ecstatic.

Swallows ceaselessly dance in the air. Why do they do it? They do not have to. Why so much effort? For the joy of flying. For the joy of existence. To celebrate the freedom of life. Similarly, dolphins are ever ready to play in water. They indulge in games with the spirit of harmony, cooperation and participation. True to their nature, dogs run all over. And tiger cubs always play.

All of this is apparently without a reason. The purpose is not the struggle for existence, but to express the joy of life, the sense of freedom; the subtle sense of existence which asserts being alive and in a state of joy.

And so it is among many other animals. And among human beings as well — that is to say in normal circumstances. It is different when we are pathologically stressed or always rushing from one insignificant job to another. The joy of existence, the joy of one's own nature expresses an inherent tendency of the Cosmos to go plus ultra, to self-realise itself.

The Upanishads are among the most sublime, creative and inspiring scriptures in human history. They are immensely creative in uplifting human horizons and aspirations to the highest levels imaginable. They are also schools of creativity and high visions. In one of these, the *Taittiriya Upanishad*, we witness a discourse on Joy, which is a hymn to Joy. It is an astonishing vision of Joy as all pervading, Joy as God. I shall share part of this Upanishad with you:

"Once Bhrigu Varuni went to his father Varuna and said: 'Father, explain to me the mystery of Brahman.'

His father spoke to him of the food of earth, of the breath of life, of the one who sees, of the one who hears, of the mind that knows, and of the one who speaks. And he further said to him: 'Seek to know him from whom all beings have come, by whom they all live, and unto whom they all return. He is Brahman.'

"So Bhrigu went and practiced *tapas*, spiritual prayer. He interpreted that Brahman was the food of earth for: from earth all beings have come, by the food of earth they all live, and unto earth they all return.

"After this he went again to his father Varuna and said: 'Father, explain further to me the mystery of Brahman. 'To him, his

father answered: 'Seek to know Brahman by *tapas*, by prayer, because Brahman is prayer.'

"So Bhrigu went and practiced *tapas*. He interpreted that Brahman was mind for: from mind all beings have come, by mind they all live, and unto mind they all return.

"After this he went again to his father Varuna and said: 'Father, explain further to me the mystery of Brahman.' To him his father answered: 'Seek to know Brahman by *tapas*, by prayer, because Brahman is prayer.'

"So Bhrigu went and practiced *tapas*. He interpreted that Brahman was reason for: from reason all beings have come, by reason they all live, and unto reason they all return.

"He went again to his father, asked the same question, and received the same answer.

"So Bhrigu went and practiced *tapas*. And then he saw that Brahman is Joy: for from joy all beings have come, by joy they all live, and unto joy they all return." (Translation by Juan Mascaro, Penguin Books, 1975).

This discourse on Joy culminates with a true hymn:

"Oh, the wonder of joy!
I am the food of life, and I am he who eats the food of life: I am the two in ONE.
I am the first-born of the world of truth, born before the gods, born in the center of immortality.
He who gives me is my salvation.
I am that food which eats the eater of food.
I have gone beyond the universe, and the light of the sun is my light." (*Ibid*)

These are extraordinary statements and far-reaching. This is an extraordinary vision in which Joy is seen as preceding gods ("I am the first-born of the world of truth, born before the gods..."). The meaning of Joy is so subtle and so profound. It is

an exceptional human experience. It contains mystical qualities, an element of the ineffable. Joy is a mystical experience in this life. At the very least, it is a bridge between the mystical and the ordinary. This sense of joy should be clearly distinguished from what is called 'fun' in English. Fun is the experience of the senses only. And it can be vulgar. Joy is never vulgar. Joy is sublime. To understand the phenomenon of joy in life is not only to understand the meaning of the word 'joy'. But 'to be' this joy, to 'emanate' this joy, to contain it — as an inner sun which is the source of ceaseless energy. Great joy is a state of continuous inner glow, which imperceptibly merges with ecstasy in the sphere of the sacred.

JOY AS A NECESSITY OF LIFE

Thus, in the evolutionary understanding, Joy was first among gods. Joy was incorporated into life — not as superficial enjoyment, but as its first divine attribute. Joy and freedom are interdependent. There is no joy of life without freedom. There is no true freedom without experiencing joy of life, without being delighted with it; without experiencing this freedom in such a spontaneous way that it becomes a song of joy.

Freedom is considered to be a necessary condition of life, especially of a conscious and aware life. This conviction is strong. It is claimed that without freedom there is only slavery; but not true life. On the other hand, the joy of life is considered as something extra, a form of luxury. However, a deeper reflection leads us to conclude that this is not so.

Only through the experience of the joy of life can we become fully aware of the value and significance of freedom. For what is slavery or limitation of freedom if not restraining our access to the variety of manifestations of life? The deeper and more versatile the form of life, the more outlets it seeks for its expression; and paradoxically, the more possibilities for its freedom to be curtailed.

Every form of limitation, every form of coercion, to constrain the natural impulses of life, is a form of prison, a denial of freedom. The denial of that which we treasure the most is felt as a very acute form of prison. For some, it is political freedom. For some, it is freedom of expression of one's opinions. For others, it is religious freedom. For birds, the freedom of flying is part of their identity; but also an essential joy of their existence.

Freedom and joy are subtly and necessarily connected. The *summum bonum* of our freedoms is precisely the joy of life. Joy is a summary and expression of all our freedoms; an enormous mirror in which our freedoms are beautifully reflected. Therefore, joy is not a luxury, but an expression of the realised forms of freedom. In the state of joy, we are free. Freedom and Joy are indispensable companions. Fighting for the joy of life, we are fighting for freedom of life. Without joy of life, there is no freedom of life.

The first God, Joy, appeared in the Cosmos in order to become a herald of the impending freedom. Cosmos is a continuous dance of Shiva. Cosmos is a continuous act of joy...dancing amidst various forms of freedom.

> *Arise! Watch.*
> *Walk on the right path.*
> *He who follows the right path*
> *Has joy in the world*
> *And in the world beyond.*

> — *Dhammapada*, 168

JOY, BLISS AND DIVINITY

Freedom was born out of Joy. However, from freedom Joy receives its strength. Joy is the blush of life. While bliss is the full radiance of life. The bliss of life, when suffused with radiance, imperceptibly merges with sanctity. For sanctity is the affirmation and expression of life, which is joyous, radiant and blissful. The progression is so

simple and so compelling. Fulfilled life of necessity resolves itself as life filled with joy. Joy has nowhere to go but resolve itself into bliss. And bliss inevitably 'gravitates' towards sanctity. This is the way of human life. And this is the way of Light itself, which we only recapitulate.

Whoever does not understand this sense of unfolding, does not understand the meaning of life. Life is such an amazingly curious phenomenon. To grasp its meaning, we require more than the most precise scientific instruments. This is what Albert Szent Gyorgy, a Nobel Laureate in chemistry, discovered during his scientific research. He once said (to me):

> "I was passionate in trying to understand the nature of life. But I couldn't behold it in its entirety. It was too big. Too complex. So I decided to study human organs. But they proved to be too complex. So I started to study human cells. But cells also turned out to be too complex. So I decided to study atoms. But even atoms proved to be too complex. So I went to study electrons, as underlying 'bricks' of life. But electrons are electrons — lifeless creatures. So in my pursuit to catch life in the net of scientific concepts, somehow, life has slipped out of my grasp."

This invariably has been the story of the reductionist approach to complex phenomena, especially to life. By 'breaking' life into its elements (of which it is made on the physical and molecular level), we have been shrinking life more and more; making it less and less significant, simply by making less of it, through the elements which could express only a speck of its content and meaning.

Spirituality is of essence to humans. It is not a feather in our cap, but actually an indispensable part of the cap. The atrophy of spiritual life signifies an atrophy of human life as such. Spiritual atrophy in our times is one of the main causes of our sliding into oblivion, of our purposeless meandering, confusion, anemia, lack

of strength and vision. This is the sickness of the soul deprived of spirituality and ultimately of Light.

The understanding of the spiritual cannot be incorporated with the scientific frameworks of understanding. For its recognition we need a conception of Life-triumphant, guided by a new rationality — holistic and trans-scientific. For spirituality is the force and energy, which is the 'juice' of our higher states of being. It sparkles at a certain point of our transcendental evolution. Alternatively, we could say that spirituality helps us to reach the higher reaches of our development. It is thus a vital force of life itself, and of our own lives.

In brief, *spirituality is a vital force*. It gives vitality and strength and energy to each of us individually; to those who embrace it or are embraced by it. Thus, it is *not a feather in our cap*, but a beam of transcendent light leading us; also a support system securing a healthy, stable, balanced and resilient life.

In these passages of transition from joy to grace to bliss to divinity, we see more and more intense Light shinning through; we observe more refined and finely tuned forms of spirituality manifesting themselves. Therefore, the passage from ordinary life to joy to bliss to divinity, is not an optional ride on the 'merry-go-round' of life which offers various possibilities. It is a sacred passage through Light in which we become more finely attuned to blossom in ever more significant spiritual forms.

Joy was declared to be the first among divinities by the Upanishads. It was an act of great human foresight and perspicuity to perceive joy as such. Joy is indeed the beginning of the spiritual road. To embrace Joy is an act of higher destiny.

Throughout this discourse I have been trying to say something very simple, yet important. Joy is not supplementary to life, but essential to the nature of life — both human and trans-human. It is not a luxury. Life is not just a biological phenomenon, full of drudgery and grim struggle for survival.

Life's inherent propensity is to enlarge itself further and further, and to deepen itself continuously. On its journey of unfolding — to become thinking and creative — life reaches this state of existence, which we may term as *the joyous mode of being*, which is the first step to divinity. When human beings forget the importance of joy, they stray from the path of their destiny; they make their life morbid; descending instead of ascending.

In the higher levels of our existence, however, we remember the beauty and importance of Joy. It is in such moments that the *Taittiriya Upanishad* was written. It is in such moments that the German poet, Friedrich Schiller, wrote his *Ode to Joy*. It is in such moments that Beethoven composed the fourth movement of his monumental *Ninth Symphony*. These are everlasting reminders that Joy is the connecting bridge between our biological existence and our divine aspirations.

The awesome journey of Light has held us in its embrace — whether we are aware of it or not. The more aware we are, the more significant the journey. And the more joyous! For what can be more fascinating and eventful than to be a part of this cosmic journey? What can be more rewarding than to realise that we are not only passive travellers, but also active participants — vital to this journey. What can be more enthralling than to see that we are a part of this great mystery which is played through us but of which we are making sense ourselves? Gradually we begin to relate to ourselves as the Cosmos itself. While we do it, we are overcome with the joy of being, and struck with the lightening awareness that it is our responsibility to spread the joy of being, which is the joy of Light.

CHAPTER 4

THE THEOLOGY OF LIGHT

LIGHT BECOMING GOD

God is Light. This intuition is acceptable to almost everybody; even to people who at the same time cherish other descriptions or deep intuition of God. Light as God appears in many sacred scriptures. Since time immemorial, human beings have been struck by the extraordinary nature of Light — its luminosity and its all-pervading nature. Eventually, Light was linked with that being, which they later described as the highest. They vested all the potency of Light in God. They forgot that Light was only an inspiration to envisage God in the image of Light.

In the embrace of Light all creation is sacred. God smiles through the 'radiance' of Light because God is this 'radiance' itself. What is the most beautiful in God is the 'radiance' of Light; what is the most significant in the image of God is the quality of Light; what is the most important in the works of God is the journey from darkness to the highest luminosity. In the nature of Light are embedded the most essential characteristics of God.

The idea of Light becoming God is appealing and intuitively simple. Yet the way towards the final stage of this metamorphosis has eluded us so far. Was Light born as God all of a sudden? Was it, perhaps, pregnant with 'God' and bore it, as children are borne? Metaphorically speaking, it must have been pregnant with 'God.' It had to contain the potency of God so that this potency could be actualised at an appropriate time. The process of this actualisation was subtle and mysterious and mind-boggling. The origin of God was bound to be mysterious. Actually every new departure of cosmic evolution is a bit mysterious. As human consciousness matured and deepened, the sense emerged that there are things and phenomena existing beyond the realm of the tangible and the observable. There emerges the feeling that there exists a trans-physical world, which is mysterious and powerful.

The prehistoric human began to intuit that Nature and the Cosmos are a repository of immense powers. These powers reside in trees, in herbs, in animals, in the realms above. They also reside in human beings as well. Thus, the sense of the invisible forces surrounding humans haunted us for many thousands of years. Then slowly, and subtly, there emerged the sense of the sacred; the sense that these invisible forces affect human destinies, are responsible for their well-being — during and perhaps even after the present life. Human beings began to cultivate intimate relationships with these special forces. They acknowledged them by paying homage to them, through rituals, both individually and together as a community.

We should understand that the sensing of these special forces and then establishing of special rituals, linking human with the forces, could not have happened if the human consciousness was not keen enough and aware enough. And here is the essential point: what was not registered in the human consciousness could not have existed outside. The human consciousness had to become

refined and articulate so that it could conceive and perceive in appropriate ways the transcendent aspects of reality. Without humans conceiving this transcendent reality, this reality could not have been experienced or apprehended in any way whatever.

Thus, the sense of transcendent reality emerged. Simultaneously, there emerged the consciousness that we live in this reality, that we are a part of this reality. The state of our consciousness dictates what we can experience; what we can perceive, conceive and even imagine. So important it is, that with a slight exaggeration only, we can say that unless certain 'realities' are conceived by the human mind or human imagination, they cannot be manifested in the outer Cosmos. This means that the process of discovery is not simply a process of 'uncovering', of finding what already exists there, but a process of co-creation with the Cosmos and Light.

With the development of human consciousness, a delineation of the transcendent forces, (which people though effected human destiny) was attempted and accomplished. This very consciousness further led to the discovery/creation of the sphere of the sacred. Slowly but inexorably the sense of spirituality was chiselled out. The images of icons, as beholding and emanating special powers, were conceived. The sense of deities, as an augmentation of these powers was the inevitable outcome. It also brought about the creation of the transcendent realms where, it was believed, the gods resided.

In time these gods became the focal points of transcendent power. They were acknowledged as controlling our lives. In due time, religions emerged. They became institutional structures of power. Their influence was vast and all pervading. They were supposed to give us spiritual support in our individual and social lives. This they did, so often to our benefit. However as time went on, they also turned out to be very controlling. Then intimidating, and sometimes imprisoning.

THE ARIAN GODS TAKE OVER

Let us remember that at first spirituality, or this divine force, which connects the human with the benevolent transcendent realm out there, was conceived as spread throughout all visible Nature — as reverberating through all living forms and making all life divine. This was especially so in matriarchal societies. But it was not so in societies which succeeded matriarchy.

Let us look at the story from the historical perspective. Around 4000 BCE, the Arian invaders from the North brought with them their sky-gods. These gods were different from early deities, which were conceived as spirits of Nature and as spreadout through Nature and Cosmos. The Arian deities were very focused and condensed. They resided in selected points; and it must be remembered — not on the earth but in the sky, thus removed from the earth. These points of spiritual power became Arian gods.

Arian people and their gods were authoritarian and conquering. After two millennia of conquests, they established their rule, which was based on a new form of consciousness, that we call patriarchal mentality. In due time, they established their patriarchal institutions. Among these institutions the most powerful are religions. In these religions, the supreme authority of gods is asserted over everything else. The process of funnelling all divinity and divine power onto single sky-gods (and then treating all other realms as profane) leads to the creation of a single all-powerful God. This in turn leads to the creation of monotheistic religions. The single all-powerful God becomes the absolute ruler, the sole spiritual authority, and the law-giver. Through its church, it sets the moral code and controls the moral life of the people; and actually all human and social institutions.

There is no question that transcendent light (of the fifth dimension) has become the most important element shaping

human destinies in patriarchal societies. This Light has also become the *most important commodity*. Whoever is in charge of this Light can rule over others. Real power over people has become spiritual power. The churches, which are in charge of this power, are aware of it and are jealously guarding the monopoly of this power.

The whole story is simple but amazing in its consequences. The Arian gods first suppressed the spirituality latent in the overall worship of Nature, characteristic of the matriarchal society. Then they subtly subsumed all spirituality (and all elements of the divine) onto their own realm. They announced themselves to be sole possessors of divine powers as well as symbols of divinity.

Then they established the monopoly of the Light. Whoever has questioned this monopoly has been suppressed and silenced. This monopoly has been most rigidly maintained by monotheistic religions. To challenge the authority of the religious institutions over this Light was so often considered to be an unforgivable heresy, frequently punished by death. This alone shows what an important monopoly it has been. Spiritual light has become a priceless commodity, especially in this part of the world, which has been governed by monotheistic religions.

During the last 5,000 years, many disturbing events happened on the spiritual map of humanity. The consciousness of the early people was bonded with all living Universe. It was pulsating the same rhythm as all living beings were. This early consciousness was democratic and egalitarian because it could not have been otherwise as all beings were of the equal spiritual status. This early consciousness was replaced by patriarchal consciousness, which was hierarchical, domineering and controlling. Almost the entire history of the so-called civilisations — with their endless conquests and wars — has been a product of patriarchal consciousness. And the history was written, by the same consciousness — justifying what has happened.

We don't know what has happened. We only have a patriarchal account of it, given through patriarchal consciousness. Only recently new accounts started to be written from the perspective of the goddess or the perspective of the matriarchal society. And these accounts are quite different from the patriarchal perspective.

RELIGIONS AS FILTERS OF BIG LIGHT

As we said earlier, monotheistic gods declared themselves to be the source of all Light and all divinity. This is evident in Abrahamic religions and also in Hinduism. Brahman is the ground and the source of all there is — eternal, unchanging, perfect. And so is God Jahve — among Abrahamic religions.

In these religions, there is an acute awareness of the importance of the spiritual sustenance for humans. Spirituality and divinity are the highest 'goods'. Against them everything else pales into insignificance. The whole way of life is so organised as to elevate and enhance the concerns for spiritual well-being, and to diminish other concerns. The scope of various other religions is so different. Consequently the forms of light, which are 'pre-selected and pre-arranged' are also different. One is indeed puzzled. Why so many conceptions of God? Why so many different routes? Why this intense competition amongst religions. If God is one, there should not be so much rivalry and competition among religions.

We are often told that indeed *God is one*. Furthermore that various religions are its different manifestations. On the surface this sounds plausible. But actually it does not explain anything. Why do religions try to destroy each other? Why all these confusions about the same God? We need answers, which are much deeper answers than traditionally given.

We should understand, to begin with, that none of the religions embrace the whole of Big Light or can access it.

Each captures only a part of it. And it does so in a peculiar way, not directly but through some kinds of filters. Each religion, and each spiritual tradition is a kind of filter through which the Big Light is filtered, processed, transformed. The result of this filtering are specific teachings and precepts, characteristics of a given religious tradition.

Because these ideas are rather new, I shall allow myself to reiterate some main points. Now, because the filters of different religions are so different, religions are different. Each filter, if it is significantly specific, establishes a separate religion, establishes relationships with Light in a specific way. It is not the same relationship for all religions. Some of these filters overlap. Hence, the similarity of the various religious teachings. Some of these filters are considerably different. Hence considerable difference, among religions, including different conceptions of God or the Divine. Each filter is legitimate — in so far as it reaches for the Light. But none can be claimed to be the only true one.

Some religious traditions claim to be the only true ones. These are the most competitive ones. They usually are the main source of trouble — in the human world. They are prepared to go to war and exterminate others in the name of their truths. Actually most religious traditions are somewhat competitive. They jealously guard and uphold the superiority of their creed.

But some religions and spiritual traditions exhibit more tolerance than others and, at the same time, possess less of a competitive zeal. Among them are Taoism and Buddhism. They offer their teachings and leave you alone. They are like Light itself, forever giving, benignly, gently and peacefully, respecting you and your dignity.

One has to look very carefully at these divine filters, which we call religions. They can be very different. Big Light shines on all. It gives and gives. It never withdraws from giving. By its nature, it

cannot be discriminating to some human beings because of their caste or sex. Only the filters are discriminating. Discrimination is the beginning of divisions; then of animosities and hatred; finally of persecution. This is not the way of the Big Light.

Existing religions are completely unable to explain why they quarrel with each other. They are unable to explain what the real differences between them are. They are at a loss to see that the same benevolent God can be an inspiration to religious wars.

The idea of religious 'filters' provides a clue to all these dilemmas. The power of the filters is camouflaged, really hidden. Ultimately, the filters are ingenious works of the human imagination. Their specific frame and configuration depends on the genius of the founder. The filters in toto represent the human genius in structuring the Big Light so that it becomes available, comprehensible and inspiring to ordinary people.

These founders (of great religions) are messengers of the Big Light. They were aware that the Light they witnessed was extraordinary and as such they called it 'divine'. The new consciousness they possessed rendered the world sacred and divine.

Let us observe that the problems of domination by religions, which manipulate, intimidate and exploit people, are mainly problems of patriarchal religions. Their filters are in the image of patriarchal consciousness, which is dominating and exploitive. Spiritualities of tribal people, especially of the matriarchal times, are symbiotic rather that dominating. The nature of these filters, which connect tribal spiritualities with Big Light, is quite different than that of patriarchal religions.

THE WAY OF MYSTICISM

Big Light and mysticism are intimately connected. Mysticism is a big enigma. And yet such a big invitation. We are afraid of it.

And we are entranced by it. Who are the mystics? The living torches of the Big Light.

The mystics are both a pride of and an embarrassment to established religions. The religions want to appropriate the mystics. On the other hand, the churches fear them. Religions and churches are quite aware that what the mystics represent does not agree with the canons and dogmas established by them. Hence the embarrassment. And finally attempts to suppress mystics as heretics.

Mystics defy all religions. Not that they do it consciously as an act of defiance. They go directly for Big Light. It is not because they intend to be defiant but because they seek the Big Light. They wilfully connect with the Big Light and embrace it. Through their peculiar genius they can connect with the Big Light and not be 'scorched' by it. To live in the continuous presence of the Big Light and be a constant witness to it, is a superhuman experience. In this sense, they are superhuman. What strikes us first of all is that they are so 'free'. The state of their being represents the ultimate dimension of freedom. They cannot be bound by anything. Their freedom is so beautiful. Yet, a bit terrifying. Nothing binds them; but nothing ever supports them, except the Big Light.

The way of mysticism is hard to define. It is a pathless path. Thus we cannot fully understand it, if at all. We cannot learn it. We cannot follow it as there are no tracks to follow and we cannot learn it as there is nothing to learn. We can speak about it, we can read about it, we can write about it. But our words are like straw in the wind — a bit deceitful. The more coherent the description, the more surely it misses the meaning and depth of mysticism. There are no adequate 'statements' which could faithfully describe the nature of mysticism.

The mystic signifies the ecstasy of being — this overwhelming Light which penetrates and emanates from the overwhelming

radiance that penetrates his soul; the sense of total tranquility and joy; and the rapture of being. He signifies the sense of touching the Divine or being touched by the Divine; the sense of being close to God...yet, be weary of words! Words so easily fit us into conventional idioms; nay, force us into conventional religious language. And this language claims that mysticism is an experience of God (with the hidden premise that this is the God of the given religion). The problem is that every religion wants to see the mystic experience as the manifestation of its god; and not of any other god; not of the cosmic god, not of the Big Light.

The established religions have far-reaching tentacles. They claim to be the sole vehicle for interpreting spiritual phenomena. They interpret mystical experience as a peculiar form of communion with God — according to their understanding of God and according to the precepts of their religion. Those who have undergone a deep mystical experience can testify that they did not encounter any particular god but a great Light. A mystical experience can be interpreted *a posteriori* as an experience of a particular God (whatever its name). It is a unique and subjective experience. Later, established religions try to affix their interpretations and impose their seals of approval.

In many aboriginal tribes, mystic states have been known. Sometimes they were induced through hallucinogenic drugs, through ecstatic dancing or continuous singing for days. This was usually an attempt to merge with the Ultimate Reality. Amongst them the shamans, the seers and the medicine men were the people who were sensitive to the Great Spirit or Big Light. In their practices they consciously sought unity with Big Light, or whatever name they used for the Ultimate.

There are paths to the Big Light, which are beyond the organised religions. The great mystics are not trapped by religions;

rather they seek to meet with Big Light. The trouble starts when they try to explain the experience of Big Light in the language accepted within given religion. One cannot 'describe' Big Light. The experience of Big Light is ecstatic. It borders on madness. Some went beyond the line, never to return. The Big Light devoured them. The best explanation of the mystic experience is silence. The great silence of the mystic who knows but is unable to describe. And the great silence on our part which enables us to understand even without words.

Mysticism, as a historical phenomenon, undeniably proves that the Big Light exists and that it is accessible to all; although more to some than to others. By its extraordinary nature, mysticism is fascinating. It gives us insights into our deepest nature. Deep down we long for it. Yet, the rational mind often tells us to hold back. It whispers to us that mysticism is beyond us. And thus removes us from the mystic joy.

Mysticism exists in all cultures. It is not a phenomenon or a property of any religion. It is a cosmic phenomenon. It is a challenge to those who have not been able to face it and also an invitation to the people who have been initiated. We recognise the philosopher by his theories; the mystic by his glow. Had it not been for his glowing self, we would have understood the mystic to be merely knowledgeable. He would have been the like of a philosopher. It is paradoxical; the lesser the mystic says the better his expression.

If Light is the kernel of mystical experience, then it can be conveyed by words, which are Light themselves. Here are some.

"Light is visible by Light. The nous sees itself, and this light, shining on the soul enlightening it and makes it a member of the spiritual world."

— Plotinus, *Enneads*, V.3.8

"Light rare, untellable, lighting the very light."

— Walt Whitman

"I saw Eternity the other night like a great ring of pure and endless light."

— Henry Vaughan

"He who knows the truth knows that Light, and he who knows that Light knows Eternity."

— St Augustine, *Confessions*, VII.10

THE ETHICS OF LIGHT

This discussion has already amply demonstrated what an extraordinary phenomenon Light is! When its deepest meaning is grasped, then it can be clearly understood; why religions quarrel with each other; why they are incomplete; why they cannot understand the meaning of mysticism and often attempt to suppress it.

The understanding of the deep nature of Light enables us to comprehend realms which are important, but which have languished in obscurity. Among these phenomena is 'human ethics' and 'human freedom'. Yes, we are acquainted with them. Yet, we need to re-examine them in order to see that they are part of the theology of Light in the broad sense: they derive their deeper meaning from the *very nature of Light*. I shall attempt to show that a new ethics, of a truly universal nature, can be derived from the ethics of Light itself. I shall also argue that the meaning of human freedom is contained in the meaning of the freedom of Light. Let me discuss ethics first.

The fundamental nature of Light is to always give. It is always glowing and illuminating; illuminating and nourishing; nourishing and uplifting; uplifting and transforming. Such is the nature of Light. Its very nature is abundance. It showers the earth with energy, which is the source of all. Its inexhaustible generosity

has embraced the humankind too. We are saturated with abundance. We are truly living in the universe of abundance.

It is time to become aware of that. We are the beings of Light. In our ethics, we must mirror the elan of light. The elan with which Light unfolds is reflective of its giving, generous and transcending nature. Our ethics must be in congruence with the laws of the Cosmos. These laws, in one way or another, recapitulate the thrust and elan of light unfolding.

We are therefore postulating human ethics, which accepts and embodies the elan of the abundance of Light. Light is always giving. Thus human ethics must be based on giving and not hoarding. From the imperative of abundance follows the imperative of giving and generosity.

Other ethical principles which are latent in the nature of Light, and which must become principles of human ethics are: sharing, solidarity and love. Furthermore, the ethics of Light must include: harmony, transcendence, spiritual well-being and beauty. Why harmony? Because generosity and sharing are meant to benefit the overall harmony. Why transcendence? Because the overall harmony is not one of immediate satisfaction but a transcendent quest for spiritual self-realisation.

Here are the eight principles of the ethics of Light:

- Giving
- Generosity
- Sharing
- Solidarity
- Love
- Harmony
- Transcendence
- Spiritual quest

The ethics of Light, which we are postulating here, are based on a deeper reading of the structure of the Cosmos. For this reason

we may call it a cosmic ethics. This ethics is natural, intuitive and rational. It is not based on any religion or divine revelation. Yet, we can call it divine because of the overall divinity of the unfolding of light, which these ethics embody and reflect. This is an altruistic ethics because all beings in the Universe cooperate with each other. It cannot be otherwise in the Universe derived from Light and governed by Light's laws.

This vision of Light as all giving — through its various manifestations — explains compellingly the altruistic nature of life and of human evolution. The quintessential expression of giving qualities of life is Mother. A mother is an embodiment of Light itself, always giving. Mothers may not know why they are giving and giving. The answer is because they must. The imperative of life is ticking in them. Nay, the cosmic imperative is ticking in them. Light's imperative is guiding them; moving and inspiring them.

At this point, the imperative of altruism, the necessity and viability of altruism is as compellingly explained as it ever can: we are altruistic because we are cosmic beings, because Light in us inspires us and compels us to continue its journey — of giving and sharing.

Altruistic ethics is part of the cosmic law. As we begin to understand the deeper structure of the Universe, we begin to accept that the higher we go, the more we share with other beings; thus we give more and more — because we are inwardly impelled to give, otherwise we slide towards decay. The altruistic ethics of Light is part of its spirituality because it is part of the divine vehicle of life, and of spirit evolving to ever-new heights.

This sense of giving and sharing is particularly apparent in illustrious beings, such as Jesus and the Buddha. They have been giving and giving. Indeed, they have been giving not

only kindness, love and compassion, but invariably Light. For the highest qualities of human behaviour — love, divinity, compassion and kindness — reside in the womb of Light. They are themselves expressions and manifestations of Light. Those who are considered the greatest beings, among humans, are recognised as the shining light.

Light will prevail because it must, because of its fundamental nature. Its very nature is giving and giving. It showers the whole Cosmos with its abundance. When we reflect on this, we realise that the Universe is in good shape. We are in good shape. The future of humanity is in a good shape.

LIGHT AS FREEDOM

Searching for the meaning of Light among the items of the physical universe is a futile endeavour. Light is about one fantastic freedom, which unveils itself to us when we recognise the true nature of Light, and our place in the unfolding 'tapestry of Light'.

Light creates freedom at every point of its creativity. For every creative act is born out of freedom. To be true vehicles and repositories of Light, we must embody this extraordinary freedom of Light with which it acts. It moves and dances in freedom and with freedom. This freedom exceeds any freedom known to humans. This freedom of Light is so intoxicating, so overwhelming, so embracing that even thinking of it, makes us free, makes us realise what strange and wonderful beings we are — moving along the paths of Light's freedom. Of all the forms of liberation, the liberation through Light is most profound. All forms of freedom are concealed expressions of the freedom of Light. All the virtues and qualities we possess somehow reflect the glories of Light.

Light is freedom. Confinement is the denial of Light. An enlargement of Light in us brings about an enlargement of our

being and freedom. We simply are unaware what great freedoms are available within our psyche and spirit. Only great artists, from time to time, have the courage to embrace these resources of freedom.

Freedom is such an important gift of spiritual liberation. And such an important criterion of the worth of Light itself. Another name for Big Light is Big Freedom. It requires the inner strength, the strength of our character to search for inner light and for spiritual destiny. In seeking spiritual freedom, we often need to extricate ourselves from the religious matrix, which has defined us hitherto. Our identity and this matrix are often intertwined and interwoven. Thus we must be careful so that our identity does not collapse during the process of freeing ourselves from the old (religious) matrix and all its trapping. Therefore we must be strong. It is an abortive quest for spiritual liberation if, instead of finding new spiritual nourishment, we land up in a fundamentalist confinement, or worse still, we slip into nihilism and total relativism. Nihilism and relativism bring no freedom. They bring confinement.

Now, religions which imprison and manipulate their followers, are not true religions of Light. A true religion enlarges and deepens your freedom. It gives you wings and does not bring chains. The greatest freedom of Light is its capacity to metamorphosise itself into the divine substance, which some call God. The greatest freedom of human beings is of the same kind. It is the capacity to metamorphosise themselves into celestial beings, by incorporating the highest attributes of Light. This freedom of Light is so divine that we can hardly find words to describe it. When we contemplate this kind of freedom, we are inclined to think that everything is possible. We feel God-like; which we are.

Light is all-embracing. Light is all-creative. Light is quintessentially free. But Light is not perfect. The creative process is not perfect. It is so because whatever is creative, is open

and undetermined. Creativity signifies continuous transcendence. He who creates, makes mistakes. Creative mistakes are not faulty endeavours. They are attempts to open reality in new ways. This is what the true meaning of transcendence is. By creative mistakes, human beings learn. In this endeavour, they follow the modus of Light. Light is a continuous learner. And so is evolution. And so is all life.

Monotheistic gods are supposed to be perfect. If they are, therefore, they are uncreative and stagnant. Remember: creativity means transcendence. Transcendence always includes searches and some mistakes. There is no perfect way to transcend. Transcendence means groping towards the new amidst uncertainty. Uncertainty means stumbling and trying. All creative endeavours are of this kind. Transcendence simply means going beyond amidst freedom, creativity and error. This is the way of Light. And of the humans — who have inherited freedom and creativity of Light.

Light signifies the greatest freedom imaginable. Traditional gods are antiquated and petrified. Past religions have mainly exploited us. They have been the instruments of suppression. They have been our tethers. Light is Liberation! We have spent too much time in the stone-age and acquired too much of the stone-age mentality. We have spent enough time in caves. And we acquired more than enough of the cave mentality. The time has come to leave the caves and the mentality of slaves in the caves. The time has come to emerge into the lucid Light and embrace the wisdom of Light and the freedom of Light. Light is not accidental to our freedom. It is essential to it. Light is the bringer of our freedom. Freedom is a form of Light, is this essential modality through which our most essential human attainments can be realised and safeguarded. Freedom, in the deepest sense, is spiritual freedom, connected with the aspiration to be Divine.

THE THEOLOGY OF LIGHT

Big Light is more encompassing than any religion and all religions. Religions are only bridges. Light is more primary, more powerful, more elementary. Light is the primary source of all, including all religions, prophets, and divinities of various religions. Light informs us that the Buddha was not Light itself, but a reflection of the Ultimate Light, a high embodiment of Light. For the same reason, Jesus was not Light itself, but a reflection of the Ultimate Light. And the same holds for Lao Tze and other Illumined Ones.

Therefore, we cannot claim that Jesus was the highest Light, while what was before was an obscure light — though reflecting some aspects of Light; and that what was after was a distorted light — although shinning with some background light (of Jesus' light). There have been some attempts to subsume and incorporate the theology of Light into existing religions, specifically, Christian theology. By understanding the nature of existing religions *as monopolies*, such attempts are not surprising. But they are illegitimate. We do not want to go backwards. We have shown that all religions are derived from Light. The ultimate source is Light. The primacy of the divinity of Light is unquestioned and stupendously clear. To claim that Jesus is the Ultimate Light would simply mean to undermine the foundations of the theology of Light and transform it into Christian theology. The theology of Light has transcended Christian theology.

This is not an attack on Christianity. Far from it! By accepting the primacy of Light — Light as the source — we can easily follow the teaching of Jesus, that is, what is most essential in the teachings proposed by Jesus Himself. In actual fact, the ethics of love, so important to the Gospel of Jesus, reflects and embodies the ethics of Light more closely than any other ethics proposed by spiritual prophets; with the exception of the Buddha, perhaps.

Indeed, these two spiritual giants, Jesus and the Buddha, understood the meaning of Light most profoundly.

People must not be nervous about their own spiritual traditions. Light is not competing with any of them. It only provides a large comfortable platform on which they all can be accommodated. Light has existed for several billion years. Organised religions have existed for merely three millennia. It should not be surprising that Light can be a host to relative new comers.

I have mentioned the idea of the theology of Light. What is then the theology of Light? It is a new vision. A new holistic vision of all there is. Expressed in the simplest way: theology of Light is this vision, which informs us that there is one stupendous unity in the Universe, which stems from Light and is nursed and nurtured by Light. It is a vision of unity amidst the relentless creativity. This unending creativity is of such power that it verges on the Divine. Nay, this creative unity is Divine. Our theology of Light is thus based on three main pillars: unity, creativity, divinity.

Everything else flows from it. The creativity of the Cosmos or of Light is so powerful that it could bring out divinities, gods and religions from the original womb of Light. This unitary phenomenon of Light, which possesses such enormous powers should not frighten but delight us. For we are part of this unity, part of this creativity, and part of this divinity. Moreover, our creative and divine mind could conceive of it and justify it.

What I have described is not a theoretical scheme or a theological fantasy, but a powerful matrix, which involves a new altruistic ethics — it has enormous positive consequences for human kind and for all creation; as well as a new sense of freedom, which is so liberating and so empowering; as well as other strategies for human action, which can be applied in real life

for the benefit of all. The matrix proposed invites us all to a holy interaction for which we have waited for a long time. The dream of a fair world is not a fantasy but a possibility. It is a promise of Light, which Light can deliver. But only with our help.

The journey of Light is the most stupendous of all journeys. We are all fascinated by it. We want to understand it. But with due humility we need to understand that there is a threshold of mystery. The journey of Light explains all other journeys. But itself? It is perhaps the ultimate mystery. 'Why' this journey in the first place? Well, because the Universe is here. But 'why' is it here? Well, because Light has been on its journey. We should not be too compulsive in trying to explain it all. Accepting mystery is actually rational. And it is beautiful. It adds profundity to the meaning of our life.

THE YOGA OF LIGHT

INTRODUCTION

Every step brings Light. Every breath brings Light. Every thought is Light. Yet to release Light in our steps and thoughts, we need to practice appropriate exercises. These exercises we shall call the yoga of Light. We need to practice them so that our yoga of Light is a living knowledge — through which we can be elevated, augmented and enlightened.

When we are engaged in spiritual knowledge, it is not sufficient to read books about it. To absorb it, we need to allow its energy and Light to seep inside ourselves, to penetrate us, to plough through our inner being. Only when we possess it does it possesses us. This process requires finesse and practice, self-discipline and reflection. What is involved is not only the brain or the mind but our entire being.

We shall now engage in meditation which will bring our awareness of the five dimensions of Light into an existential focus, into our life structures, into our psychic structures.

We shall see and experience how our Light intimately interacts with the basic aspects of our living and with sublime aspects of our spiritual life. Yet we should approach these exercises with reverence and caution. They are subtle and far-reaching. We should not plunge into them and expect wonders overnight. We ought not jump too far to begin with, so that we do not find ourselves jumping from a high ski-jump. Secondly, it would be desirable if the practitioner of the yoga of Light had practiced some sort of meditation before. Thirdly, the practitioner must not be impatient and rush into the most advanced exercises before mastering the rudimentary ones first. And finally, it would be a good idea if, at first, particular meditations listed here were read to the practitioner aloud, so that he can concentrate on the meditations.

Practices and Meditations

Meditation One

Sit comfortably, completely relaxed. The head, neck and spine should be in one straight line. Start breathing from your toes and up to the top of your head. Thus we begin. Relax your toes, heels, soles, knees, thighs, hips, your abdomen and all the internal organs of your stomach. Now relax the fingers of your hands, relax your arms, elbows, shoulders...your chest, lungs and your wonderful heart. All relaxed — the neck, the head, the brain and the mind. The whole body beautifully relaxed.

Now meditate upon a Buddha-like being sitting on the lotus flower in the lotus position, the being who emanates peace, compassion and love. Now imagine this being at a distance, sitting on a hill. Next, imagine a path of white light stretching from this being to your very heart. Let this being now float on this road of Light towards you — so much Light and peace and serenity.

The Buddha-like being comes closer and closer. And enters your heart and sits there.

Now let the body of the Buddha grow within you until his body just conforms to your body: where your legs become the Buddha's legs; your hands, the Buddha's hands; your head, the Buddha's head; your heart, the Buddha's heart; your mind, the Buddha's mind. Now breathe gently and feel yourself to be the Buddha.

Now feel what it is like to be penetrated by the feeling of total compassion. Compassion for everything there is. For those far away and for even those close to you. Feel this great compassion, understanding and forgiveness. Empathise, for to empathise is to forgive. Now direct this compassion and forgiveness to yourself. Everybody needs compassion. So do you. You need to be able to forgive yourself as well. Empathy, understanding and forgiveness for all. Feel compassion but without any attachment.

Now feel what it is like to be penetrated by Light; clear, lucid, white light. Let this light emanate out of your eyes, out of your toes and fingers...out of all the pores in your body. Be Light. You are now a being of Light. Now let this being of Light and compassion — which you now are — start to travel outside your body. Sense more and more of the world from within.

Come closer to the majestic snow-covered tops of the high Himalayas. Experience them in the full glory of the shining Light. May this Light, which you are united with, the Light of the shining Himalayas, become you.

You are absorbed by the Light of the Himalayas. Now, rise higher towards the sun shining upon the Himalayas. Go to the crown of the sun and unite with the Light and energy of the sun. Dwell there for a while. Now you are going higher still to focus on the galaxies. You are now somewhere in the mountains, far away from human habitation surrounded by the theatre of

the stars. You are one with the stars. Experience the great silence of the stars...stay there for a while. You and the stars are one.

Now very, very slowly start to return. You are gently travelling from the stars to the sun. Now from the sun to the shining peaks of the Himalayas. From the Himalayas you are travelling back to your own country, to the house in which you sit, to the room in which you are. You are now back in your own body.

You are again in the normal reality. Feel parts of your body. Start breathing gently. Be aware of your breath: in and out. In about five to ten seconds, open your eyes. Allow fifteen to twenty minutes for this meditation.

MEDITATION TWO

Now sit in a comfortable position with your head, neck and chest in a straight line. Be very relaxed. Close your eyes and breathe normally. Observe your breath. You are just breathing — in and out.

You are one with the Universe and with yourself. Just breathing. In and out, very gently. But also being aware what a gift breathing is. Just smile to yourself in appreciation of this gift. Keep breathing gently. Now observe the gift of Light. Light has been a gift indeed! Start by meditating upon the first dimension of Light as pure potency. Now become aware of the second dimension of Light — Light as life. Become aware of every cell in your body as a creation of Light. Become aware what a wonderful job Light has done in creating these cells working, all working so well in harmony.

Starting from your toes, consider that each atom of your body is made of Light. Realise what a joy it is to have so much Light within you! Assume smoothly touching all these atoms of Light as you go from your toes to your head through the legs,

the abdomen and the chest. Take your time in touching these countless atoms, and being responded to by them.

Now, observe your tissues and organs as great cathedrals of Light — each beautifully orchestrated. Become aware of your entire body as one great symphony of Light. Become aware what a stupendous work Light has done on the biological level. Take time to do so.

Now let Light, this enormous outside Light, caress and kiss your body rolling from your toes to the top of the head. Let it soothe your heart, your eyes, your mind. Calmly observe the miracle of Light. As Light balms your body consider it being cleansed, becoming luminous and shiny. Take some time doing that.

The parts of your body which may be troubling, aching, or not functioning too well in any sense — suffuse them with Light for Light is a healer. Let Light surround and bandage them; for a while meditate upon these parts.

After this encounter with Light, put yourself at ease; relax your whole body. Feel the radiance over all your body and inside. Now relax again. And breathe — normally and gently.

Allow fifteen to twenty minutes for this meditation.

MEDITATION THREE

We are now going to reflect on the next 'unfolding of Light' — when Light became the joy of life.

We are going to relate this new evolutionary departure to Light in our own life. Consider just how happy birds are when flying, especially in spring; how happy fish are when swimming. Each in its own element experiences the joy of life. There is something beautiful in the spectacle of life being joyous. Joy is not sensuous pleasure, not a state of physical well-being alone. Joy is a metaphysical form of well-being bordering on the mystical.

Yes, our senses are involved in the experience of joy, but this experience has a trans-physical dimension, an aura of another reality; it touches these realms which are beyond the body. Joy is the mirror in which we catch the smile of the Divine.

Remember we are not talking about physical pleasure or these ordinary pursuits which we sometimes call fun. Joy is something more subtle, more sublime. It makes your being, sing or perhaps even dance — as your nature is being fulfilled by the joy of being — of all creatures in the Universe.

Now remember your own experiences when you were naturally high and exhilarated; either walking through a forest, or climbing mountains in a beautiful terrain, or singing or dancing, or doing what you really like. Yes, the activities which bring joy to your existence. Remember these moments, reflect on them. Re-live them vividly.

Take time to re-live. Remember what a joy it was to have these experiences. Now slowly come back and register that joy is natural to life, to your existence. So smile. Smile a lot. Smiling brings you health and increases your inner harmony. And when you smile, smile with such spirit that your eyes smile and shine too. As you smile your eyes light up. You smile, Light smiles. You smile Light, Light smiles you. Let your eyes emanate this smiling light always.

You have experienced Light as Joy. Now return to focus on your breathing. Breathe naturally and gently.

Allow fifteen to twenty minutes for this meditation.

MEDITATION FOUR

We return to the journey of Light. In more recent times, another profound transformation of Light has occurred, another quality of life and existence has emerged. From its primary form Light cascaded to being life; from life to Joy; from Joy to creativity

and transcendence. It blossomed as the creative and thinking Logos.

Thus Light doubled upon itself once more and created beings and capacities which surpassed all previous achievements of life and of the Cosmos. The joyous light became the creative light. For this purpose Light needed agents endowed with the creative capacities and sensitivities to receive the transcendent, to become the symbolic and transcendent being; the *Homo Creator* and *Homo Symbolicus*.

Now, take a deep breath and recall your encounters with the fourth dimension of Light, which is the sphere of creativity and transcendence. These encounters were numerous, if not endless.

Try to recollect your experience of listening to great music, be it a symphony of Mozart's or an Indian raga played by a master. Retreat into the depths of your mind and your heart and re-live the sublime moments when you were transported.

You may wish to reflect on the experience of some great sculpture, which moved you and made you see the meaning of existence; some great painting which somehow struck a chord within you. Think what creative powers would have participated in the making of these pieces. Reflect upon the beauty of art. Take time to reflect on these experiences.

Now reflect upon your own creative endeavours, which rendered you most creative and totally absorbed in your creativity. It could range from making an object of art to solving a mathematical equation to being submerged in meditation to reach your inner self. Yes, meditation is a creative act. Reflect upon the most creative aspects of your nature and of your life. Take time to reflect. Now return to your breathing. Breathe gently while you are suffused in your Light. Just breathe.

Be grateful to Light for this gift of creativity and for being surrounded by such creativity. Creativity is indeed the gift of

the Cosmos. Be aware from now on (and always!) what a shining bundle of creativity you are yourself. Be aware of the extraordinary powers of Light with which you are vested.

MEDITATION FIVE

Light kept unfolding and doubling upon itself. The net transformation happened when Light went into its fifth dimension and became Light Divine. The divinity of Light is its most recent attribute and its most profound characteristic. To reveal itself in this transformation, it had to create the most subtle sensitivities in the human: the sensitivity for the sacred, for the Divine, for the God-like.

Now feel this Light Divine which is a part of your nature. Feel how incomparably subtle and beautiful you are because this Light has found a dwelling in you. Feel what a responsibility and joy it is to be a sanctuary hosting this Light and maintaining its sacred nature. Feel how by maintaining its sanctity, you have maintained your deepest self. Take time to reflect.

Now reflect upon the experiences when you felt that you were touching the Divine, or being touched by the Divine — yes by this Light Divine of the fifth dimension; or whatever name you gave to this dimension before. You may have another name for this Divine Light. The usual name for this Light is God — which is but the crystallisation of the Big Light in human language.

Contemplate upon this core of your being which is capable of receiving the Big Light, of identifying with it, of merging with it — even if you do not have words to describe it. Is there anything higher, bigger, more significant?

This is the greatest human happiness. You may call it the bliss of God in you. Saints and prophets retreated into solitude and often to remote places to be embraced by this Light/God.

Allow fifteen to twenty minutes for this meditation.

Return to your breathing. Breathe gently. Relax completely. We have gone together through quite a journey. Let us review briefly its various stages:

- Light as life: You participate in all the life cycles nourished by Light and benefit from them. Remember yourself as made of atoms of Light.

- Light as joy: You share with living beings, especially animals, the joy of being alive. Remember your experience of Joy.

- Light as creativity: Light in you advanced to the point of making you a true creator, artist. Dwell upon the creative aspects of your being.

- Light as divinity: How the Light in you crystallised into the divine awareness and the capacity to receive and to create the divine reality around you. Gently embrace the divinity in yourself. You are co-creating with the Divine. You are part of the creative force of 'God'. There is no other agenda for you. There is only this Big Light to embrace and to live to its glory until you become it.

Allow ten to fifteen minutes for this meditation. Return to this meditation from time to time.

PARTICULAR PRACTICES OF THE YOGA OF LIGHT

We have introduced and practiced general meditations on Light. Their purpose is to make you better acquainted with the nature of Light at various levels of its being. A deeper purpose of the meditations is to internalise the basic ideas concerning Light as forms of energy, so that they do not stay in your head as ideas only. We shall now go a step further. We shall introduce special practices and exercises, to be practiced daily — to attune your

being to the realities of Light and derive more benefits from your awareness of its multifarious manifestations. The exercises on yoga of Light are divided into four levels.

LEVEL I: BECOMING DEEPER IMMERSED INTO LIGHT

- Remember when you wake up in the morning that you wake up in Light; are welcomed by Light. Respond by welcoming Light and thank it for its existence. Remember how lovely it is to live in the Universe of Light.
- Do the same in the evening. Thank Light for being your companion and for guiding you through the day. Do it intentionally, not only with words but with all your heart.
- During the day, allow yourself to be guided by Light. Ask it how it would like to guide you so that you are more focused, peaceful, radiant. It requires thirty seconds of peaceful space. Do it only if you have thirty seconds of peaceful space to spare, otherwise, don't do it.

These three exercises enable you to become befriended by Light and befriend it. To wake up to the idea just do it for at least two weeks.

Try not to skip any of these steps if you can help it. Get used to the idea of living in the Light. In due time, when you are ready, start conceiving your own exercises.

In bed at night, you may reflect on the events of the day which were lived in Light, and why they feel so good. Maybe you also wish to reflect on the 'patches of darkness', when you chose to refuse Light, and why they didn't feel so good. As time goes on, you might want to converse with Light and from time to time; and gently ask it what particular guidance it wants to give you for your daily life. Be humble and in joyous anticipation.

LEVEL II A: MASSAGING YOUR BODY WITH INNER LIGHT

All is made of Light. Thus your body is made of Light — every particle and atom of it.

Now experience your body as Light. From the toes to the top of the head. Your toes are made of Light. Concentrate on them. Contemplate each toe as made of Light, which underlies the constituent atoms of your toes. Concentrate on this Light. How lovely it is to have toes made of Light!

Then experience your soles and heels as Light. You are concentrating on particular parts of your body as Light. Then embrace the ankles as Light, then your calves and knees. Feel what a lovely thing it is to have your body made of Light, which is the ultimate constituent of your 'architecture'.

Go up slowly. Don't rush. Experience your thighs as Light, and your hips; and then the bones of which the legs are made. It is all Light. You should feel good experiencing yourself as Light.

Go up to your abdomen and concentrate on all parts of your stomach and the digestive system. Up to your rib cage and your spine. Experience them as Light. Then your lungs — as made of Light. Then your heart. It is all Light. Experiencing your heart as Light should be joyous, for the heart is an enormous repository of Light.

Now let's go back to the tips of your fingers and whole fingers. Feel them and the underlying Light. Then the palms and wrists — feel them as the underlying Light. Then the lower arms and elbows. Then upper arms and shoulders — feel the primordial Light of which they were made.

Then go to your neck. Then go inside your brain — one enormous fire of electrons. Feel the underlying Light. Now feel

the entire body as made of Light — on the subtle level. You should feel energised and good. Now relax and breathe calmly for two minutes. The yoga of inner light has been completed.

LEVEL II B: LIGHT AS THERAPY

Return to the parts of your body, which you felt were aching a bit during your massage with inner Light.

These are the parts, which need attention. Go back to these places and embrace them with your inner Light. Tell your inner Light to wrap them well, to soothe them, heal them. This is the most elemental massage you can give to yourself — through your inner Light, on the somatic level.

Remember also that there is the outer light. We are going to repeat what we have done with the inner Light. Now, massage yourself with the outer Light — slowly and gently: from the toes to the top of your head. Gently go up through your body. Attend to the aching parts. Wrap these places with more outer Light, and give these places more intensity.

Linger around the parts a bit longer. When you reach the head, remember that your mind is a precious instrument — so often under all kinds of tensions and pressures. Surround your brain and mind with a gentle soothing Light and then let your mind relax — very deeply.

The yoga of massage through the outer Light has been completed. Be mindful that this Light therapy is elemental and subtle. Be also aware that every exercise involving Light is a therapy in itself, even the simplest one where you welcome Light in the morning and remind yourself how lovely it is to live in the Universe of Light.

The idea of therapy through Light is vast and important. Light is healing. For Light is life. The yoga of Light is a precious asset. It should be treated with reverence.

- In your daily meditations, reflect upon your creative nature. You are not only made of clay but, of the creative substance of the Universe.

- You do not have to strain in order to express your creative nature. You are naturally creative because the Cosmos has made you so. Yet you need to find your distinctive path in which your creativity expresses itself in the most felicitous way.

- Find the realm in which your nature can flourish best in a creative manner. It may be in the domain of art or science or just the way you juggle the ordinary in daily life. Observe what gives you the greatest joy while you are doing it, and what is recognised by others as your natural gifts. Cultivate these special gifts of your nature. Develop them more and more until you acquire mastery.

- Creativity is not only doing what you are good at. It is also a sort of activity in which you can totally lose yourself. Total absorption, total rapture is one of the greatest joys. So joyous it is that it almost feels divine.

- Do not be afraid of being creative. Creativity requires courage. In turn, creativity brings you courage. It emancipates your spirit. Being creatively engaged, you are free; you are authentic.

- Creative courage means going beyond what you have achieved already. You must transcend yourself continually. Never be afraid of transcending yourself. Shoot for the stars because this is the way in which your creativity reaches its acme.

- Do not be mortified, or even apologetic for making mistakes as you engage in creative endeavours. To be creative means trying new things, means employing the method of trial and error. Mistakes are inevitable on the creative path.

Great artists and masters have known this secret. Evolution itself has worked through the method of trial and error. And so has God.

- Being creative means giving coherence, depth and meaning to what you are doing. Creativity is not only doing things well and efficiently. It is doing them with panache, sharpness and originality. It is always making things with care and love, never sloppily. Sloppiness is the opposite of creativity. Another opposite of creativity is destruction.

- Try to express and live your life through the acts of coherence, meaning and beauty. Indeed coherence and meaning result in beauty. And beauty itself is coherent and meaningful. By beholding beauty and befriending the stars, you help yourself on your creative path.

LEVEL IV: HOW TO BE DIVINE

- Be aware that you are a spiritual being. Your nature has three aspects physical, psychic and spiritual. You need to be fully aware of each in order to develop each appropriately. Know that without spiritual practice there is no spiritual advancement, and ultimately no enlightenment. Yes, enlightenment is the goal — regardless of whether you fully achieve it or not. Just do not get stuck in the mud and wait for a miracle to deliver you. You are your own miracle delivering yourself.

- Develop your own spiritual practices. You may draw from whatever spiritual tradition is close to you or is most appropriate to your nature. There are many spiritual paths which are equivalent. The destination for all of them is enlightenment. Yoga of Light does not prescribe which spiritual tradition you should follow. Your spiritual path must be one of liberation and not of confinement.

- Solitude and silence are deep sources of spiritual sustenance. And so important are they, that it is hardly possible to embark

on a serious spiritual journey without enlisting solitude as an ally.

- Inner peace is the foundation of all spiritual practices. It has to be continually cultivated. This could be through the special exercises of the yoga of Light — by enacting daily your sense of unity with Light.

- Courage is another precondition for spiritual ascent. The spiritual kingdom is forever open to you — if you have the courage to enter it. This courage to enter it requires a fierce determination to actualise your spiritual potential and your latent divinity.

- Generosity, altruism and compassion are other preconditions for pursuing the path. These attributes of your behaviour and thinking are not arbitrary. They follow from the ethics of Light. Because Light is generous, altruistic and compassionate, anybody who follows a truly spiritual path would instinctively obey these ethical commandments.

- Love is close to divinity. So, love! In all manifestations of your being. Nourish a loving heart, and even a loving mind. A loving mind is the companion of compassionate being. Love is nurturing the world. Love is a bridge to divinity.

- Spiritual life is about flying. Fly! But fly in control. We have seen too many wounded Icaruses. Fly like an eagle, which is capable to return to the earth at will.

- Remember: all life is Divine. The lotus flower symbolises this supremely. Although its roots are submerged in the mud, it blooms with radiance and beauty.

REFLECTING ON ALL THE YOGAS

By distinguishing four different levels of exercises on light, we do not mean to suggest that they are separate domains. In fact, they interact with each other and are interwoven.

Seen in the total vision of Light, as one unitary phenomenon, all these exercises (although they focus on different aspects of our existence and probe various depths of our experience) are spiritual practices. A simple act of amazement, when we realise that we live in the universe of Light, it is a spiritual experience and a spiritual practice. Even more so is reaching out to the stars to unlock your creative potential. Creativity is an awesome spiritual power.

Inspired by the glow of the evolving Light, we can grasp and embrace the entire unity of life and the whole Universe. The right practice on any of the four levels, when guided by this luminous unity of Light, would make one partake subtly in other levels.

The exercises of level III focus on creativity. They contain and embrace all products of human cultures. Human cultures are a unique creation of the Universe. They form a special layer of the Cosmos — of incomparable richness and diversity. This layer could be called Logo-sphere, as it is the result of Logosynthesis. This Logo-sphere is huge. It contains endless creative exercises, practices, styles and modes. Our purpose is to find our path among this richness and vibrancy without being intimidated or lost.

Exercises of level IV focus on the development of spirituality. Spiritualities and religions form another special layer of the Cosmos, which is deep and immense. This layer could be called Theo-sphere, as it has been the result of Theosynthesis. It is important to see that level III and level IV are consequences of great syntheses of Light. By seeing them connected, we see the wonderful unity of human consciousness. It is also important to see these two respective spheres as different. In their historical articulation, they led to different human experiences. And consequently resulted in different exercises and yogas.

Levels I and II seemingly focus on the body (or to use the conventional term), on the biosphere. Yet, the exercises within

each preliminary level continually touch on levels III and IV for the simple reason that our creative and spiritual heritage is encoded on our genes, on our perception, on our conventional thinking. To awake to the beauty of the day or the glory of Light, is not a physical experience. The more attuned you are spiritually, the more significant will be your reactions to Light.

On the subtle level, your entire body is made of Light, that is to say human light. This underlying Light carries with itself the evolutionary memory of the species, including the memory of Logosynthesis and Theosynthesis. You do not have ordinary blood in your veins. You have the human blood. For this reason you can respond with compassion and love. The same holds for Light underlying the subtle architecture of your body.

You are not made of ordinary Light. You are made of human Light. For this reason, you can respond in a subtle, beautiful and spiritual way to the plethora of life around.

Exercises and yogas of Light awaken you to the magnificence of your being and invite you to continue on the awakened path of life. The greatest yoga of Light is your own life — when you are living it at your best.

ACTION FOLLOWS BEING

As you practice various yogas, you participate in various sensitivities. You express your being through them. As you begin to tread the foothills of enlightenment, you refine some delicate sensitivities, which have always been dormant in you: compassion, unconditional love, seeing beyond the ordinary, the sense of grace which brings enormous peace.

As your being becomes more subtle, your perspective becomes subtler and deeper, consequently your action becomes more meaningful. The quality of your action depends upon the quality of your being. New action, wiser action, stronger action

will follow from new being, wiser being, stronger being. The way to do is to be. To make your action excellent and superior you must become a superior being. This is the way of Taoism, especially as expressed in one of its epigrams: the sage does nothing, but nothing is left undone.

When your being becomes luminous, then all is well. And all actions are right. But your being must be attuned to the great Tao. Only then your action will always be right. And then, every so often, your inaction will amount to powerful action. Meditation is powerful action because it prepares the ground for all other action.

Remember: action follows being. When the order is reversed (when being follows action), all kinds of undesirable and disastrous things may happen. Actually in present Western society, we force human beings to follow action. Let us see what we mean by that. It could start as innocently as Henry Ford inventing the conveyor belt for the production of automobiles. The aftermath could be similar to what happened in this case where man then had to adjust to the rhythm and speed of the machine. As the century progressed, the machine accelerated its speed (in its various embodiments and forms) and we, humans, had to adjust and re-adjust.

Our lives had to be adjusted to the running of machines, until we became breathless, confused, exhausted, dispirited, alienated. This is not the right Tao. This is not the right life. This is not the right yoga. And all of this is the result of being following action. Remember: the sage does nothing, but nothing is left undone.

When being is right, all action is right, everything is right.

You may want to reflect on why the actions of human beings misfire so often, and sometimes lead to disastrous results. The answer is simple — because they are performed by those whose

being is not right, not coherent enough, not seeing enough, not deep enough. This is another example of the wrong order of things — of being following (the imperatives of) action.

In our times, yoga acquires a special significance as our existential and spiritual life has been shelved and has to be replenished. The teachers of yoga and mindful practitioners should be clearly aware that the social and technological forces, which promised us salvation, are now the main source of alienation, and of existential and spiritual plight. All kinds of actions are imposed on us, that are not congruent with our being.

We should also be aware how precarious our life is. Our yogas must spell out good strategies for life. Not only for our individual life, but also for our life as connected with life at large. For our individual lives are woven into the cycles of Nature. Yoga cannot be isolated from life and must be a part of it. Yoga means: work on yourself until you become a more radiant particle of Light. But it also means: work on yourself as a part of the larger pattern of life, to make life more sustainable, radiant and more benevolent to all.

We need to understand that there can be no inner peace until we have made peace with Nature. It is our responsibility to assist in making peace with Nature. We practice yoga in order to have a healthy and harmonious body. But we also practice yoga to attain peace of mind. If your mind is not at peace, then your yoga is not working well enough. If you truly care for your peace of mind and for the harmony within your body, you cannot escape the responsibility of healing the planet. Heal the earth/heal thyself are aspects of the same process. All personal considerations have larger social and political implications. A life style which adversely effects the health of the planet or the well-being of other humans is not the right yoga, not the right state of being.

Thus the yoga of creative life leads us to an understanding of the suffering of Mother Earth, and also of the understanding how the pain and damage of Mother Earth affects all living beings, including human beings; thus including your life. The new sensitivities inform us that we need not only to understand the theory of the plight of earth, but also act to heal earth and all Nature. For *the world is a sanctuary*. And we are responsible guardians taking custody of it. We are no longer unseeing egoists only using and abusing it. For if we were, this would not be the right state of being.

We need to emphasise that the yoga of creative life, in our times, signifies the recognition of the suffering of earth; also an understanding that we suffer because we have inflicted pain on Nature and other beings. This recognition implies and necessitates appropriate action, and appropriate yoga — to heal the planet and yourself; to cleanse the planet and yourself; to recognise furthermore that no inner peace is possible without making peace with Nature.

The yoga of creative life, above all, means that we live in joy and in hope. Joy and hope are aspects of each other. As the Upanishads say: 'From joy all beings have come, by joy they all live, and into joy they all return.' In our hectic, jittery and often violent world we may be asked: how is it possible?

Why joy? Why happiness in this Universe? Because such is its nature.

The yoga of creative life ultimately merges with the yoga of being, which includes all yogas and all life. Thus all yoga leads, first of all, to health of the body, then to the peace of mind, then to the joy of existence, and, finally, to the luminosity of the soul. Joy is a part of this luminosity. Luminosity is part of the cosmic Joy of which *Taittiriya Upanishad* speaks so eloquently and so movingly.

The way of the Universe is from energy to health to happiness to bliss. That is what the Cosmos is about.

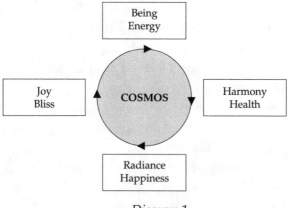

Diagram 1

PRECEPTS ON LIVING AND DYING

- To live in communion with Nature is an incomparable joy. To forget about this communion is to forget a part of ourselves.
- Nature is suffused with Light and spiritual energy. Forlorn is the one who is cut off from this energy, for this energy is nourishing us in every way.
- Nature observes balance. You cannot take out of it some of its elements without upsetting this balance. When the balance is upset, all kinds of disharmonies occur. Sooner or later, they do affect humans.
- The birds fly in joy, the grass waves in contentment, the trees sing when wind blows through them. All beings rejoice in natural conditions. Join the chorus and experience the joy of life alongside all other life.
- The joy of life should be your continuous companion. Do not lose it when you grow old. Joy is a vital ember in the fire of life.

- Being in the state of natural joy enables you to see radiance and beauty in ordinary things.
- The power to think is such a precious gift. To think independently is more precious still. Treasure this gift and use it well. It is a privilege to be a thinking human.
- The works done by physical labour perish so soon. Only the works of imagination, of mind, and of wisdom survive and endure — to inspire and delight.
- Aim high, for your aspirations are a part of your destiny. Without high aspirations you cannot self-realise yourself and you cannot reach the Divine.
- Unite with those who fight for truth, justice, dignity, and beauty.
- Working for the benefit of all, for the glory of the Universe is a source of a great joy. Do not listen to the prophets of selfishness. They are misguided and attempt to misguide you.
- You cannot always be optimistic. But you can try. Optimism and hope are great sustaining forces, much more important than reason and rationality.
- Never forget about limitless possibilities, which reside dormant within you waiting to be awakened and actualised.
- You are the master of your destiny. But in order to realise it, you need to work on yourself.
- Trouble and misfortune, sorrow and suffering are given to us as an obstacle course on our way to the spiritual enlightenment.
- When it is done with the right reason, work is joyous therapy.
- Great lives are simple lives. Cherish the purity and simplicity of your life. Live in dignified simplicity.
- Your humanity requires your dignity. Dignity requires self-confidence and self-respect. To be human you must have respect for yourself.

- The abundance of Light means the abundance of life, the abundance of joy, the abundance of creativity.
- Allow yourself to be embraced by Light. It is the best companion. It helps you to lead good life.
- Never underestimate the power and beauty of Light. May Light be with you.
- Light is equitable. It serves the saint and the sinner. But it must be handled carefully. Otherwise it can scorch and burn you.
- Light purifies and heals while nothing can pollute Light. In its most sublime manifestation, Light becomes divinity.
- Silent meditation is a passage to inner peace. And also a path to the spiritual enlightenment.
- A noble thought is a prayer. A noble life is a continuous prayer. Prayer is a journey of the soul to heaven — on the wings of the spiritual energy.
- The road to the Divine does not lead through rituals, but a spiritual ascent, which scales insurmountable peaks.
- The innocence of a child is delightful. But the purity of a saint is much more admirable.
- Why should you live well? Because it is a joy to do so. But also for a deeper reason: it is an imperative of the Cosmos that you self-realise yourself.
- When a human being is attuned to the highest, his countenance changes and his smile becomes divine. Cultivate this high attunement so that you become radiant.
- Offer your gratitude to life every day. For you never know which will be the last one. Live every day as if it were your last.
- Live each day fully and in glory. When the last day comes, try to meet it with a serene face and a smile on your lips.
- Imagine your most beautiful and most serene smile. Imagine that you are dying with this smile. This is dying well.

- Preparing to die well prepares us to live well. To envisage that you are dying well immediately quiets your soul.
- Death is usually viewed with apprehension and is dreaded. But death can be source of a gentle joy — when we consider it as a journey to an unknown land.
- Life and death are intimately connected. There is something sublime in contemplating death. By witnessing that we are living beautifully, we can die beautifully. By imagining that we die beautifully, we are preparing ourselves to do so.
- Philosophy is a training for death. But also for living well.
- Philosophy is this kind of meditation which enables you to live well and to die serenely.
- Great truths are simple. You are here for a while. Play your divine role well. Be close to gods. Be always in touch with the Light. Do not cling when the time comes. And smile as you go through life.

THE ECLIPSE OF MATRIARCHY AND ITS CONSEQUENCES

THE STORY OF TIAMAT AND MARDUK

The Arian people came from the North, wave after wave, from the fourth millennium BCE onwards. They brought with them the sky-gods. These gods finally coalesced to form what we now call organised religions.

This gave rise to a new religious era, in which transcendent spirituality began to prevail in contrast to the earlier matriarchal spirituality. It also marked the ascent of patriarchy, which became the dominant cultural, social and religious force, and it has ruled with great determination ever since.

On another plane, this ascent of patriarchy signified the withering of matriarchy, being systematically suppressed and eradicated by the patriarchal mind and its institutions.

With this suppression went the eradication of matriarchal spirituality which was immanent as it was rooted in the earth and celebrated every living form as sacred.

The transition from matriarchy to patriarchy was not a peaceful affair. We do not have historical records describing this transition. We possess, however, some mythological records as expressed in myths, which shed revealing light on this gruesome period.

One of these records is the story of two gods — Tiamat and Marduk, which is described in the Babylonian epic — composed and committed to tablets around 1750 BCE. The events leading to the epic probably happened a millennium or so before. The tablets on which the story was described were deciphered only in 1848.

In this story young Marduk, the God of wind and sun, is equipped with an invincible thunderbolt with which he is going to slay Tiamat, the primordial Mother Goddess. The first strange thing is that Tiamat is his mother. The second strange thing is the unusual way with which he annihilates her. This is how the battle is described in the tablet.

"The lord spread out his net to enfold her,
The Evil Wind, which followed behind, he let loose in
her face.
When Tiamat opened her mouth to consume him,
He drove in the Evil Wind that she close not her lips.
As the fierce winds charged her belly,
Her body was distended and her mouth was wide open.
He released the arrow, it tore her belly,
It cut through her insides, splitting the heart.
Having thus subdued her, he extinguished her life.
He cast down her carcass to stand upon it.

The lord trod on the legs of Tiamat,

With his unsparing mace he crushed her skull.

When the arteries of her blood he had severed,

The North Wind bore it to places undisclosed.

On seeing this, his fathers were joyful and jubilant,

They brought gifts of homage to him.

Then the lord paused to view her dead body,

That he might divide the monster and do artful works..."

When I first read this account, I was horrified. 'This is *not* how gods behave,' was my reaction. Some time later I returned to the account, and my conclusion was the same: 'This is *not* how gods behave.' Later still, as I was bothered with this whole account of the Sun God so heinously slaying his mother, I asked myself over and again: why?

This unusual cruel episode of gods fighting with each other, gives us a key (a cruel key indeed) of what happened some 4,500 years ago in the transition from matriarchy to patriarchy. The ferocity of Marduk may surprise those who think of gods as benign beings — bringers of Light and compassion. Yet, when we look at the whole story of religion, inspired and controlled by male god(s), the imprint of Marduk, with his invincible thunderbolt which subdues all, is too visible to consider Marduk a freak god of the cruel Babylonians.

Robert Graves, in his *Greek Myths*, describes Marduk as an upstart god, suggesting that he did not have any polish or refinement characteristic of mature gods. Yet these traits of Marduk, which we really abhor, may be the ones which came to define the whole patriarchal mentality for the last 4,000 years. For this mentality is cruel and controlling. And its imperatives seem to be coming from the thunderbolt gods.

The story of Tiamat and Marduk has had its consequences. We are awakening to their gravity, in Western culture, only recently, as we repeatedly ask ourselves: why have we seen so much violence in the world during the last 4,000 years, in spite of the ameliorating influence of organised religions. Of late, we are more and more often asking: has this violence per chance occurred 'because' of the influence of organised religions and their peculiar view of power and hierarchy?

The story of Tiamat and Marduk has its consequences but it also had its causes. After I read the story for the second time, I had an uneasy feeling that there was something grossly unnatural in the son slaying his mother, especially his goddess mother. There was some sense in me which told me that there must have been some deeper reasons. In the course of my thinking and reading, I have discovered that in more ancient times, when matriarchy flourished, the Sun God, who was also a lover of the ruling goddess mother earth, was often sacrificed for her; and sometimes in a gruesome manner. To be a man at that time was definitely to be inferior. And some men, out of envy and perhaps despair, castrated themselves, to be more like women.

That state of affairs had gone on for quite a while. It was the cult of ecstatic eroticism, the worship of fertility — not of immortality, which was to come later. The power of woman, of the goddess earth, was enormous, and at times abused. And not infrequently, at the expense of men. They did not like it. Most of the time, they sulked and felt inferior. But the time of reckoning was coming. We shall never know all the reasons which contributed to *the great reversal*. But the abuses of the goddess played a significant part in this reversal. When the time of explosion occurred, sometimes it manifested itself as the story of Tiamat and Marduk.

The ascent of monotheistic religions has been viewed as a superior development, truly a gift of God. The story is far more

interesting and far from benign. This story has been brought to us by new scholarship, mainly of the feminist persuasion, during the last twenty-five years. Its conclusions are so unpalatable to the established male mentality that we (by and large male minds) do not want to hear it, often responding by the proverbial shrug of shoulders, and by murmuring under our noses: it is merely a feminist exaggeration. But finally, hear we must, even if it is an exaggeration. To be an exaggerated story, there must be a story in the first place.

The story is relatively simple, although chilling in its consequences. Some 5,000 years ago tribes from the North, on their horses started to descend on the southern people. The people on these horses were believers in the Sun God. Earlier they overthrew the cult of Mother Earth in their midst. They came wave after wave for hundreds of years, actually for two millennia. They conquered by the sword. Often skillfully mingled with the local populations. They always brought with them new Sun-oriented gods. These new gods often merged with the existing ones. But somehow always had the upper hand. As the result, the whole landscape changed. Old goddesses were pushed aside, sometimes gently, often brutally. Old worshipping of the goddess was suppressed. The powers of the goddess were in due time considered evil, forbidden and persecuted. And here is the kernel of the story. Women, once at the pinnacle of power and creation, were not only marginalised and diminished, but also feared. And sometimes hated. Was it because of the old hang up in the male psyche recalling the superiority of female powers? Probably so. The pattern varied from people to people. But the end result has been nothing short of frightening.

Looking from a larger perspective, it seems as though God Marduk has been on the rampage over the last 4,000 years, slaying Tiamat over and again. It is sufficient to recall the institution of

the Inquisition, within the heart of the 'Christian' church. Some 7,000,000 human beings were exterminated over 400 years as heretics; about 6,000,000 were women, most of them accused of being witches. Was this whole spectacle Marduk slaying his mother again? We, the males of the dominant culture, do not want to think about it. And so often we excuse ourselves by saying that these were the mistakes of one institution. Whereas it was the vendetta against women, which has been going on for millennia. As painful as it is, we need to be aware of it in order to be able to amend our ways.

What we are discussing is the peculiar stigma of patriarchal institutions, including institutional religions of the last 3,000 years. We are discussing enormous crimes committed against women, against Nature and other defenseless creatures, who have been overpowered by thunder gods; and by us — the people who have served them.

We are reflecting on a peculiar imbalance in favour of the aggressive, mental and manipulative; and at the expense of the caring, loving, giving and nourishing. We are contemplating establishing a new balance, harmony and justice for all the people. And that also means men who have been wronged by the straitjacket they created for the world and themselves. We cannot be happy, balanced and self-realised, if we are not whole. We cannot be whole if we deny the qualities of the heart. A new balance must be established. A fundamental rectification of past religious beliefs must take place. Thus, we are talking about the renewal of religion at the source.

Going to the source means understanding what has happened to organised religions since the advent of patriarchy. Yet in a deeper sense, it means going to the source of all sources, which is Light. Only through understanding the nature, meaning and evolution of Light (in the entire Cosmos) can we appreciate

the beauty of the teaching of Arian gods; and then, later, the fall from grace of the very same gods as they attempted to monopolise Light to their advantage.

The meaning of Big Light informs us about the nature of the filters through which organised religions arranged and interpreted Light. They also inform us how Light has become the most important commodity — jealously guarded by priests and religious institutions which wanted to keep the monopoly over it.

Furthermore, a true understanding of Big Light also helps us to understand what is to be done to recover Light, to recover our spirituality and divinity. We cannot simply return to old dogmas or dust off our favourite myths. We are in the process of removing the scales from our eyes, or *removing the filters* that distort the meaning of our life and the sense of the entire Cosmos.

The theologian Thomas Berry postulates that we must re-invent the human on the species level in order to overcome the present moral and spiritual plight. I don't think we need to go that far. But we need to recover Big Light and establish harmonious and mutually beneficial relationship with it — so that we recover our spirituality and divinity and unfold further as spiritual beings. Perhaps this kind of recovery is tantamount to re-inventing ourselves on the species level. If so, then be it.

It is quite clear that in the process, we need to free our transcendent mind from the cage of the grasping mentality of the God Marduk and his followers. If we do so, then the earth can become fair and the old dream of harmony among people can become a reality.

JESUS CHRIST — A FEMALE GOD IN THE MALE FORM

The Christians duly emphasise that their religion is based on love. As such, in principle, it is against the abuse of one person by another.

In fact, the great paradigm of love is a wonderful foundation for creating a just and harmonious world. This is something to be proud of, the Christians say. However, the preaching of love is one thing and the actual practice of Christians is quite another.

After 1,700 years of continuous existence of Christianity, we need to ask: what has gone wrong? Why is the great religion of love limping? Yet before we attempt to answer these two questions, it is important to ask and answer another question: what has gone right?

Christianity had emerged. A new prophet of Light through love appeared. These were great salutary events. Some have suggested that the decadence of Rome created — as its opposite — a religion of love and caring. We need to look at a larger scene. Already, by the time of the disintegration of Rome, patriarchal culture in various parts of the world was running amok, creating a great deal of cruelty, injustice and destruction.

The benign Light of the fifth dimension needed to try another experiment in order to mitigate the harshness of sky-gods who somehow forgot that they meant to bring more Light and deeper Light — and not conquests and intimidation. Thus, Light brought about new prophets, who were still preaching transcendent spirituality, but suffused this spirituality with love and compassion. One such prophet was the Buddha. Another such prophet was Jesus.

The phenomenon of Jesus Christ is something extraordinary, given the constraints of his culture and his religion; and given the fact that he was born at the time when patriarchal mentality was riding high; and still subduing whatever rudiments of the culture of the goddess and of the matriarchal cosmology was in existence.

Jesus' teaching was a revolution. In the harsh patriarchal world, in which the principles of an eye for an eye and a tooth for

a tooth prevailed, in which vengeance, conquest, and submission were the ruling values — to announce the idea of 'Turn the other cheek' was a revolution. This revolution has been recognised and hailed for good reason. It signified a profound turning point. Instead of insisting on the gruesome eye for an eye, we have the courage and wisdom to say: "I forgive your wrong doings, even if you strike me again." That much has been understood in the standard Western interpretations of Jesus' moral revelation.

What has not been fully understood, if at all, is the fact that this revolution was touching much deeper chords and layers — beyond the confines of traditional morality. It has not been understood at any depth that Jesus was bringing back the quality of the goddess, the eternal Mother, which is always forgiving, always healing, always acting through the heart and never concerned with abstract principles of male morality, based on reason alone. For the Mother (the eternal goddess) the greatest justice is the blossoming of life. It is through the quality of the heart that this justice is understood. The logic of the heart, or the morality of the heart, is not readily understood by the male mind; and even by those who praise Jesus for having brought the quality of the heart into Christian religion — for so often these proclamations are conceived and expressed through the categories of the mind alone.

I mentioned that there was a deeper aspect of Jesus' revolution in addition to what is commonly acknowledged. It is this. Christ was a female god born in a male form. He attempts to bring back the qualities of the goddess into the world which had become quite harsh. It may be thus said that Jesus is a female God. While Christians were still persecuted in Rome, the Romans thought of Christianity as a lowly religion fit for women and slaves. They were so right, and so wrong. Wrong because they themselves were the slaves of the male mentality inspired by God Marduk. So right

because Christianity was not only for women but was embodying the essential characteristics of the great Mother Goddess.

For this reason Jesus is so different, and so peculiar — one might even say refreshing — against the prophets of the Old Testament. Instead of gloom and doom, He brings love and affirmation and forgiveness. He says: "I bring you life abundant." This is quite in contrast to the wrathful and revengeful God of the Old Testament.

Moreover, in his parable, "Turn the other cheek," Jesus says to Marduk: "You better stop slaying your mother. Enough of this has gone on." Jesus is saying to us — people of the ecological age — "You better stop slaying your Mother Earth. Enough of this has gone on."

This is the true revolution of Christ's teaching. This is good gospel. This is what has gone right. We all know it — in our bones and subconscious — that the message of love is right. Jesus' message was a great articulation of our being through which we can shine. Now since love is so enduring, so magnetic and attractive, why has it not prevailed? We are back to our first question: what has gone wrong? And back to the next question: why is the great religion of love limping?

The answers are not far to seek. Because the brute forces of patriarchal mentality have struck back and suppressed and intimidated the forces of love. The forces of love have not been entirely extinguished. Yet what has been most glorious and radiant in Christianity has been suppressed and intimidated.

The forces of conquest have been just too strong. For this reason, we have witnessed a real tragedy in the unfolding history of Christianity as Christ's teachings have been sadly suppressed and perverted. Thus Jesus' revolution was one that was not. The best we can say is that this revolution is still smoldering, though suppressed.

Undoubtedly, the forces of male mentality subverted the gentle teachings of Jesus. Instead of bringing back the quality of the goddess, we have witnessed, during the height of the medieval Inquisition, the burning of witches by the millions. In the last millennium we witnessed, in the Christian world, the religious wars, first against Islam; then among Christians themselves in the seventeenth century. We witnessed the colonial wars of conquest of other people. In the name of civilising barbarians, we were slaughtering people at a frightening scale on various continents.

We remember the teaching of Jesus: "It is easier for a camel to pass through the eye of a needle than for a rich man to enter the Kingdom of God." Somehow this teaching has been altered by Calvinism and Protestantism; and then by the ideology of capitalism to such a degree that the poor are now seen as responsible for their own plight, while triumphant capitalists thrive on greed, exploitation, ruthlessness and utter social irresponsibility.

The churches have not protested against this perversion of Christ's teaching; at least not sufficiently. Is it because the institution of the church has been infiltrated by the dominant patriarchal mentality?

The Christian churches are weak at present. They will not strengthen themselves — and they will not strengthen the people whom they are supposed to serve — if they continue to ally themselves with the dominant forces of the status quo, which actually is un-Christian and worshipping Mammon, which is worshipping money. The Christian churches must realise what a wonderfully balanced Lord Jesus was. By recognising this balance, by recognising the female qualities in Jesus, which are the fountains of love, the churches may renew themselves. But not earlier.

When we look at the present pride of the West, the so-called process of globalisation, we see the old story of conquest and

expansion going on; this time via electronic means and Western economic models of exploitation. Whoever has the eyes to see, realises that the whole raison d'être of globalisation is robbery. The elite, already disgustingly rich, are manipulating the rest of the world to their financial advantage. This is a profoundly anti-Christian spectacle. And the churches are mute (again) — while the high riders of Wall Street and other financial centres are wreaking havoc to economies of entire continents and to the ecology of the whole planet. Are these financial wizards, perchance, not the emissaries of God Marduk? If not, whose emissaries are they? Here, in these two questions, there is an answer to what has gone wrong. We have enshrined God Marduk at the expense of Lord Jesus.

THE UNFINISHED REVOLUTION

Christ's teaching was a revolution, which was suppressed and unfinished. Yet its remaining, smouldering fragments are still waiting to be re-ignited and transformed into a blazing flame. Humanity will not rot in meaninglessness and stupor for ever. We are not descendents of Marduk but of Light and of Jesus Christ.

Jesus' gospel of love was one of the most radiant phenomenon that the Cosmos has created. Yet even with its beauty and radiance it did not prevail. Jesus had to be crucified because he was too upsetting to the existing order of conquest and control. Jesus had to be crucified during the endless burning of so-called witches — for he was too kind to the persecuted and too loving to the down trodden. As one woman has said it: "The truth is that Christ's crucifixion is one event in the long and perpetual crucifixion of the Woman."

Although we are discussing Christianity, and specifically focusing on the phenomenon of the prophet Jesus, our concern is with religion at large. All major religions are patriarchal.

Their main imperatives have been embedded in our culture, especially Western culture; or to say it more precisely — in Western post-Greek culture. With the ancient Greeks, particularly of the archaic period, the story is different, the suppression of the goddess not so ruthless. Admittedly the goddess is dethroned. For instance, the Goddess Sibyl is expelled from Delphi and her serpent slain — as Apollo took the rule over Delphi. Nevertheless, the priestesses remained in the temple and continued to be the most important oracle for all the Hellas. Zeus did become the chief god. Yet Athena was elevated to the rank of the Goddess of Wisdom. Greek male philosophers laid the foundations of wisdom and thinking. However, it is from the woman Deotyma that Socrates learns the deepest wisdom.

We mentioned earlier that Light created new kinds of prophets in order to ameliorate the excesses of ruthless sky-gods, such as Marduk. One of these prophets was Jesus. Another was the Buddha. The Buddha was another female god in the male form. And the qualities of giving, of gentleness, and of tenderness are abundant in him. Compassion was the Buddha's path, compassion as a path of justice and of overcoming the rigid cast system of Brahmanical India.

The Buddha's quest was not unlike Jesus' quest: the return to simplicity and to justice under the guidance of compassion. Compassion and love are twin sisters. The Buddha practiced what he preached, as he lived in simplicity and austerity. Even in his seventies, he was the first among his monks to go early in the morning, with his begging bowl, to ask for alms from the village people.

At first the spread of Buddhism was slow. Then King Ashoka united India in the third century BCE. He became an ardent Buddhist, without donning the robe. He spread the teaching of the Buddha to all 84,000 villages in his huge country, stretching from

what is now Burma to what is now Afghanistan. For a number of centuries India was the land of the Buddha.

Then in the ninth century AD, a reversal occurred. The Brahmins came back with a great gusto, led by a very young but brilliant Hindu saint, Adi Shankara. Thus, after a millennium of good Dharma, which preached equality, justice, non-violence and compassion, the divisive caste system was re-introduced.

Patriarchal mentality took over again — with its customary hierarchy, suppression and injustice. Were the religions of love and of compassion not strong enough to prevail in the long run? Or was the patriarchal mentality too strong, and devious enough to wait for centuries until it finally prevailed? Both questions are right and both are missing the point.

This whole period of the last 5,000 years has been a part of a great psychic and spiritual evolution. It was not merely a fight of good and evil — of the prophets of Light (the Buddha and Jesus) vs the prophets of darkness (Marduk and present peddlers of globalism). There are ups and downs in the odyssey of Light; as they are in human evolution, and in the vicissitudes of individual lives.

One of the most agonising problems in our times has been philosophical. We do not understand. We do not understand the changes in our psyche and in our spirituality. Because of that, we do not understand many of the negative consequences, which the epochal transition to patriarchy has brought about. We do not understand why we do not understand. In frustration and anger, we lash out in various directions, often in violence. This only increases our plight and our degradation. The civilisation of masters is descending into a whining crowd of half idiots and sulking children. Existing civilisation, existing culture, existing forms of knowledge have clearly exhausted themselves. We simply cannot use existing tools and forms of knowledge to

repair our chronic cracks. For these very tools and very forms of knowledge brought about our cracks and our present crises.

We need to evolve a new social project and a new human project. Each should be a project of a fundamental renewal, thus a renewal of spirituality, of human imagination, of human knowledge, of human solidarity and justice; and all of this by reconnecting with Big Light in a significant way. The philosophy of the bottom line has failed us dismally. For how long can we believe in a fiction, which is so destructive?

The prophet Jesus seems to have lost against the merchants whom he wanted to remove from the temple. But love has not lost its power and its enduring qualities. Nobody dares to challenge it as a universal force of the greatest importance. If some challenge it, they do so only obliquely, deviously, surreptitiously, indirectly; and sometimes through gambits of hypocrisy — by bemoaning that love is a beautiful thing but impossible to practice in our present world. We shall recall what La Rouchefoucauld has said: "Hypocrisy is a tribute that vice pays to virtue."

Thus love is holding. Only institutions, which appropriated the teachings of Jesus, are not holding. Simply because there is no love in them, and there is no spiritual energy. The gospel of love is a living flame. When the bearers of the torch of love wither within, when their hearts become dry and loveless, they cannot give love and inspiration. They only pretend. What is left are only gestures and rituals, not a living flame. Yes, Buddhism was squeezed out of India. But not entirely so. On the surface the Brahmins won. But not completely. They won at the price of absorbing so many of the teachings of the Buddha that Hinduism has become a well integrated composite of old Brahmanism and of Buddhism.

Surprisingly, Buddhism is taking root in the West, which just shows that the West is not adverse to religious sentiments. But it needs new forms of spiritual nourishment. Why is Buddhism

welcome in the West? Firstly, because it is so undogmatic. It lays out certain deeper views on the nature of the human, and leaves you alone. There is not torturous theology in it.

Secondly, practitioners and masters of Buddhism are exemplars of living spiritual energy. They do not talk about spirituality. They themselves are beacons of it. They show how a spiritually attuned life helps the individual to live well and how it helps in social interactions — by bringing peace, *ahimsa*, and compassion to all beings. Buddhism is still a religion of Light, which demonstrates that Light is not spurious to life but essential to it — both in ordinary life and especially in the spiritually well-attuned life.

The strength of Light, as expressed by love and compassion is enormous. It can be eclipsed from time to time for a while. But it will return to flourish. The revolution started by the Buddha and Jesus is going on. Light has nowhere to go but to bear more Light, deeper Light, more transcendent and divine Light. As this Light grows in us, a revolution in understanding is happening and deepening. So often our moral and spiritual lapses are the result of the lack of understanding, of insufficient understanding.

Revolution of Light cannot be extinguished. We are in the midst of the unfinished revolution of Light, of spirituality, of love, of compassion. We are at the threshold of a new evolutionary departure, at the threshold of the Era of Light, which wants to bring to life a new level of understanding and radiance. We have a powerful legacy to continue, the legacy of love of Jesus, the legacy of compassion and non-violence of the Buddha, the legacy of simplicity and unfathomable depth of Lao Tze. We have to repossess the world. Our engagement with mystery and divinity has not ended. It is entering a new stage.

After 5,000 years of experiments with patriarchy; and after 400 years of experiments with science and technology, we are

back to the drawing board: which way to turn to assure ourselves of the existence, which is truly human?

Religions are our own creation. They mean to be vehicles on the road of self-perfection. Religions are only as good as they help us to make ourselves good, noble, happy, fulfilled, radiant and generous; but also altruistic and profound in our understanding.

FROM INFORMATION TO WISDOM TO IMMORTALITY

THE CHEQUERED LEGACY OF KNOWLEDGE

At the beginning was a void. Out of the void emerged Light. Out of Light emerged all forms of life. Out of the human forms of life, spirituality emerged.

The spiritual journey is an amazing effort to organise Light in lucid patterns, which finally becomes steps to God; or to divinity; or to Big Light; or to Spiritual Bliss. These are different names for the same radiant phenomenon. This phenomenon signifies a life of search of those who are called; and who are capable of responding to their inner calling.

Many are unable to respond; or their calling is too weak in them; or they are simply too confused. They stay in the shadows all their lives. And sometimes are happy or at least satisfied with

their condition. They cannot be blamed. But they cannot be envied either for remaining in semi-darkness.

The 'path of light' is always arduous and after trying a little, many give up saying they are happy where they are. Maybe they are. Maybe they are not. We need to remember what the philosopher John Stuart Mill once said: "What is better — to be an unhappy Socrates or a happy cabbage?" Before we reach the path of spiritual becoming, there is the stage of diffused light, perhaps the stage of a happy cabbage. In this stage, not much happens, spiritually speaking, for there is not enough awakening. This is the stage of ignorance in which one does not know that one is supposed to learn and unfold.

Then there is the next stage where one has learnt enough of what he is supposed to learn. This predisposition that one "is supposed to learn" is a strange one. Given any stage of one's knowledge, it does not intrinsically or logically follow that one is supposed to learn more. But the learning organism knows. It is one of the predispositions of intelligence that it wants to enlarge itself.

The stage of awareness in which we know that we are 'suppose' to learn more and more, on deeper and deeper levels, represents a higher stage of our being — in contrast to the one in which we simply know that we 'should' learn.

Then after many stages, while following the odyssey of spiritual becoming, we arrive at the stage where we know that we are no longer supposed to learn. Paradoxical, isn't it? We are only supposed to radiate. We shall explore the beauty and subtlety of spiritual ascent in this chapter. Before we embark on our journey, we shall take a quick look at how we handle knowledge.

Conforming to the empiricist materialist paradigm, we are feeding on information to gather knowledge with which we do not know what to do, except for applying it as a utility tool

for survival. This knowledge does trifle little to nourish the spiritual being within all of us.

Ours has been often called the age of information and sometimes the age of information explosion. Alternatively, it has been called the age of knowledge or the age of knowledge explosion. How very strange, therefore, that in this age of knowledge we are so confused. We are also confused in understanding the meanings of 'the age of knowledge' and 'the age of information'? Chunks of knowledge are thrown at us. Streams of information are showered over us. We should be in the ecstasy of knowing, or perhaps even in the bliss of enlightenment. Why are we not? Why are we staggering under the burden of knowledge?

The reason is that we simply do not know. We only pretend that we do and are repetitive with our slogans, "Our knowledge triples over every ten years, isn't it incredible how great we are!" We do not wish to rub salt into the wound and say that not only are we confused but that ours is the age of great confusion. Socrates maintained that, "Unexamined life is not worth living." We wish to add that unexamined knowledge is not worth having.

KNOWLEDGE AS A FILTER

We shall therefore try to follow an alternative route and suggest that the entire path of knowledge is a path of magic. Or to use our own language, we shall say that the entire path of knowledge is a path of Light. And this path is so extraordinary that it is almost magical; magical in the sense that it cannot be explained through accepted rational strategies and constructs. Of this Albert Einstein was clearly aware when he wrote:

"The most beautiful thing we can experience is the mysterious. It is the source of all true art and science. He to whom this emotion is a stranger, who can no longer pause to wonder

and stand wrapped in awe, is as good as dead: his eyes are closed."

Einstein was not a fool. And those who claim that science has lost its way are not fools either. Knowledge is a very noble quest of humans to understand and to make something of their own life through this understanding. We are entirely right in demanding knowledge, which brings wisdom and enlightenment. For this we need to go beyond the horizons of science which, with all its theories and equations, can help us only a little. The rationality of science is so limited and crippling. By applying this so-called rationality of science, we have created the world of confusion, chaos and violence.

An alternative path to knowledge — as leading to wisdom, enlightenment and a good life — is not only justified, but necessary. We shall demonstrate this by examining *knowledge as filters* and show that the present inadequate knowledge is a set of defective filters, through which we filter all reality.

We cannot receive reality directly. But only through filters, either of knowledge, or of religion, or of ethics. These filters are actually filters through which the light of understanding reaches our mind and our entire being and makes us see, comprehend, act intelligently. Knowledge filters are different from religious filters. Religious filters process the highest Light of divinity, in the Universe and in us. Knowledge filters process the Light of understanding. Ultimately they merge into each other as there is no reception of the Divine Light without some kind of Light of understanding. But often time, there is the Light of understanding, hence of knowledge, without the Divine Light at the end of the process. In brief, there is a difference, which needs to be handled very carefully. For the light of understanding has an aura of divinity at its edges.

Since knowledge — every form of knowledge — is a set of filters, through which we filter and process the inputs of the outside world, it immediately follows that there is no knowledge, which can be established once and for all. There is no absolute knowledge, certain and indubitable knowledge.

There was a period of Western history when we thought that we possessed such knowledge — as couched by Newton's mechanistic paradigm. Now we know that it was one of the transition stages. Newtonian filters have been eclipsed by other filters. But these new filters, whether of quantum physics or of the new physics are only filters — not ultimate knowledge.

Karl Popper formulated the first approximation of the idea here proposed, as he claimed that all knowledge is tentative and none is absolute. The filters do not represent subjective predilections. They represent the collective vision of a culture. In this sense filters are inter-subjective, but not objective.

The distinction is subtle but vital. Objectivity implies something that exists out there, independently of us. Inter-subjectivity implies that the forms of knowledge, and thus filters of knowledge emerge out of the process in which many minds participate, and the forms are accepted by the community and made obligatory through the invisible cognitive contract. But in no sense are these filters and these forms of knowledge objective. Thus the filters of so-called scientific knowledge are far from being objective and rational. They contain ethical imperatives as well as social agendas and visions. These filters, in fact, have become powerful myths of Western culture.

Let us see some of these hidden imperatives built into the filters of our present knowledge. One of the outstanding architects of the scientific world view was Francis Bacon. His conception of *scientia est potentia* proved to be very powerful and influential and was built into our present filters. He claimed that the ancient

people were wise but, "Their knowledge was but a boyhood of knowledge. It could speak but it could not generate. It was full of words but barren of works." Specifically Bacon proposed that we create knowledge, which can generate and transform to our advantage. Following his recommendation, we have created knowledge which possesses terrifying power and which is beyond our capacity to control.

I also mentioned that there are social and ethical imperatives built into the filters of scientific knowledge. Indeed it is so. In addition to Bacon's conception *scientia est potentia*, built into pragmatic paradigm of knowledge, are renaissance and post- renaissance utopias, such as Thomas Moore's *Utopia*, Tomasso Campanella's *The City of the Sun*, Bacon's *The New Atlantis*, which postulate that man can save himself through his own means and create an utopia on earth. This overall vision has been built into the pragmatic filters of scientific knowledge.

Filters of knowledge act in their subtle way on the individual level, that is to say within the structure of a particular human consciousness. These filters are an expression of particular human consciousness. This can be most eloquently seen in great poets and prophets. Their words seem to be pouring out of another depth and of another space to astonish and delight us. William Blake, the poet wrote:

"To see The World in a Grain of Sand
And a Heaven in a Wild Flower
Hold Infinity in the palm of your hand
And Eternity in an Hour."

This is exemplary of how knowledge at times so easily merges with Light. It is through the change of consciousness that the world can be changed. It is through the change of consciousness that new filters can be constructed to render to us a new picture

of reality. We are in the midst of a gigantic struggle, whereby the old mechanistic consciousness is trying to hold to the old, while the new spiritually inclined consciousness is attempting to create a new dawn, based on a new holism and a new understanding of Light.

STRIVING FOR WISDOM

The filters of present knowledge do not have much use of wisdom. Scientific knowledge is lost in front of wisdom. It does not know what to do with it and even how to 'look at it'. The phenomenon of wisdom is a paradox in our times. We have specialists who should answer all our questions. Yet, the more we specialise, the less tentative our understanding becomes. Although specialisation was supposed to replace all traditional knowledge, including 'so-called wisdom', just because of excessive specialisation, we crave wisdom more than ever before.

Wisdom is the search for the awareness that integrates, builds knowledge into enlightenment, makes trivial existence dignified and gracious. Wisdom is the possession of the *right knowledge*. But wisdom is also the right state of being.

Wisdom is a balance of our own being vis-à-vis other human beings and vis-à-vis the entire Cosmos. We need not avoid such terms as 'Cosmos' for we are creatures of the Cosmos, and until and unless we find our place in it, it is unlikely that we shall find the peace within and that kind of balance, which we call wisdom.

Wisdom is the possession of the right knowledge for the given state of the world, conditions of society, human condition. The state of the world changes. The conditions of society change. The articulation of knowledge goes on. The articulation of the human being continues. The human mind and human sensitivities become increasingly refined. For all these reasons, we cannot embrace one structure of wisdom for all times, we must seek a

different structure, a different form of balance for each epoch. Wisdom is not a set of permanent forms but a set of dynamic structures: always to be re-built, re-structured, re-adjusted, re-articulated. Evolutionary wisdom is the understanding of how the human condition changes through centuries, millennia and eons of time. Only such a conception of wisdom can aid the race in its evolutionary journey.

Living wisdom is evolutionary wisdom. As we evolve, the conditions of the world and of our being evolve and change. And so this knowledge, which we call the living flame of wisdom, also changes. It is indeed wise to recognise the nature of evolutionary wisdom. It is indeed wise not to cling to old antiquated principles but to cultivate the living flame of which we are a part. Past spiritual traditions, of nearly all religions, have so often insisted that the wisdom they offer is absolute, while it is only temporary. For all wisdom is historical and evolving, including the so-called religious wisdom.

The process of the acquisition of wisdom takes time. For it is a process of sculpting the inner person. You cannot be a student of wisdom and acquire wisdom. Acquiring wisdom is like sculpting the inner man. Sculpting in marble is difficult enough. But sculpting the human soul is far more difficult. For the substance we handle is so delicate, fragile and elusive. It refuses to be forced in any prefabricated moulds. Yet it needs to acquire distinctive shapes.

Wisdom is a form of Light, a form of seeing. Only when we take this larger view, we can liberate ourselves from the pragmatic 'boxes of knowledge'. Filters of any given form of knowledge may encourage the acquisition of wisdom or may inhibit it. If filters of a given knowledge block the recognition of wisdom or obscure it, then human beings are in trouble: it is difficult for them to become wise.

We strive for wisdom in order to arrive at a deeper life. Ordinary knowledge focuses on so-called good life, which means materially satisfactory life. The focus of wisdom is different. While saying that we strive for a deeper life, we are not renouncing a good life. We are only emphasising that we are aiming at a better life. For deeper life is a better life.

THE LADDER OF ENLIGHTENMENT

Wisdom offers itself as stepping stones to enlightenment and divinity. Wisdom represents a ladder to heaven. When we submerge ourselves deep enough in the folds of wisdom, we touch the ineffable, we merge with the ineffable. Wisdom is Divine because it helps us to understand divinity, and is itself a vehicle of the Divine.

Wisdom signifies coherence, holding onto the centre, discernment and judgement. Wisdom simply signifies holism, a holistic vision of the world and of all that there is. Let us notice that discernment and judgement are only possible if there is the centre, which informs us how to judge; and what are the reasons for discernment.

Furthermore, the centre that holds is the invisible axis, which coordinates all. It is around this invisible axis that things are woven and by which they are assigned their place and their significance. When we speak of holism, we invariably imply a meaningful whole, made of parts, which are coalescing together. What makes them coalesce then together is the centre that holds them together. When the centre is gone, coherence is gone.

Searching for a holistic perspective is not a pipe dream but a necessary foundation for sane and coherent living. By bringing into the compass of wisdom its various components: discernment, judgement, coherence and the centre that holds, we articulate a life worth living.

A holistic perspective is nothing short of philosophy. Before you accept and fully develop one, you have to be fastidious, discriminating, and wise. Yes, there is a dilemma here. To arrive at wisdom you have to possess a right holistic perspective. To build a right holism, you have to be wise.

We should be aware of two dangers. One is to accept too rashly a half-baked, superficial and shallow holism, which is not deep enough to enable you to transcend wisdom, as you reach for enlightenment and even sanctity.

The second danger is of a different kind. Beware of religions as forms of holism, and especially of the fundamentalist variety. They offer you ready solutions for everything, but ultimately make you a prisoner of narrow dogmatic schemes. You wither in the shadows of the dogmas. Your freedom may be taken away from you. You do not grow spiritually.

There is a certain asymmetry between wisdom and knowledge, as there is between knowledge and information. Through the elements of information alone or more precisely — by dwelling in the universe of information and using its basic units — you cannot understand the nature of knowledge. Correspondingly, through the net of concepts of knowledge you cannot understand the nature of wisdom. But through wisdom you can understand both knowledge and information. Therefore, let us witness a certain asymmetry: from a higher level you can understand the lower level, but not conversely.

And this is so with higher levels of human development, which are beyond wisdom, such as self-realisation, enlightenment, sanctity and finally divinity — if we dare to go that high. Each new level of our ascent is a high step, which leads to a new plateau. Before we climb it, we cannot see what is on the higher level; and who are we going to be on this higher level. When we reach it, we see perfectly well what is happening on lower levels and why we could not see before. The diagram illustrates the situation well.

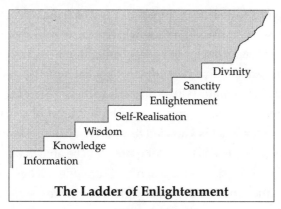

The Ladder of Enlightenment

Diagram 2

The higher we are on this spiritual ladder the freer we are from the constraining power of filters, both of knowledge and of religion. With the ascent to the stage of wisdom, we free ourselves considerably from the shackles and filters of knowledge. We use knowledge — artfully and beautifully, but are not manipulated by it. On the contrary, we see through it — to embrace wider horizons.

On the level of sanctity, and even more so of divinity (where mystics and saints reside in their most sublime states), we are completely beyond filters, merging directly with the Big Light. Our horizons are infinite. And we are infinite. We touch immortality.

THE PROCESS OF SELF-REALISATION

Beyond wisdom is self-realisation. 'Self-realisation' is a beautiful word. But the process of self-realisation cannot be limited to words. Self-realisation itself is a unique existential process, which enables one — through a peculiar 'process of melting' — to reach the inner god. Living in the light of inner god signifies reaching spiritual enlightenment. This form of enlightenment is different from the French Enlightenment of the eighteenth century. Self-enlightenment is based on wisdom, and it touches sanctity.

Striving to reach the inner god is a spiritual process; it is the process of transcending knowledge for the sake of wisdom, transcending wisdom for the sake of enlightenment, transcending enlightenment for the sake of sanctity. Each of these stages of self-realisation manifests itself through a different state of existence and of understanding. Only from a higher level of wisdom can we truly know what is knowledge and what is important in it for wise living. One needs to be enlightened to be able to understand the enlightened state of existence. From the higher peaks of self-realisation, like from peaks of mountains, we see clearly why we had to travel through valleys and hills, to reach the peaks.

Sages, saints, and philosophers alike have attempted to capture the idea of self-realisation in words. But the task has proven elusive. Although we can say many useful things about self-realisation, there is no agreed definition of what it is. This is partly because it is one of the ultimate states of human existence. Such states do not easily lend themselves to verbal explanations; just as the idea of sainthood cannot be easily explained. The two ideas are related. A self-realised person is on the verge of sainthood. And saints are undoubtedly self-realised persons.

Without trying to define the meaning of self-realisation, we shall notice that self-realisation has different levels. Thus the question what is self-realisation can be considered on at least three levels:

- On the level of the species
- On the level of a given culture or spiritual tradition
- On the level of the individual

Concerning the first point, human self-realisation is delineated by what is attainable by the human species. What is beyond the human species is outside the scope of self-realisation. Spiritual attainments are the highest attainments of the human species. For this reason to fulfill your human destiny, you must

strive for the highest spiritual reaches. Self-realisation is therefore related to this particular realm of human existence where your spiritual essence resides. To be realised entails two conditions, firstly, to possess the spiritual potential within yourself, and secondly, to carry it to fruition. Beings which do not have our kind of spiritual potential, cannot be self-realised in our sense.

In so far as we know, our form of spirituality does not exist among animals. In the absence of any knowledge as to what forms of spirituality the bees or the bears could possess, it is indeed hard to talk meaningfully about self-realisation among animals; let alone among trees or rocks. We have enough difficulties to understand self-realisation among humans. So, for the time being it is more prudent to reserve the term 'self-realisation' for humans and leave other species out of our consideration.

We now come to the second point, self-realisation on the cultural level. The pursuit of self-realisation always happens within a culture or a given spiritual tradition. The goal is the same or similar — the liberation of the human, lasting peace and harmony, coming close to the Divine. Yet within the various traditions, the process of self-realisation is differently perceived. And that should not surprise or upset us. This is simply because different cultures use different filters for processing reality and for reaching the Divine. There are many different paths around the Mountain of Enlightenment, leading to its peaks. These paths have various names. Here are some of them:

- Grace (Christian culture)
- *Sartori* (Zen Buddhism)
- *Samadhi* (Hinduism)
- *Bodhisattva* (Mahayana Buddhism)

These paths may appear different. Yet, the intent is the same. It is the liberation of the human from the shackles, opening our hearts to the beat of the cosmic rhythm; opening our eyes to the

Light immeasurable; and also to the peace within. The names of the paths leading up the Mountain of Enlightenment are described differently. But it is essentially the same journey.

We now come to the third point, self-realisation on the level of the individual. It is true that we realise ourselves within the possibilities of our species, and that we usually follow a specific path outlined by a culture or a given spiritual or religious tradition. Yet, ultimately the path of self-realisation is uniquely and inexorably your own. People who have been on the path in the past can help. But nobody can achieve self-realisation for you.

Ultimately, it does not matter which path you take, or whether you combine various paths — as long as you ascent towards greater Light and bring out the inner god to flourish. The Mountain of Enlightenment is welcoming, generous and tolerant. Yet it is a difficult journey. It may be treacherous, particularly, if you are not equipped properly, and especially if you do not embark upon the journey with due reverence and the spirit of humility and selflessness. There are many traps and delusions awaiting the spiritual seeker if he does not begin his journey with prudence, dedication and determination.

Although we are intuitively clear what the ultimate stage of self-realisation is, there may be different limits to self-realisation among different human beings. This is not the recognition of relativism, but the recognition of the uniqueness of each human individual. Once we have climbed to a very high altitude on the slope of the Mountain, we may find that each of us has a separate peak of our destiny. Together they form one magnificent Mountain of Enlightenment. Some are prepared to call it God.

These peaks (let us not confuse them with lowly hills!) may be different, yet, we clearly and instantly recognise those who are on the higher reaches of self-realisation. Hence the universal

recognition of the Great Lights such as the Buddha, Jesus Christ, Zarathustra. They are the great beacons showing us the ultimate reaches.

There should be no competition among spiritual seekers concerning who is most enlightened. The enlightened ones, only bow to each other. Let me illustrate my point with a story. At the beginning of the twentieth century, there were two great actresses in the world, Sarah Bernhardt and Helena Modrzejewska. One day they met in Paris. Afterwards, one curious person asked with a great deal of zeal: "What did you talk about?" She heard the answer: "We didn't talk." What did you do? "We knelt in front of each other."

This is a true picture of appreciation and worship.

ON THE PATH IN OUR TIMES

Let us now see whether among the many paths leading to the Mountain of Enlightenment we can find some common characteristics. What are the steps which we need to take in order to be on the path of self-realisation? Here are at least five of these steps:

- **You give more than you receive:** Although this is the first step, it is very important. For if one constantly wants to receive, if one wants to hoard and accumulate, one is not on the path of self-realisation. St Francis has said it sublimely: "It is in giving that one receives." This sentiment is reiterated in all spiritual traditions. The sense of being blessed by giving is enshrined by many myths and tales. One of them is the myth of Prometheus. Selfless giving is an important stage in overcoming one's ego.

- **You constantly give Light:** You are a source of Light to others. You are a source. You are Light. This happens when you are on higher reaches of your journey. If you are constantly

giving Light and inspiration to others, it is a sure sign that you are on the path. How do you become a source of Light, while at the beginning you crave more and more Light from others? This is one of the mysteries. But also an inherent part of your own journey of becoming. You must ignite this Light which lies inside. This is usually done by stripping away the unnecessary layers until you reach the inner Light, the God within. In the Western tradition, this is usually described as the Socratic journey. You may also want to come closer to those who emit Light. Often adepts on the path follow a guru who guides them. This may be beneficial because an enlightened guru may help one to release one's own Light. But it may also be detrimental — when the follower is completely eclipsed by the Light of the guru and shines only like the moon, through the reflected Light of the master. This is not a good condition. You also may (and indeed should!) follow sacred literature on the subject of how to release the inner Light. Sacred literature is a source of Light. There is subtle and deep Light, which is contained in the words and symbols of great texts. These words and symbols are nourishing spiritually, they are emanating with energy.

- **You have to overcome your ego:** This is the most obvious part of your journey. And yet the most difficult at the same time. Transcending one's ego is an arduous task and often it takes a lifetime. The point is not to crush your ego but beautifully transcend it. There are many people with crushed egos — sad skeletons of the human divine potential. Most of the time this ego is crushed by others or by some unfortunate circumstances. The first condition is to keep your ego integrated. The next step, after one's ego is integrated, is to transcend it. There are two aspects in the process. The psychological aspect of

overcoming the traps and confinements of the ego lies in the realisation that as we grow and mature, we no longer crave for new toys, be it sports cars or fancy dresses. Our deepest self has little to do with what dress we wear or what car we drive. It is such an elementary thing to realise, yet so important to remember. Consumerism is a form of infantile mentality, expressing the ego through the acquisition of material objects. The second aspect of overcoming the ego has the cosmological or cosmic meaning. The awareness of the cosmic dimensions of ourselves helps us to establish a distance between the world and ourselves, also to acquire maturity in overcoming the instinct to cling. For why should we cling to our 'smallness' while we are so enormous and magnificent — being an intrinsic part of this magnificent Universe? Yes, we are an inherent aspect of the entire glory that surrounds us. We are woven in the cosmic tapestry. We reverberate with its rhythms. We are a part of this fantastic enormous Light. In the moments of great insights, we are truly magnificent. We need to remember continually what the struggle is about.

- **You have to overcome your fears, your anxieties:** This is a consequence of growing in maturity and wisdom. Once you realise that your fears and phobia and insecurities are the consequence of casting yourself in the shell of your smallness, you must attempt to get outside this confinement, which imposes on you all kinds of fears. Yes, fears are real and may persecute you. But only as long as you create around yourself the world of phantoms and expect bad things to happen to you. Instead, you must cultivate the attitude of fearlessness within yourself. This fearlessness is necessary when you are on the path. It is also desirable in ordinary life — so that bad things do not happen to you because you invite them.

The power of the human mind in creating the desirable realities is simply enormous. You must become aware of this power. You must use it in your journey. Why should you be fearful while you are a shining aspect of this magnificent Universe? Look at your fears from high above. Look how small and significant they are while you traverse your high mountain. Keep traversing without any fears.

- **You long to be on the path:** Yes, the longing and the determination are important. Sometimes people have the longing but persuade themselves that their circumstances would not allow them to enter the path. Practical conditions of life can always be an excuse for not following the path. Practical life is hard. It would appear that no one has the obligations to put an extra effort to transcend all the obstacles and impediments. Except those who have in their bones this sublime conviction that they belong to the spiritual realm — and not only to the practical world. They have this fierce determination within to follow the path. What is the source of this determination? Your inner god and this enormous Light, which is always around you.

THE CREATIVE COSMOS

SEARCHING FOR A RIGHT COSMIC ORDER

We were not born out of Adam's rib. We were born out of cosmic dust. This dust was so pregnant and potent that it rendered us capable of generating thought. This thought became so powerful that it was able to create symbols and gods. Through these symbols we have been able to divinise the reality around us; and also divinise our own being. Such was the potency of the original cosmic dust, out of which we came. Our path is one of self-transcendence — from dust to the images of God and then to reality of God itself. We create realities through our own symbols.

We know that a coherent and holistic picture of all is possible. Thus we search. To search for a coherent order is part of the dignity of being human, a manifestation of creative intelligence in action. A correct reading of creative evolution enables us to distill creativity as one of the *cosmic forces*, which moves and shapes all the evolving Cosmos, including the transformation of Light

into five dimensions; including the proliferation of life into its endless forms; including the emergence of the forms of thought and forms of art. The force of creativity is cosmic. It is immense in its outreach.

Only in the twentieth century had we begun to appreciate its true meaning and significance; and not yet completely. Creativity is still left out of the Standard Models of physics, or GUTs. In my opinion, it should be in the very centre of truly comprehensive models of the Cosmos. Now, this cosmic and elevated view of evolution should be clearly distinguished from more mundane conceptions of it, such as social Darwinism and neo-Darwinism, which explain evolutionary change through mechanisms of adaptation in the development of species. This is correct as far as it goes. But it does not go very far. The whole theory (of Darwinian evolution) is too simplistic, too crude, and actually question begging. It only repeats its dogmas and does not explain.

Charles Darwin's opus, *On the Origin of Species*, was published in 1859. At the time it was indeed a shock to the established human understanding. It took decades before people became used to the idea. But nothing stands still. Everything evolves. Including the very idea of evolution.

In the same year, 1859, Henri Bergson was born. He was a French philosopher of great originality, and a noted writer who received a Nobel prize for literature. By the time he became a mature philosopher, the 'idea' of evolution was absorbed and accepted, and could be looked at in a new way. This is what Bergson did. He gave a new interpretation of evolution, created for it a much larger framework, and showed it to be far more significant and all-embracing than the Darwinian constraints would allow.

With a stroke of genius, he gave wings to the idea of evolution in his work *Creative Evolution* (1907). Since Bergson's time there has been a lively debate going on between the proponents of

the Darwinian concept of evolution (Jacques Monod, *Chance and Necessity*, published in 1970) and evolutionary biologists who, under the inspiration of Bergson and Pierre Teilhard de Chardin have woven an altogether different picture of what they consider 'evolutionary' understanding.

Pierre Teilhard de Chardin attended Bergson's lectures and seminars in Paris. He seems to have absorbed so much of Bergson's philosophy that he did not dare to express it openly. In due time he created his own opus, most magnificently rendered in *The Phenomenon of Man* (1959). This book is the milestone in showing the creative nature of evolution. From amoebae to Leonardo da Vinci, evolution can be seen as a continuous chain of miraculously executed steps which lead upward and upward. The elan of life defies the laws of classical physics. Life is creative. Evolution is creative. This creativeness cannot be reduced to a brute play of chance and necessity. Neo-Darwinism is only the first approximation, not a complete theory of evolution.

The Nobel Laureate, Albert Szent Gyorgy, has argued that it is absurd to assume that an intricate whole (a living organism) may be improved by a random mutation of one of its elements. It is like saying that you could improve a Swiss watch by bending one of its wheels or axes, "To get a better watch you must change all the wheels simultaneously to make a better fit again."

This line of thinking has been continued by many eminent thinkers in the second half of the twentieth century. One of them was Ilya Prigogine, another Nobel Laureate. He tried to explain how the genius of life can combat entropy and in effect, create its opposite, which is sometimes called 'synthropy' or anti-entropy. In his *Order Out of Chaos*, he proposed that at the times of big jumps, which are irreversible, through structures, which he called 'dissipative', life can reorganise itself on a higher level and create more 'aliveness' and consequently go 'upward.'

This view of the Universe and of evolution is consonant with our deepest intuitions concerning the nature of life. We respond to the idea of life as devouring entropy because we know it from our own experience of life. We have been shaped by creative forces of life, which have continually resisted entropy and marvellously transcended it.

In brief, evolution needs to be treated seriously, with utmost respect, indeed with reverence. For it is an awesome vehicle delivering slowly but inexorable things of beauty and exquisite complexity in which the meaning of the universe and of our lives reside. Evolutionary paradigms of the universe are congruent with our reason and our understanding as we know it from our own life.

So called GUTs of contemporary physics are splendid feats of human imagination. But they are so 'remote' from our understanding. They do not take evolution seriously, if at all. They do not take us, humans, seriously, if at all. It is all a matter of mathematical equations, which are to bind the four basic physical forces of the universe (the weak, the strong, electromagnetic and gravity) in one coherent whole. The determination to find this coherence, or to impose it on the Cosmos is so overwhelming that no mathematics is too abstract or too far out. But for all the striving, the coherence is not there. The elegance is illusory. This whole approach does not work and cannot be right. These abstract theories of the Universe, as expressed by GUTs, may perhaps be satisfactory to some mathematical gods, which do not interact with our forms of reality.

There is a great deal of arrogance underlying the plethora of GUTs. Many of them are claiming to be 'theories of everything.' This is surely a vast exaggeration considering how limited is their language. Furthermore, these theories want to finish the map of knowledge once and for all — to say now the last word about the Universe. This is a preposterously arrogant presumption.

FOLLOWING THE PATH OF CREATIVE EVOLUTION

We are ready to pick up the Ariadne thread of evolution as the unifying holistic force, which gives us a satisfactory framework for understanding life, meaning and our destiny — within the destiny of the entire Cosmos. Bergson gave us a new perspective on the nature of evolution, showing its creative character and freeing it from the stupor of sheer mechanisms and of blind chance; and freeing us from an image of the stupid monkey, which, while sitting at the typewriter for time enough — can type out all the Shakespearean tragedies.

Pierre Teilhard de Chardin, following the creative design of Bergson, showed how the evolution of the entire biological life can be rendered as a continuous unfolding of increasing consciousness. Teilhard's 'complexity/consciousness thesis' states that the more complex is the organism, the more conscious it becomes. This was an impressive demonstration of how creative evolution unfolds.

Ilya Prigogine carried out this mode of evolutionary thinking and proposed that crucial jumps in the unfolding of evolution occur through dissipative structures, which overcome stagnation and crises and lead evolution to increased aliveness. Teilhard would call this increased consciousness. Actually, both Teilhard and Prigogine complement each other.

Yet neither of the two has been specific enough to show how the process of increasing consciousness or aliveness manifests itself in the human realm. Teilhard's articulation was deep and insightful. Prigogine's articulation was ingenious and brilliant — as he used differential equations to demonstrate his point. We need to articulate their stories further. Evolution is evolving, including our understanding of the meaning of evolution.

What kind of means and devices have evolution and life been using in order to increase their consciousness and in order

to create life-enhancing structures which devour entropy? Let us look at the process of articulation of life at its various stages of development. Let us notice that as life articulates itself and becomes more conscious, it becomes *more sensitive*. Indeed, it is through the power of new sensitivities that life articulates itself and becomes more resilient and more conscious. Thus, sensitivities reveal themselves to be powerful and indispensable vehicles for the articulation of life.

When the first amoebas emerged from the primordial organic soup, they were victorious because they acquired a new sensitivity enabling them to react to the environment in a semi-conscious manner, which was the beginning of all learning. For learning is a capacity, a sensitivity, to react to the environment and its conditions with a feedback. The glory of evolution starts when organisms begin to use their capacities, thus their sensitivities, in a conscious and deliberate manner to further their well-being.

From the organic soup via the amoeba to the fish; from the fish via reptiles to primates; from the primates to man — this has been a continuous and enthralling story of the acquisition and refinement of ever-new sensitivities.

When matter started to sense and then evolved the eye as the organ of its new sensitivity, this was an occasion of great importance. Reality could now be 'seen', could be articulated according to the power of the seeing eye. Without the eye to see, there is no reality to be seen. It is the eye that brought to reality its visual aspect. The existence of the eye and the existence of the visual reality are aspects of each other; one cannot exist without the other. For what is the seeing eye that has nothing to see? And what is the visual reality that has never been seen?

The seeing ability of the eye is a form of sensitivity through which we articulate reality around us. Seeing is one of the many sensitivities. All sensitivities are products of the articulation

of evolution. But they are not just passive repositories of the evolutionary process.

Through them we mould, apprehend and articulate what we call reality. Sensitivities are articulators of reality. There is no more to reality (for us) than our sensitivities can render. To say it once more: the emergence of every new form of sensitivity is a new window to see the world.

With new sensitivities we articulate the world in new ways; we elicit from the world new aspects. The power of sensitivities is the power of co-creation. No aspect of reality imposes itself on us with an irresistible force; we take it in and then assimilate it if, and only if, we possess an appropriate sensitivity that is capable of processing this aspect of reality for us.

We have thus articulated what is missing both in the thought of Teilhard and of Prigogine — the specific vehicles through which the evolutionary ascent is taking place. Teilhard postulates the complexity/consciousness thesis. But he does not explain what are the vehicles or forces of the continuous unfolding of evolutionary consciousness. Prigogine postulates dissipative structures. But again he does not explain through which vehicles do dissipative structures perform their work. We have postulated that sensitivities are the vehicles of the evolutionary process. The meaning of dissipative structures in the context of evolution is explained.

Sensitivities are sublime entities shaping evolution and our own lives. Why has evolution developed higher forms of consciousness? The answer is: to be more seeing. Translated into our human language means *to be more knowing*; and, further still, to be able to perform better and better in the complex reality surrounding life. On the human level we have developed special capacities, special sensitivities which enable us to navigate ourselves more skillfully and adroitly in very complicated

human topographies. We have developed aesthetic sensitivity. We have developed ethical sensitivity. We have developed the sense of the sacred or the sensitivity to the divine. We have developed the mathematical and logical sensitivities.

These sensitivities are very recent arrivals in our evolutionary journey, and are new vehicles through which we articulate ourselves and deepen the reality surrounding us. Through aesthetic sensitivities we can contemplate the world as beautiful, we can shape our own life into a phenomena of beauty. What a wonderful enlargement of the meaning of life!

Through articulating ethical sensitivities, we have become fully aware that 'might does not mean right;' that all human beings appreciate justice and fairness. Refining our ethical structures and our ethical sensitivities has made us subtler and deeper, less coarse and brutal. This has enabled human societies to be governed by ethical codes and moral principles.

Now, a few words should be said about mathematical or logical sensitivities. Mathematics and logic are often considered a cold game of numbers, in a sense antithetical to spirituality. But we should look into the matter in a deeper and subtler way. There was a time, perhaps 3,000 – 4,000 years ago when people were unaware what it meant to think logically, that is to say deductively, according to certain rules that lead to assured conclusions. Then formal logic was introduced by Aristotle under the name of syllogistics. And formal logic has flowered ever since; including computer logic.

We have just discussed higher human sensitivities. We have showed that evolution has created these sensitivities in order to make more of itself through us. For we are its tentacles, eyes, ears, organs of thinking and of seeing. We are one with evolution. We are partners in evolution. We are an inherent aspect of cooperative evolution. Only such a reading of the evolutionary history

is worthy of this incredible spectacle called the evolutionary process; and of this incredible being called the human. Other readings of evolution, which diminish and dwarf us as mere puppets, controlled by the blind forces of chance and necessity, are unworthy of our minds and of the intelligence of evolution.

Evolution seen as a dynamic process of unfolding through the continuous increase of consciousness (and via ever more subtle sensitivities) makes sense from the biological as well as the spiritual point of view. Evolution is a self-divinising process. Once we understand fully its awesome unfolding and its magnificent flowering, we cannot but view it with awe and reverence. We bow to evolution and consider it sacred as a result of a deeper understanding of the whole life process.

THE CREATIVE COSMOS

You open your eyes and you see the endless skies. And beyond them the myriad of galaxies. Through the galaxies, the whole cosmos reverberates with fantastic energy. Energy is eternal delight. The galaxies, the cosmic dust, our shining eyes — all is energy, all is Light. This is an unbelievable story. And the only story worth believing in. Through our eyes and our mind we can comprehend it all. This is miraculous enough to consider our life extraordinary and stupendous.

How did it come about, this wonderful transformation? Mystery shrouds most of the Universe. Mystery shrouds the meaning of our life. Mystery shrouds the process of transformation from the cosmic dust to the shining eyes. Knowing that you do not know makes you humble, makes you open, makes you continually surprised. Discovery is such a wonderful thing. Continuous search is a Joy forever.

The Universe is one stupendous evolutionary dance. We shall now show that creativity is omnipresent. Biological evolution

arrived rather late in the unfolding of the Cosmos. It is the middle of the story of evolution, not the beginning of it. Was the Cosmos uncreative until that time? Nay. It was creative from the beginning. During the first several billion years, the Universe was in the state of a delicate balance. What is the source and reason of this balance?

By probing the early stages of the Universe, astrophysicists found — to their surprise and sometimes astonishment — that the density of the Universe was 'just right' (for the creation of the future life), that the composition of various elements in the early Universe was 'just correct' (for the creation of carbon out of which proto-life could emerge), that there was a peculiar balance in this vast stupendous stellar theatre, as if the Universe knew that we were coming.

All of this has led to a theory, which is now called the Anthropic Principle (AP). AP could be expressed as follows: the early Cosmos behaved as if it were aware that it was to conceive life. This is astonishing on the first encounter. But much less so when we understand that the Cosmos has been creative through and through.

The AP is simply an expression and embodiment of the creativity of the Cosmos. We should be mindful that extraordinary subtle forms of creativity were required to hold the structure of the Universe together. The essence of the creativity of AP has been to hold the Universe in balance and coherence, while at the same time creating new elements and their combinations out of which life could emerge. The creativity of AP was subtle and almost invisible — until you comprehend what an important role it played in the creation of life. Without a coherent and stable structure of the Universe, and its capacity to create carbon and then the rudiments of life, nothing else would have followed. It is now almost universally agreed that the AP cannot be confined

to the technical vocabulary of astro-physics. It is a principle governing the development of the entire Cosmos. As such it has a philosophical and theological significance. Therefore, it belongs more to philosophy than to science. AP is not a scientific principle but a cosmic principle. Its understanding far exceeds the vocabulary and the scope of science.

Because the Cosmos is creative, evolution is creative. Because the Cosmos is creative, human consciousness is creative. Because the Cosmos is creative, human art is creative. And the elements mentioned: evolution, consciousness and art are not separate compartments of the creative workshop of the Universe, but the endless waves of the ocean of the creative Cosmos.

THE CREATIVITY OF CONSCIOUS THINKING

We shall now attempt to see how creative thinking can connect the various stages of the creativity of the Cosmos so that finally what appears in front of us is one continuous river, indeed, one immense ocean of creativity. The AP having done its job, so to speak, and generated life, of course, was not the end of the story. The genius of organic evolution stepped in when the AP had ended its work. The creativity of organic evolution is a continuation of the work of the AP. To reiterate, at the point where the function of AP ceased, the creative biological evolution began. The two are waves of the same process. We have just connected the cosmological evolution and biological evolution, which so far have been kept apart.

Once we begin to see how smooth and continuous is the process, we immediately see the whole panorama, namely, that the creative process is present in *all the next stages* of the unfolding of the Universe. Throughout all the tempestuous developments of organic and human evolution, we see the relentless creativity of the Cosmos. What we were unable to understand through the Darwinist methodology of 'chance and necessity,' we can

understand through creativity. This is what the genius of life is about — transcendence through creativity.

The creative acts of the Cosmos can be seen everywhere. For the Cosmos is everywhere. Creativity is part of the essence of the Universe. The Cosmos is the greatest creator. We are its tentacles. These tentacles are not separate from the Cosmos. They are unique expressions of cosmic powers. Thus we are the creative Cosmos in action. We create because the Cosmos is creative. And because we are a part of it.

To see the creativity of the Cosmos as omnipresent enables us to look at the vicissitudes of biological life and of human life with a new understanding, with empathy, with insights unknown before. Creativity is never easy, either in art or in bringing about new biological forms. The Cosmos itself, as well as its creative helpers — evolution and human beings — so often have to improvise. This method of trial and error, and of continuous improvements, does not nullify the meaning and validity of the creative process. On the contrary, the method affirms it! Creativity is a song of joy; sometimes a song of agony — sung together.

When biological forms started to articulate themselves, evolution flexed its wings and reflected to itself: "Where do we go from here? Well, we 'could' stay on the level of lower forms and be happy. But Mr Cosmos wants us to transcend and transcend." Thus evolution evolved new organisms, endowed with more consciousness; then with more refined consciousness; later still came subtle and powerful sensitivities. Finally, reflective thought was born. And this reflective thought started its own odyssey of creativity.

Thought is an extraordinary form of the sensitivity of the Cosmos. With it, you can touch so many things, which are beyond reach. With it, you can touch the stars, and can try to understand how they relate to our destiny. Thought has made us (and the Cosmos!) aware how miraculous thinking is; and how

creative it is. Whatever you touch with thought is a creative act. Yes, indeed. Sometimes it is mundanely creative, sometimes awesomely creative. We constantly re-create our life through thought. If our thoughts are mundane and repetitive, we create a pedestrian reality; and a pedestrian life for ourselves. If our thoughts are magnificent, we create magnificent reality; and we have a chance to create a great life for ourselves.

Through our thoughts, we devise icons. First we create them in our minds. Then in clay. Then in wood. And then in stone. These icons become dwelling places of extraordinary images, and in due time of extraordinary powers with which we endow them. We can endow them with transcendent powers. Through these powers they can act upon the external world. But these powers can also affect us. By emulating these icons, we can feel uplifted, guided and enlightened. What a wonderful creativity of the mind! At this juncture the Cosmos grins with delight. For we have created human symbols of divinity. Through them, we can see the Universe in a grain of sand; and the glory of God in a shaft of Light.

With thought we devise theories of knowledge, of science, of philosophy, of religion. These theories are icons in their own right. An icon of knowledge, to begin with, is meant to be a refractive prism through which we can see more clearly, more widely and more deeply. Often enough, theories conceived within our knowledge serve these very purposes. They give us truth, which liberates. Sometimes however, these icons of knowledge become filters, which act like the glass darkly — desecrating and sullying the beauty and grandeur of creation. The icons of knowledge have the power to define and control; to uplift and to defile.

Powerful and far-reaching theories of general knowledge and of science are both beautiful and dangerous. These icons are almost religious in character. They give us much power. And yet, at the same time, they claim so much of your identity.

They are never indifferent tools, glad to be of use; and glad to leave you undisturbed. For this is a point to remember. Once you use knowledge given to you, you are 'disturbed.' Creative process is always a 'disturbing' process. However, it may be disturbing for better or worse. It is disturbing for the better, if it leads to transcendence and finally to the self-realisation. It is disturbing for the worse, if it leads to chaos, disintegration, fractured existence and a denial of the great cosmic potential in us.

Thus no knowledge is indifferent. Once we absorb it, we are wrapped into it. It penetrates the core of our existence. It shapes and defines our identity. It also defines and controls the world around us. If this happens, the controlling nature of our knowledge becomes a determining factor of our existence. We and our knowledge are one. And it cannot be otherwise. As we understand so we act. We understand as our knowledge orders us. An innocent icon of cognition may become a tyrant coercing our visions and actions.

This is clearly so with regard to religion and religious structure of beliefs. And even more so when religious imperatives are reinforced by punishing institutions (such as the Inquisition). Such institutions usually attempt to discourage us to 'know' to 'understand' in ways which are different from what the orthodoxy proclaims. We have discussed this problem while analysing the nature of religious filters — their liberating and their constraining capacities.

Filters of knowledge nearly always possess a semi-religious significance. They select and organise, relate and coordinate — not only the bits of disconnected knowledge but whole world views. And within these world views, they define how the mind should look at the knowledge given to it; how it should handle knowledge; how it should act through it; and to what purposes. Moreover, the mind is subtly instructed how it should shape the

self, the identity of the individual — so that the individual fits in a given mould of knowledge. The totality of these subtle acts of filtering is a form of indoctrination.

It would be a mistaken view to hold that this process is characteristic of old religious societies but has nothing to do with the modern scientific world view. The scientific world view is supposed to be free of any religious penumbra. The truth is that it is not. The scientific world view possesses all the features, which are characteristic of the dogmatic systems of knowledge, which we usually associate with orthodox religions. In their total effects, the filters of scientific knowledge are hardly distinguishable from the effects of religious filters. Both kinds of these filters attempt to define the whole reality around us, while using their respective knowledge for controlling this reality, and while using it also to fit the human into the niches they prepared for us.

CREATIVITY AS A DIVINE NECESSITY

WHY DO WE HAVE TO CREATE?

We create because the Cosmos is creating through us. We create because the Cosmos is creative. We create because we are an outreach of the creative Cosmos.

Human creativity, particularly in the realm of art, is so inexplicable and yet so obvious. Inexplicable when we consider artistic creation as an abnormal and eccentric occupation of human beings, who indulge in something which is both unnecessary and impractical. It is obvious when we consider artistic creation as a part of a larger creativity of the Cosmos. When we understand creativity in this perspective, many puzzles, mysteries and agonies, connected with the creative act, become quite comprehensible and even exciting.

The agonies of creative art have been particularly striking in the twentieth century. Classical idioms and forms of art

have burnt themselves out. The bold and sometimes bizarre experiments with form — in both music and visual arts — have led to some intriguing and fascinating results, but also to some disturbing pathologies. The crisis deepened throughout the twentieth century. The agonising dilemma was: how to create while one is completely paralysed and unable to create? How to express the meaning of life, which has become impossible and even monstrous? What is the role of an artist in the world gone haywire? Is an artist doomed to be a vehicle of the pathologies affecting our world? Is it the only thing the artists can do? To capitulate to the process of disintegration?

Some artists are prepared to say: "What else can we do in these impossible times?" Yet, we can do much more than that. I will propose that creativity is boundless and will unfold and unfold in positive ways. We do not need to capitulate to pathologies or make monkeys of ourselves by inventing new absurdities simply because other artists have not yet thought of them.

Inspiring art of the future is possible and inevitable. Simply because to create is a necessity. But not an ordinary necessity; especially not a necessity imposed on us by others. It is a divine necessity. Divine because it is a part of the cosmic imperative. We create because the Cosmos creates through us. Sometimes we are aware of it. Most of the time we are not. The higher the art, and the greater the power of an artist, the more lucid is his awareness that creating is divine.

Let us start with fundamental questions. Why do we create? Because we 'can'. And because we 'must'. Both answers are obvious and both are shrouded in the veil of mystery. What does it mean that we can create? What does it mean that we must create? We may say that, "We can create." It simply means that we possess appropriate predilections, facilities and talents to do so. But why? We could have been semi-perfect biological automata.

And no doubt our life would have been 'easier'. But we are not. And for this reason our life is more difficult...and more beautiful.

Why must we create? Nobody forces us to do so. Yet we must. Why in every culture have there been people 'on the limb,' inspired and in touch with the invisible forces? Those inspired ones have been shamans, prophets and artists. Shamans are artists. And prophets are artists. When prophetic and shamanic aspects disappear from art, it withers, becomes a pale shadow of its potency. The inspired visionaries and seekers of holy grails create cultures. They define the essence of the human species. They raise the aspirations and the very meaning of existence of the human race.

Artists are chosen by gods. They are entrusted with a mission, which they understand, even if they cannot express it in words. We create because we must, which in the last consequence means that creativity is part of the essence of being human, part of our deepest nature, as well as part of the deepest nature of the evolving Cosmos.

What then is creativity? I know when you do not ask. I know when I create. But even then I do not. For I am so absorbed in the creative act that the whole world ceases to exist for me. Only after being submerged in this process, I know. Namely, what a divine process it was! Even if it was accompanied by pains and agonies.

The nature of creativity is heavenly. It is one of its attributes. The next attribute of creativity is that it is very natural to humans. And the third attribute is that it is an awesome superhuman process. These three attributes of the creative act — its divine nature, its absolute naturalness, and its superhuman character are woven together, thus making it so inspiring, mysterious, compelling and inevitable.

So, why must we create? Because the Cosmos does it through us. Because it is joy to do so. Because creativity is the surest vehicle of self-realisation. In self-realising ourselves we

simply create ourselves in a divine image. It is so because we cannot resist entering the mysterious cavern of becoming, in which the unfoldment of the Universe takes place through the powers of creativity.

The human condition is one and the same for the whole human race. It is common to all human beings. Yes, we are different. Therefore we have different talents and propensities. But the essential nature is the same. The essential nature of all life is creativity. And so it is with human life. Artists embody and express this propensity for creativity more poignantly, clearly and forcefully than others. But this creative drive is present in all of us. Each of us has a creative spark, which wants to shine, even if it shines only dimly.

Ordinary people often protest against being creative or having anything to do with creativity and artistry. But this is so only on the surface. In fact everybody throbs and twitches to be creative and inventive. Observe people's reactions to their work. Everybody wants to be recognised for his work and achievement. Undoubtedly there is some pride and ego involved here. Deeper down, however, it is something else. It is this intuitive impulse to do something out of the ordinary, inventive and creative; even if it concerns small things. There is a sense of glee and of joy when one is recognised for a small inventive thing in ordinary life. Even if it is only a new way of driving a nail into the wall. Life loves novelty. Even more so life loves creative genius.

Creative people are so alive. It is a joy to be with them. It is a joy to watch them. Uncreative people, on the other hand, are boring. We avoid them. Not because we want to discriminate against them, but because the life in us is not attracted by them. We are always repelled by stagnation, decay and death. Thus creativity is the sign of life unfolding and blossoming. Decay and boredom are opposite to blossoming. Thus creativity equals life.

Life equals creativity. At the other end of the spectrum we see that boredom equals decay. Death equals the end of creativity.

We can look at this issue in yet another way. Repetitious and boring work is avoided because it is a form of slavery. When any initiative is denied to you, you feel trapped, enslaved, diminished. Why would you not elect to be a happy slave, doing what is given to you, regardless how mindless and repetitious it is? Because it is against your nature, which wants to embrace life and express it in your inimitable way. For a true expression of your nature, you need freedom not slavery.

Freedom and creativity are ecstatic and joyous. Intensely creative people seem to dwell in the space of God. They feel God-like. We receive their work as gifts of God. This is so because of the extraordinary illumination, energy and life enhancing qualities, which their work brings. Thus we can express our contrast in yet another way. Uncreative work brings you close to slavery. Intensely creative work brings you close to God.

Uncreative drudging so often signifies stagnation and boredom. Yet, let us be careful. The opposite of stagnation — frantic activity and rushing — is not tantamount to creativity. The torrent of rushing is actually antithetical to creativity, which requires reflective space, some degree of inner concentration and solitude. Continuous rushing obliterates solitude and reflective spirit. Rushing is against grace. Rushing is against creativity. For creativity is a form of grace.

In short, creativity may wither as the result of stagnation, boredom and repetitiveness of our work, within which we feel enslaved and reduced. But it also can be smothered and suffocated in the torrent of rushing, which produces but stress in an individual, and a jittery repelling energy in the work produced.

Creativity signifies the middle road. It requires an intense glowing inside, which is neither frantic nor rushing, neither

steeped in the stupor of apathy nor in the chains of enslavement, but which is a steady gazer of clean energy, friendly to life and creation.

THE BLESSED HUMAN CONDITION

The world is full of gloom, pessimism and nihilism. Yet, these are only temporary hiccups of the human condition. We may be passing through a period of mild paranoia. After we recover from it, we shall see our condition in a deeper and more transcendent light.

The human condition is not cursed, as some philosophers and prophets of darkness tell us. These prophets are affected by the myopia of present knowledge. They did not make the effort to see deeper. The teachings of post-modernists, and earlier of Jean Paul Sartre, and earlier still of Arthur Schopenhauer try to justify our despair and pessimism by arguing that we live in a purposeless Universe; and that our own life has no meaning. They have looked at a wrong cosmos; at any rate, they have looked at it wrongly — by being much too affected by mechanistic philosophy. As the result, they have made of the Cosmos a lifeless stupid caricature. In the process, they have attempted to stupefy us. And themselves as well.

The human condition is blessed because the Cosmos is creative. We are part of this creativity. The human race is a proud part of the creative dance of the Universe. Artists are the most creative spearhead of humanity. They have a particular reason to be proud of their existence. They are the leading torches bringing us all to more lucid light. I am repeating some of my arguments because it is important that we get the whole picture right. Otherwise, we shall slide back into old absurd philosophies, which, by claiming that the world is absurd, are attempting to make us absurd.

The Cosmos is not absurd. The Cosmos is creative. Creativity is not absurd. Creativity is divine. Thus we live in a creative and

divine Cosmos. And it is a great privilege to dwell in such a Cosmos. It is a privilege to know it. It is an honour to participate in this overall creativity. These are important truths, which we must learn, repeat and contemplate — to stay sane and continue to be creative. Once you fully wake up and recognise the creative nature of the Cosmos, you immediately understand that your participation in the creative becoming of the Cosmos is your *moral responsibility*, is your cosmic responsibility, is your honour, glory and joy.

Because artists understand this responsibility deeper than others — even if they cannot clearly express it — they are privileged beings. And they know it. Again, even if they cannot express it, cannot articulate this awareness, which drives them on and on. True enough, this force occasionally seems to torture them. On other occasions however, it sends them to heaven and makes them feel sublime.

Like recognises the like, as Plotinus says. We recognise the creative madness in artists because there are some embers of this madness in ourselves. We intuitively know what it means to struggle to make some sense of our creativity and make the spark of creativity glow in us. We know what it means to be haunted by the spirit of creative becoming in ourselves; and what moments of ecstasy we experience when we do succeed.

Deep down we also understand that the drama of creative becoming is much more intense within artists. For this reason, we empathise with them. We all participate in the same mysterious cosmic drama — even if only as auxiliary actors. We understand the tortured moments of their creativity because we have experienced the glimmers of this agony ourselves. We understand and envy their creative ecstasy because we have been visited by such moments ourselves.

We understand that creative pains and agonies of art are not useless labours of impractical existence. They are significant

points of Light in the process of the becoming of the Universe. We understand our own sufferings in life because we are aware that they are not desperate cries of our existence in the absurd universe. They are pains of becoming — as we try to fathom creativity in our own life. Sometimes we understand this less consciously, sometimes more consciously.

All of this we do understand, that is, when we go deeper into ourselves. Thus we understand (if only dimly) the glory of belonging to this Cosmos. It is a great solace and an immense source of support to know that you live in a creative and divine Universe.

The human condition is blessed and artists are particularly privileged. They must not apologise for their existence; whatever vicissitudes befall on them. Yet this must be understood as well, that artists' lives are difficult and sometimes agonising. Nevertheless they are beautiful and strangely elevated.

Mozart died in poverty while still composing his divine Requiem. Beethoven suffered *the strings and arrows of outrageous fortune* most of his creative life. Rembrandt painted his most sublime pictures while penniless and in debt. Leonardo's creative genius was mistreated by lesser beings of his time quite often. Michaelangelo, while creating his magnificent pieces, lived in continuous agony because of the impossible demands placed on him by the Pope whom he served.

But glorious lives they lived indeed. Perhaps there is some strange justice at work here. No doubt, artists are privileged. Partly because they are very sensitive. Being so sensitive, they are also vulnerable. Being so vulnerable they can be easily hurt. When hurt, they suffer more intensely than others. So is their suffering a part of their creative gift? Is this a part of a larger pattern of justice — that exceptional gifts are equalised by some agonies?

Let us also be mindful that some qualities cancel out other qualities. If you are grasping and hoarding, you cannot be too

sensitive because then your hoarding and grasping will impinge on your moral conscience. If you are an artist of high sensitivities, on the other hand, you can hardly care for grasping and hoarding.Your mind is elsewhere, your sensitivities would not allow for that.

The blessed ones are givers, not hoarders. Artists always give. They cannot do otherwise. The fundamental reason is cosmic. Yes, cosmic. Light is always giving. What artists and other creators give is cosmic energy, which flows through them, and must be shared. It is so obvious to them, and sometimes to us, that Light and life must be shared. Artists do not create for themselves. They are a part of a larger flow, which they articulate in their unique way.

Beyond understanding images, symbols and the vicissitudes of forms, we need to develop the insight, which will enable us to recognise works of art as hidden sources of energy. We need to develop the sensitivities to recognise different forms of arts as various and different forms of energy. And also we need to understand how this energy affects us.

A new path is in front of us, a new conception of art offers itself: art as an embodiment and emanation of cosmic energies. Let me emphasise. Beyond the forms and symbols, beyond the symmetries and particular tensions within the works of art, there lies a hidden reservoir of energy; sometimes weak energy, sometimes strong energy; most of the time positive energy, sometimes negative energy.

Seeing works of art as fields of energy enables us to integrate art into the *big flow of life*. As well as it enables us to perceive art as an expression of the evolution of Big Light.

Art is a particular manifestation of the glory of energy of life. The purpose of this energy, which is contained in art, is to sustain the human species and make it flourish. In so far as the human species contributes to the flowering of evolution, the energy of art

is an aspect of the flowering of evolution. We have just arrived at an understanding, which informs us that art is not whimsical but essential to the pursuit of evolution itself.

There are fundamental reasons for separating bad and especially nihilistic (or destructive) art from good art or what we call elevating art. Bad art does not contain much good energy. Destructive art contains negative energy. Elevating art contains a reservoir of good sustaining energy. We are drawn to great art for it contains and emanates nourishing psychic energy.

This new understanding of art also enables us to comprehend another important phenomenon, namely the lives of the saints; as well as the peculiar energy with which their teaching emanates. This energy too is a part of the glory of evolution. We have no doubt whatsoever that the energy emanating from great saints is life-enhancing in the deepest sense. Whoever has been in their presence can testify to that fact.

We may go a step further. Great spiritual teachings, which have survived, did so because they are nourishing and sustaining, because they contain positive spiritual energy. It is a bit of a mystery how the power of these texts work. It follows from our discussion that these great saints and great spiritual teachings can be considered as great works of art — in so far as they emanate this amazing sustaining energy, which is so important to the health and balance of our psychic lives.

The new conception of art here proposed, as the emanating reservoir of good sustaining energy, sheds a new light on three important realms:

- It enables us to see art with new depth.
- It enables us to integrate art with the *big flow of life*.
- It enables us to see saints and sacred texts as the embodiment of great art.

This new interpretation enables us to see the saints and exceptional spiritual lights not as something apart from life but as something, which is part of the great tapestry of life. Such a conception, we dare say, does not diminish the life of the Buddha or the life of Jesus of Nazareth but rather makes their lives more integrated with the *big flow of life*.

In our times, the lives of Mahatma Gandhi, and of Mother Teresa equally deserve to be called great works of art, for they have been great healers and sources of sustaining spiritual energy. In this discussion, we have enlarged the meaning of artists to include spiritual leaders. They are creators in their own right. They are repositories of great psychic and spiritual energy. They are relentless givers. Through them, Light, as a continuous giver, shines supreme.

We have been developing a new *philosophy of Light*. Therefore we needed to show that art and the creative process are part of this philosophy, truly a part of the new vision of the Cosmos. We have demonstrated that art is a source of energy: life-enhancing energy, psychic and spiritual energy. We have also demonstrated that artists, by their nature, are vehicles of this energy. Moreover, they are continuous givers. They are obedient to the imperative of all giving Light.

Through our new philosophy of Light, we have shown how things fit together, are interlinked to help each other: from the early development of the Cosmos, via the AP; via the creative genius of organic evolution to the evolution of art during the last several thousand years.

Such an important phenomenon as human creativity cannot be whimsical in the way of the unfolding Cosmos. This we have shown conclusively. And we have also justified why the creative process is so elevating to the humans and why the human condition is blessed.

THE UNIQUE ROLE OF HUMAN CREATIVITY

Since the Cosmos is creative throughout, it would seem that there is nothing exceptional in human creativity. But there is. Not because we are partial to ourselves and consider everything which is human as precious to us; but because of the exceptional nature of this creativity; because of its condense, concentrated and crystallised character.

The field of human creativity, especially in art, has become a cauldron, a laboratory in which the creative process has been ceaselessly worked upon, condensed, magnified and refined; so diligently reflected upon, deepened and re-reflected that it became a qualitatively different form of creativity — as contrasted with earlier forms of creativity, which were more diffused, more tentative and more amorphous.

We, humans became conscious of the nature of the creative act and of the creative process — of its powers, characteristics, uniqueness and mystery. The bees can build beehives and within them create wonderfully symmetrical hexagonal cells. But they are not aware of their creativity. The human beings at one point became aware of their creativity. And, by recognising the nature of the creative act, they recognised the creativity of evolution and of the Cosmos.

We are only one beam of the creative powers of the Cosmos. This is one truth. However, we must recognise another truth, namely that in the human — the creative powers have crystallised themselves in especially magnified and magnificent ways. In the realm of art, important magic had occurred — a self-conscious articulation of the creative act occurred. Through the creation of works of art, through their contemplation, through dwelling amidst them; and while being inspired and elevated by them, we have understood the essence of the creative act, and thereby of the nature of creativity itself.

Therefore, it is through the prism of our understanding of the creative act that we decipher the attributes of creativity in all art; and subsequently in all spheres of life; and furthermore in evolution at large; and finally in the workings of the whole Cosmos.

Thus we are not listless receivers of the crumbs of creativity dropped on our table by the Cosmos and evolution. We are significant actors in the drama of unfolding creativity: on our own human stage, and on a larger cosmic stage — by making sense of what is going on. We are co-creating with the Cosmos, while being created by it.

Our self-awareness of the beauty and of the importance of the creative act, and our awareness of our role in crystallising the nature of this act should make us proud of our condition. Our condition is not cursed. On the contrary it is blessed. Our creativity has a divine character. The blessed human condition is so often unaware how great it is. While observing the Cosmos, whether being overwhelmed by the vastness of the stars or the subtle beauty of water lilies, we are witnessing a very strange phenomenon: of the Cosmos itself looking at itself through our eyes.

For we are the eyes and minds of the Cosmos. It is quite possible that there are other minds — in addition to ours. But this does not diminish our role. The Cosmos cannot think of itself without thinking. In order to think, it had to create thinking beings. We have said that the Cosmos has always been creative. But we can now add that it has created without full awareness of what it was doing. Through the human articulation of the creative act, and through the conscious understanding of the process of creativity, the Cosmos is now aware of its own creativity. It is a bit strange to say this, but there is no other way to say it. Through human thinking the creativity of the Cosmos has been revealed: what a joy to be aware of one's own creativity!

We need to express the matter simply but without arrogance. Art is the paradigm of all creativity. By grasping the essence of

this creativity, we (humans) have been able to define other forms of creativity and reflect on the multitude of creativities in the universe. In this sense, the role of art is enormously important.

ART IS THE YARDSTICK OF THE CREATIVITY OF THE COSMOS.

This way of putting the matter is both revealing and also a bit puzzling. For it leads to the question: would the Cosmos have not been creative if the human mind did not come along to squeeze the essence of creativity through its engagement with art? How do we answer this question? Especially as we have maintained that the Cosmos has been creative all along...? Now whatever propensities and qualities we find in the Cosmos, they reveal themselves only when appropriate sensitivities are developed to seize them; which is to say, when there is an appropriate mind to handle them, and appropriate language to express them. Sensitivities, mind and language are parts of the apparatus of articulation.

What is the status of processes, propensities, qualities and attributes, which have not yet been named? We shall say this in our language: what has not been articulated? Do we say that they have not been discovered? Or do we say that they do not (yet) exist? Common sense, shaped by older static views of the Universe, wants to say: they are not yet discovered; because they cannot be later discovered, if they did not exist already. But this is not the right approach. Articulation is much more than a discovery of things existing.

When things remain unarticulated, they are simply not created. And we have an immediate impulse to say: not 'yet' created. But this impulse is premature. It assumes that they were 'bound' to be created, that they just 'waited' to be unveiled in one form or another.

This is not how creativity works. Some things, which are unarticulated, may remain unarticulated, therefore non-existent, forever. Therefore what is not articulated does not exist. We can now appreciate the power and beauty of articulation as a vehicle of creation. For this process brings things to existence out of their original amorphous magma. We can furthermore appreciate the importance of articulating the essence of the creative process — which may have languished in the bowels of the Cosmos forever, if the human mind did not bring it to radiance, crystallisation and scintillating effervescence through its reflection in works of art.

The creative art is magical. Once it brings things to existence, they are so obvious and inevitable. But before they are brought to existence, they are neither obvious nor inevitable; because they are not yet existent. It is an eternal mystery as to which things will come to existence and which will not. It is awesome that some things which could have come to existence, never will. It is equally awesome, that things, which have come to existence, may not have come. Does the Cosmos play some strange roulette? No, this is not a roulette. But the creative act of unfolding, which may unfold in so many ways. For this reason, no set of fixed 'scientific' laws can describe this act.

The only laws are the creative laws of the Cosmos; which are not fixed but creative. For this reason, we are free and the Universe is free. This may be the deepest secret of freedom: freedom is a hidden dimension of creativity. Freedom is a manifestation of creativity. Creativity is a vehicle and an expression of freedom. The two are inseparable.

ORDERS OF CREATIVITY—
THEIR DEPTHS AND
TRAPS

SIX ORDERS OF CREATIVITY

We have followed the odyssey of the creative elan of the Cosmos
— from the Anthropic Principle to organic evolution, to individual
human creativity. We have seen that creativity is built into the
very nature of the Cosmos, as a kind of divine necessity.

This divine necessity is built into the nature of human life as
well. The cosmic imperative of creativity makes the human life
dramatic, demanding and breathtaking. Concentrating on human
creativity has enabled us to perceive the creative process in sharp
focus. By understanding the supremely condensed forms of
creativity in human art, we have been able to perceive the creative
process in the Cosmos at large.

Now we need to take a closer look at this period of evolution
of consciousness in which it became self-consciousness, and started

to generate new forms of creativity beyond the organic forms of life. We shall acknowledge that creativity in the biological realm has brought about many wonders, as for example the capacity of newly hatched turtles, which (after being hatched on an island) immediately make for the sea in order to swim back to the land from which their parents came.

The next stage of the unfolding of evolution led to the articulation of consciousness, which was able to draft symbols. Through these symbols reality was transmogrified. As symbolic consciousness made its way, it created new wonders, which were inconceivable in the merely biological realm of existence. Thus in addition to cosmological and biological creativity, we shall distinguish four other orders of creativity and show how they have been changing the world. By distinguishing the six orders of creativity, we shall show how immensely varied creativity has been, while branching out into new levels of manifestation.

We shall present the six orders of creativity in chronological order. We shall use diagrams to make our story more compelling and more immediate. In the two diagrams that follow, we present different images of the six orders of creativity. In the last diagram, we shall see how the most recent orders of creativity have been infringing on the ancient orders.

At each new level of creativity, former levels of creativity are preserved and continued. However, the topography of the Universe and of the mind is changed. When art and religion emerged, the human mind changed. And so did the world surrounding humans. Similarly, when science and technology emerged — and their respective orders of creativity — the human mind again underwent a change; and so did the world surrounding humans.

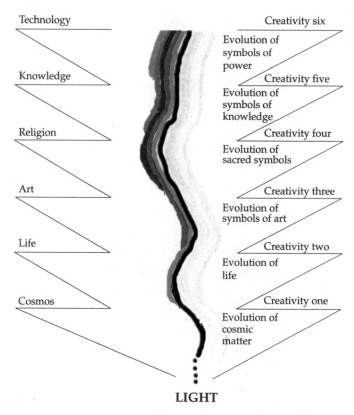

Technology		Creativity six
Knowledge		Evolution of symbols of power
		Creativity five
Religion		Evolution of symbols of knowledge
		Creativity four
Art		Evolution of sacred symbols
		Creativity three
Life		Evolution of symbols of art
		Creativity two
Cosmos		Evolution of life
		Creativity one
		Evolution of cosmic matter

LIGHT

Diagram 3

In the recent stages of the evolutionary journey, the new orders of creativity have attempted to dominate and even suppress the older ones. This struggle of the orders of creativity sometimes expresses the evolutionary unfolding of the Cosmos, whose motto is *plus ultra*. Sometimes this struggle expresses the wilfulness of humans who want to impose their sense of order onto the existing orders. We humans must be mindful that the first four orders of creativity simply denote the cosmic order. We need to be cautious and wise while inventing 'new orders'. These invented orders must not clash with the underlying cosmic order.

We could now discuss the six orders of creativity.

- **Creativity one, through AP:** This is one of the strangest of cosmic forces. It emerged out of the creative bowels of the Cosmos. It is a great maintainer of the physical order of things. It organises the Universe so that it is neither too dense, because then it would suffer a gravitational collapse; nor too thin, because then no stars could be born. Through the works of the AP heavier elements evolved out of the original helium. From heavier elements the proto-blocks of life were born. The AP is responsible for astro-physical stability and the physical structure of the Cosmos. The AP is a pre-condition of all other orders of creativity. It has created a matrix for the emergence of all biological life.

- **Creativity two, through the evolution of life:** It emerges at the point when AP has done its job, by giving birth to the proto-forms of life. As the second order of creativity it continues the work of the AP. But it also transcends it — by generating an extraordinary variety of exquisite forms of life. Basically, every new form of life is a triumph of biological creativity. Biological evolution is often seen as a discrete phenomenon, but it truly must be seen as a part of the spectrum of creativities of the Cosmos. Each form of creativity is a form of magic. The achievements of every form of creativity are so staggering that they are simply beyond reason.

- **Creativity three, through the evolution of art:** As the evolution of life continues, it brings forth ever more subtle and complex forms of consciousness, until finally it brings about self-consciousness in humans. At this point a new creative power emerges: the human mind, which generates its own creative orders as it goes along. The organic evolution of life is a continuation and extension of the work of AP.

The creativity of human mind is a continuation, and also a transcendence of the evolution of life. It is through the conscious and creative mind that we are able to understand all that there is, including the very meaning of creativity. As the human mind refines itself, it invents symbols — the unique entities through which the mind makes its ascent to even more subtle and penetrating readings of the Universe. The world becomes a transcendent phenomenon. For symbols are not only names of things. They also signify transcendent qualities — as they point out to phenomena invisible to the human eye and beyond the reach of human senses. When symbols explode in the realm of artistic creativity, we witness the emergence of *homo creativus*. We also witness a new chapter in the creativity of the Cosmos. The Cosmos is able to express itself in a new way — by exhibiting its hitherto hidden attributes. One of the stunning features of artistic creativity is that it has taught us what creation and creativity truly signify.

- **Creativity four, through the evolution of the sacred symbols:** Over the last several thousand years, we have witnessed the rise of a new kinds of symbols. They try to reach out to what we now call the divine. This stage of evolution represents the crystallisation of the sense of the religious and of the divine. Within this stage, religious and spiritual art flourishes, bringing a new depth to human experience. The transcendent symbols of sacred art attempt to connect us with the divine; and make us divine. Through this process, human life deepens, is made more subtle and refined. Seen from a larger evolutionary perspective, the evolution of sacred symbols represents a very significant step in the unfolding of the ultimate destiny of the Cosmos;

which includes the destiny of humans. Sacred symbols have become the defining characteristics of our spiritual journey. The ultimate terminus is envisaged through the meaning and glory of these symbols. Without these symbols it is inconceivable to imagine heaven, nirvana and paradise.

- **Creativity five, through the evolution of intellectual understanding:** This new stage of human creativity represents the transition from Egyptian culture, (controlled by religion and religious symbols) to Greek culture, (guided by lucid Logos and its predominantly human forms of understanding). In due time, science is born. A new form of creativity is articulated — probing the physical universe ever so more deeply. In the process, a sense of power and of control over the Universe is developed. Science has also articulated a new kind of symbol: mathematical symbols as underlying the structure of physical reality. This is best expressed in the works and visions of Pythagoras and Galileo. Yet in this new venture science goes overboard — insisting that mathematical symbols can provide a sufficient matrix for the description of all reality. Moreover, in its zeal to explain everything through physical and mathematical symbols, science has tended to brush aside the subtle and the sensitive forms of understanding as contained in philosophy, poetry and religion and also attempted to undercut the legacy of art and religion. At its most lopsided, and while allaying itself with expansive and aggressive technology, science has created mechanistic filters, which proved detrimental to civilisation, culture and human spirit.

- **Creativity six, through the evolution of symbols generating power:** Technology is an extension of science. It is an application of science to practical life. Yet, at a certain point it becomes an autonomous force. It then overshadows and

subdues science to its agenda and imperatives. The main mission of science is to probe the world deeper and deeper in order to acquire right knowledge. The main mission and distinctive imperative of technology is control and manipulation. The imperative of technology is: "What can be done, must be done." In following this imperative, technology attempts to invent new products and gadgets. Then it attempts to impose them on society, by claiming that society needs them 'because they are here.' This leads to the creation of artificial needs and trivial forms of fulfillment. On another level it leads to the production of ever more destructive weapons. A striking feature of technological creativity is that with its exuberance, it effectively suppresses other forms of creativity. It actually does so on a stupendous scale. In this sense it has become a menace, and a cancer, which is eating away the vital forces of life at large. Technological creativity is upsetting the cosmic order of things, by thwarting or trivialising other orders and forms of creativity. In this sense technology's triumph is evolution's demise. The diagram given here represents the expansive creativity of technology, at the top of the tree of life, which is upsetting cosmic creativity. It shows that creativity of technology is not genuine transcendence but a form of cancer affecting negatively other forms of creativity.

SYMBOLS AND POWERS

Consciousness is a very powerful agent of evolution. It is ever changing. It can take different shapes and forms in different cultures which may spell out different visions of reality and different conceptions of human life. Consciousness and symbols often go hand in hand. They express the elan and visions of a culture. These symbols possess strange powers, which can empower and disempower people.

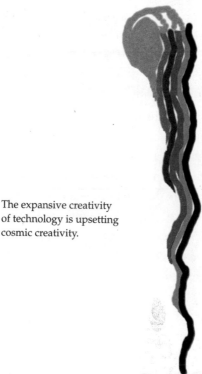

The expansive creativity
of technology is upsetting
cosmic creativity.

Diagram 4

As we watch the transition from the early pre-historic
societies to historic ones, we see changes in consciousness.
The consciousness of the early people was 'amorphous' and
quite nebulous. It was shaped more by intuition than rational
thought. It was holistic and merged with Nature rather than
being separate from it. Looking at the early art, we see that it
also was amorphous. It showed the human as woven into the
tapestry of the entire Cosmos. It was thus holistic-cosmic art. As
is the consciousness of the people, so is their world, and so is
their art, and so is their concept of the human. All exist in mutual
interdependence, interwoven in larger tapestries.

After the early amorphic-cosmic art, there occurs the crystallisation of human consciousness and the simultaneous crystallisation of icons signifying supernatural powers — organised religions emerge. The human being attempts to define himself in the image of his new icons. Art takes upon itself a similar task. It attempts to express the supernatural world. This world and this art are filtered through the meaning and images of God/ gods of this time. Art begins to reach deeper layers of the human psyche. It begins to discover and articulate the sacred — in the world and within the human. Art deepens spiritually. It creates unsurpassed masterpieces eulogising the greatness of God.

The deeper the consciousness the higher are our aspirations and horizons; and, simultaneously, the higher are the flights of art, which attempts to convey the depth of the Universe. Such was the art in the most sublime periods of human history: the great Egyptian art, the great Indian and Buddhist art — at the time of their spiritual flowering. And so it is in the classical period of ancient Greece and then in the period of the Renaissance. Great minds could conceive and give birth to great art because they were in exulted and elevated states of consciousness.

The sublime art does not only express the depth of human consciousness. It creates this depth. For art is not only a mirror. It is a co-creator of the depth of the human world. Let us remember: as is our consciousness, so is our world and so is the phenomenon of man. Great consciousness creates great worlds and great humans. Correspondingly, small consciousness creates small humans and small worlds.

The meaning of art, as well as of human life is measured by the steps in the development of the whole evolution, of the whole Cosmos — on the transcendent ladder leading to the self-realisation of the Cosmos. This criterion illuminates the whole scene of both art and of human development. Thus not art for art's

sake, but art in the service of transcendence. Art is an expression of transcendence, is a torch illuminating the horizon of the whole of evolution, and is a crystallisation of the cutting edge creative process of the Cosmos.

And so it is with religion, knowledge and technology. They must be judged by the evolutionary criterion: to what degree and in what sense do they contribute to the self-realisation of the Cosmos which also includes human destiny? They must be judged by the degrees by which they are freeing man to pursue his highest spiritual destiny. And also by their failures to do so — while imposing constraints and various forms of slavery.

Symbols of a given consciousness may be empowering and disempowering, and this is true of the symbols of religions. Nietzsche had a cosmic vision of the human who, in his creative powers, is like God. He wrote that, "Every person is a co-worker in building the whole cosmic existence, whether he is aware of it or not, whether he is willing to do the work or not. We must be ourselves, like God — just, kind, generous towards all beings; and create them anew, as we had created them so far. When the human becomes fully an embodiment of Humanity, we will move the entire nature...that is when he [the human] learns to transform himself."

Nietzsche's visions clearly anticipate our programme of releasing the cosmic creativity in us until we become God-like. Such a vision is a liberation from the constraints of organised religions, which invariably, while offering some liberation, put their subtle shackles on us. Nietzsche was a volcano of energy and inspiration, ceaselessly seeking new visions, and new horizons, and not only criticising the old and the dilapidated. His flashes of genius are as relevant today as they were in nineteenth century. As for example: "We possess art so that truth does not kill us."

Let us now observe that symbols in different religions may have a different range of powers and may set people's aspirations

and energies in different directions. In Buddhism the central symbol is the lotus flower, which symbolises radiance. But, furthermore, it distinctly suggests that out of the mud a beautiful flower can emerge. So often the Buddha is seen sitting on the lotus flower. This exemplifies the radiant qualities of the Buddha and of the flower. The tranquility of the Buddha's mind and the radiance of the lotus flower can emerge out of the mud. We are this lotus flower. But the road out of the mud is often difficult. Yet the radiance is ours — at the end of a well-travelled road.

In Hinduism, one of the central symbols is Shiva, a god of creation, destruction and re-creation. Sometimes he is represented as Shiva Nataraja, the dancing Shiva — of many legs and hands. This is the symbol of the continuous creation of the Universe, amidst ecstatic dancing. Shiva is pregnant with energy and exploding with it. He is both meditation and action. He inspires us to accept responsibility because he himself is supremely responsible. One of the mythic stories from the life of Shiva portrays Parvati, his consort, covering his eyes from behind in a playful moment. Shiva turns to her rather angrily and says: "Woman, you must not do that. This single moment between us may signify thousands of years on earth, in which terrible things may happen if I do not constantly watch over the world."

Each religion is unique and it develops its unique symbols to convey its conception of the Divine. Yet finally there is the tribunal of evolution, of life ascending, of the self-realisation of the Cosmos — to which all conceptions of divinity must submit. Each religion must contribute to the transcending qualities of human life, for this transcendence is part of the cosmic equation; they must contribute to the peace of the mind of humans, and to the peace on earth and in the Universe.

This is an imperative for science and technology as well. They are not outside the evolutionary matrix, they are not outside the

cosmic imperative of creativity. If, perchance, they step outside the cosmic matrix, then this spells out bad auguries for them... and for us.

THE PROFANE SCIENCE AND TECHNOLOGY

During the last three centuries, science has grown by leaps and bounds. The story of its unfolding is the story of a phenomenal success. But also a story of a phenomenal failure. Science has succeeded in changing our view of the Cosmos — from deistic to mechanistic. But it also promised to be a vehicle of salvation. Through a bold programme called progress, it promised prosperity and happiness for all, as well as peace on earth. In this promise it has failed dismally.

Science wanted to replace all former forms of knowledge as it considered them inferior to its own. Instead, it showed itself to be inferior. It has failed as it attempted to manipulate and control Nature. Also it has rendered itself incapable of seeing: of seeing what it was doing; of understanding the deeper meaning of what knowledge is about.

Science deliberately wanted to be secular which meant to be liberated from the constraints and controls of religion—its dogmas, its unreasonableness, its punishing authority. Yet the secularism of science turned out to be another form of confinement. More importantly, it proved to be a radical severance from the nexus of all sacred knowledge. Unsacred knowledge has become denuded knowledge, indifferent knowledge, sullied knowledge.

Knowledge should have never, never be used carelessly or against humans. For knowledge is part of the sacred light. Knowledge stripped of spirituality became separate from the sacred. Secular knowledge is profane knowledge; at times vulgar and destructive knowledge. The unseeing knowledge drifts from

one project to another; sometimes from one nightmare to another; so often only to gratify one's quest for power.

Profane knowledge leads to a profane world. In following its agenda, science strips reality of the sacred, of the spiritual, of the profound, of the mysterious. The world void of mystery is impoverished, degraded, dwarfed, washed out of its intrinsic beauty. The sacred is an inherent quality of the Universe. The term 'sacred' does not exist in the vocabulary of science. By not possessing it, science is unable to comprehend it. By being unable to comprehend it, it tends to push it out, or destroy it — as something of an obstruction.

This form of blindness is not merely an instance of an omission. It creates pathological qualities in the mind. Desecrated knowledge leads to madness. For this, knowledge is deprived of values and vision. In its intoxication with power, it leads to the fury of destruction. Our fractured and mutilated world is a consequence of the pathological mind, which is guided by alienated and profane knowledge, which desecrates everything it touches.

The fundamental choice in our times is not between insanity and sanity; but between insanity and sanctity. It is either madness or sanctity. Such is our choice. So-called common sense and ordinary sanity are not sufficient any more because they have become so infiltrated by the ethos (and pathology) of science and its poisonous rationality.

So it is either madness or sanctity. Whoever cannot see the starkness of this choice, is probably so effected by present pathologies that he considers them normal. But they are not normal. Human beings are repositories of the divine Light. Deep down we are all beholders of this light.

The reverence for knowledge being professed is not a pipe dream. It has been known in historical societies. In Egypt,

knowledge was revered as sacred. There was a conviction that knowledge was something special, a gift of heaven, a form of sacred light. Such a view was held by many societies, in pre-Egyptian times, within the Egyptian culture, and also later.

When Pythagoras returned to Greece, he was an Egyptian priest. He was initiated in Egypt, after many years of studying the mysteries of ancient knowledge. Subsequently, he brought to Greece his profound knowledge and the conviction that true knowledge should be well guarded, and it should not be displayed to everybody in the marketplace.

The profane consciousness creates filters of knowledge in its own image. We have been asking what kind of intelligence has created mechanistic filters...and other institutions, which are unfriendly to life and to the spiritual quest. The answer is: alienated consciousness, which we call secular consciousness, and whose other name is profane consciousness. We should remember, along with the Egyptian priests: profane consciousness leads to a profane world. Thus our problems are deep-rooted. Our crises lie in the very foundations of our knowledge. We cannot solve them through existing knowledge.

While discussing various orders of creativity, at the beginning of this chapter, we noticed that as new orders of creativity emerged after the AP, they added to each other, augmented the creative process of the Cosmos. This process continues with Creativity five, which represents the evolution of the symbols of intellectual understanding.

Let us be aware that older systems of knowledge were surrounded with the aura of the 'sacrum', were impregnated with cosmic meanings and significances, were held in awe, were tolerant of other sacred aspects and dimensions of the Universe.

The picture changes with modern knowledge or secular knowledge. This knowledge becomes increasingly intolerant of the modes of creativity other than its own. Consequently it suppresses (sometimes deliberately, sometimes inadvertently) the other modes of creative endeavour — especially in the spiritual realm and in the realm of art. These realms are viewed as 'less important' than the production of scientific knowledge. Thus, the hosanna of science over all has had a crippling effect on our artistic imagination and on our spiritual sensitivities. In this picture of the progressive mechanisation of the Cosmos, and the triumphant march of science, Nietzsche's aphorism: "We possess art so that truth does not kill us," acquires a special poignancy.

It is just a blessing of heavens that we are not yet all insane. What has saved us, and our sanity, is the existence of transcendent energy, stored in the works of art. But also in great books of humanity, which are continuously emanating ancient wisdom and the spiritual energy of the sages, prophets and poets. Sophocles, Dante, Shakespeare, Cervantes, Dostoyevsky — have held us in their tender embrace making us aware that the human condition is frail and fraught with dangers but stupendous nevertheless.

A great sustainer of our integrity has been music. Music is a peculiar gift of the gods. So ethereal, so intangible and yet so profound is its impact on the soul. Because of its ethereal and immaterial nature, it has been able to withstand the pounding of the mechanistic engines much better than other realms of human life. The sublime sounds of Palestrina, Monteverdi and Vivaldi continue to delight and sustain.

This resilience of music against the encroachments of tawdry materialism proved to be a blessing — in the high noon of technological expansion. Concerts of sacred and old music are immensely popular because they are renewing and sustaining at the core.

The greatest architects of Western music — J.S. Bach, Mozart, Beethoven, Wagner created their masterpieces under the shadow of technological progress. Yet their voices sing the glory of the transcendent — in defiance of the mechanistic madness.

THE LETHAL NATURE OF TECHNOLOGICAL CREATIVITY

We need to go to the core of things in determining why technology has been so destructive. Science and technology have invented quite a number of useful things. But the bottom of the technological cauldron is poisonous. We must see that quite clearly. Enough is enough. Enough superficiality and blindness. Enough of the cries: hurrah technology! The time for a deeper reflection has arrived.

Technology at its most exuberant and expansive is most unthinking. It is then that it fundamentally disturbs other creative orders upon which our existence vitally depends. Earlier creative orders supported and articulated each other. At its most aggressive, the technological order attempts to suppress other orders of creativity. Whoever has the eye to see, must understand that.

Let us now examine Diagram 3, which shows how creative orders of the Cosmos emerged out of each other, augmented each other, and continued the legacy of the previous orders while articulating them. Often, indeed, the new orders went beyond the existing ones — in their distinctive forms of creativity. In this diagram of cosmic creativity, the creativity of science and then of technology are latecomers, are branches at the top of the tree. For their existence, they needed the presence of the whole tree.

Let us observe quite attentively that something strange has happened at the top of the tree, at the level or the layers of creativity of technology. This creativity has been dynamic and relentless so much so that it not only has tried to diminish the importance of

other orders of creativity, but actually has attempted to disturb the structure of the whole tree, by encroaching on other orders of creativity.

Technology held such great promises...or perhaps it was our wishful thinking pertaining to which we made technology a great saviour and deliverer. As it is increasingly showing its limitations in the role of a Messiah; and is increasingly exhibiting its dark and sinister aspects, perhaps the time has come to re-evaluate its historic and evolutionary role altogether. Our new sober conclusion informs us that technology does not belong to the great creative orders of the Cosmos, which aid life and are benevolent to the unfolding of evolution at large. Technology has shown itself to be a *pathological form of creativity* — that is when it is judged by the orders of creativity, which existed before it.

Technology may be clever enough in inventing new gadgets, such as an electric toothbrush or a new software. But alas, it has also tried to tamper with the genetic makeup of crops and especially of living organisms. Technology is not wise enough to direct the destinies of human beings. The urge to make money through new bio-technological inventions is not sufficient to interfere with life's ancient matrix and its underlying laws! Such sacrilegious practices, attempt to alter the basic structures of life and primordial orders of creativity, bode bad omens for the human species. Those who are aware of what is at stake, must adamantly oppose the new barbarians!

Technological art has brought about many interesting inventions. But pushing these inventions as the only important things of our times, has muddied the waters by blurring the meaning of art, the meaning of beauty, the sense of aesthetic experience. Through these aggressive incursions into realms which are not its own, technology has been *a cosmic menace*. It has been like mistletoe attached to the top of the tree of

cosmic creativities. Although it has looked attractive, as mistletoe often does, in its exuberant growth, it has tried to suffocate the entire tree.

The tree of evolution was not created to host such parasitic creatures as technology. The phenomenon of the 'mistletoe technology' is dangerous. It undermines the existing orders of creativity. This is reason enough to be alarmed by the further uncontrolled expansion of technology.

We live in a universe of continuity and stability. If the AP had not built for stability, our universe could have collapsed many times over; actually, without ever permitting life to emerge. If biological creativity had not built for stability, our life-systems (each of us individually) would have been collapsing in our childhood. Indeed, it is doubtful whether such a complex system, as the human phenomenon, could have ever emerged in the conditions of instability.

Feverish creativity of technology increasingly looks like an anomaly of cosmic creativity. Perhaps it has been an experiment, which has misfired. Since this experiment has been pushed and controlled by unthinking and unseeing people, it is the responsibility of thinking and seeing people to stop it before it is too late. Technological progress is parasitic; 'mistletoe technology' is strangling the whole tree of life.

BEAUTY AS A NECESSITY
OF THE HUMAN
CONDITION

EARLY ENCOUNTERS WITH CONTEMPORARY ART

I have always been drawn to art, to its mystery, to its magic. I have been fascinated with the nature of art, and the nature of the aesthetic experience. While a student of philosophy at Warsaw University, I divided my time almost equally between logic, which was my main predilection, and aesthetics and the study of beauty, which charmed me with their allures.

In the late 1950s, I was choosing the subject of my MA thesis at the University. Philosophy was a great subject to study in Warsaw at that time. There were some outstanding philosophers who towered over the European scene. I had great difficulties whether to choose logic and semantics, on the one hand, or aesthetics and philosophy of art, on the other. Aesthetics came

so easily to me. It did not require any effort. Logic and semantics required great effort and diligence. I chose logic and semantics, persuading myself that I could always do aesthetics in my spare time, on the margin as it were.

And this is how it has been for the last forty years. I didn't betray aesthetics and the philosophy of art, but watched it from a distance, for a while with fascination, then with dismay. In the middle of 1960s I found myself in Los Angeles, teaching philosophy at the University of Southern California. I lived almost walking distance from La Cienega Blvd, which was the hub of new art, with lots of galleries out-competing each other in promoting new art.

Each gallery wanted to be a vanguard of the avant-garde art. After watching the scene for several years, I realised that something strange had happened to the avant-garde. It became a vehicle for promotion of commercial art. The avant-garde ceased to exist. The ever-new art became cold, cunning and clinical. Then it burst in a myriad of ephemeral movements such as minimal art, conceptual art, op art, pop art, art of the real. Then it started to be ugly art — assaulting our sensibility for the sake of new effects.

Then, in the 1980s, art started to be even more brutal, systematically assaulting our psyche — sometimes under the pretence that it was showing the disgusting in order to make us more sublime, or at least more comprehending. All possible idioms have been exhausted. But art had to go on. Artists were screaming inside. They tried to shock the public because this was all that was left of their art.

In the late 1980s Mrs. Roman, an artist, and a wife of a well-known New York psychiatrist, Dr Mel Roman, committed suicide as an art form. It was not just an ordinary suicide, but an elaborate ceremony in the presence of friends. Yes, the suicide was successful. Her picture in an elaborate coffin was well publicised.

I thought at this time that art was turning itself into pathology. This pathological art continued in the 1990s.

Thus during the last twenty years art has become increasingly unfriendly to humans. Traditionally art has been life-enhancing. In recent years and decades art has tried the opposite — to assault us, to murder us inside. In brief, art has become 'necrophilic', promoting death and not life.

THE CELEBRATION OF UGLINESS?

Let us look, in this context, at the existing relationships between business and art; also art, sponsorship and advertising. When we start to analyse with some perspicuity the values, which are being promoted in the marketplace, then some strange coincidences appear.

Actually, it requires some sharpness of perception to see what is going on — beyond the mist and confusion. But it is quite striking that the debasement of taste in art is strongly congruent with the destruction of the environment by big business and industry. Logically speaking there is no reason why it should be so. But there are contingent reasons for this state of affairs. The ethos of present capitalism seems to encourage low taste and the prevalence of ugly and destructive art. Why should it be so? Because by creating the attitude that it is all a mess, we live in an ugly, stinking, destructive world, the destruction of the environment and the uglification of the human world by industry and technology, are somewhat justified. The hidden premise is: since we live in a destructive ugly world, its further destruction, by industry and technology, is not so important; it is a part of the same ugly miasma in which we have found ourselves.

In this context ugly art, art glorifying the disgusting, the brutal and the destructive (which may be termed as necrophilic art) is an ally of the destructive industry. Now, if we go a bit

deeper, we realise that this ugly production, which is going on in the area of art, does not deserve the name of any art, even 'ugly art'. It is simply not art. It is a brazen propaganda for the status quo. It is thus a form of advertising carried through visual means.

Looking at the complex relationships, we mentioned earlier, we are now beginning to understand why rich sponsors are so 'eager' to support ugly and destructive art (which is often misnamed realistic), and why big sponsors are so reluctant to support art aspiring to beauty, dignity, and transcendence — which is often called idealistic or 'unrealistic'. It is in their interests to do so. The ugly pseudo-art, which attempts to debase us, which inhibits our criteria of discernment and our sense of beauty, makes us playable customers in the marketplace and ultimately makes us accept the messiness and ugliness of the world because 'this is how things are.' In this sense, the ugly pseudo-art is a tool of propaganda for the forces which are destructive and 'uglifying' the world — rather than helping it.

Thus looking with a penetrating gaze, we might wish to conclude that we witness the conspiracy of low consciousness; which is the conspiracy to debase our consciousness. I am far from endorsing conspiracy theories as an easy explanation of what has gone wrong with the world. But the scale and persistence, in which the ugly and the violent are pushed on us, in an orchestrated manner, should make us reflect.

Within this larger picture of manipulation and exploitation of the world, the ugly pseudo-art is just a tool skillfully used for the interests of those who care but little about art. And in this context, the 'artists' are the unseeing puppets, glad to be of use.

However, art cannot be blind. It has always been a vehicle of acute seeing, and at times of sublime seeing. Art has always been allied with life. If it rejects life, it rejects itself. Art void of life is self-denial of its own definition.

We are aware that we live in the times of confusion and moral crisis. But to accept this confusion is to add to it. To do nothing about our moral crisis is to deepen it. It is of little help to bemoan that, all coherence gone; and we must accept the mud and ugliness, violence and madness of the world. We do not have to! Only the weak will do so. We have other measures than the idea of, 'Man is wolf to a man' (*homo homini lupus*). We can and must re-articulate human nature, away from the ugly and destructive; and towards beautiful, transcendent, and noble. Here we have the words of Shakespeare from *Hamlet*:

"What piece of work is a man,
how noble in reason,
how infinite in faculties,
in form and moving, how express and admirable,
in action how like an angel,
in apprehension how like a god:
the beauty of the world,
the paragon of animals—"

And here is the perspective of the Buddha. In one of his discourses, the Buddha thus elaborated on the greatness of human nature:

"O monks, it is a great privilege to be born in the human form. If we imagine a turtle who lives at the bottom of an ocean; if we imagine that there is a rubber yoke which floats on the surface of the ocean being pushed by the winds, hither and thither, and if we imagine that the turtle emerges to the surface of the ocean once in a hundred years — would it then be easy for the turtle to insert his neck into the yoke? No, monks, it would not be easy. It is equally difficult to be born in the human form. And we must cherish this state of our being."

All existence is holy. And human existence is especially divine. We are aware of its frailty and its greatness. We are aware that we must cherish it. And fight for its integrity. Such a view is not archaic sentimentality. Rather, it is an expression of noble wisdom. Actually wisdom is noble; and nobility is wise. The merchants of ugliness have no voice in these matters. 'Unwisdom' cannot instruct wisdom.

Now returning to the question, which is the title of this section: do we witness the celebration of ugliness in our time? Not at all! What we witness is myopia of vision, combined with the dimness of wits and the corruption of values and human integrity. Such a concoction is dangerous because it is unseeing, arrogant and destructive. We need to use all the resources of our clarity, integrity and wisdom to overcome this state of muddiness and obtuseness. Our aim is always the same: clear vision amidst radiance and joy...while aspiring for beauty.

WHY IS IT DIFFICULT TO TALK ABOUT BEAUTY?

Beauty is so immediate, so obvious, so compelling. So simple. Yet so evasive, so nebulous, so reluctant to reveal itself when you try to catch it in the net of precise concepts, especially when you try to justify it with logic and bolster with physical descriptions. For beauty transcends logic; and all physical descriptions; and hard and fast definitions.

Beauty has served humankind well — as a support of things upright, enduring and wholesome. It has guided the human sense of order, of symmetry, of right balance. It has shaped our appreciation of what holds well with frugal means — for things beautiful are not superfluous, cumbersome, awkward and falling apart. It has helped to design our conception of heaven — for heaven must be perfect, beautiful, enduring, amazing

and mysterious. You cannot endow heaven with such attributes, if you do not have a concept of beauty in the background.

So the presence of beauty in our world has been essential, be it on the aesthetic level, on the spiritual level and on the practical level. Remove the guiding presence of beauty in the world of practical things, and you will see what havoc you have caused. Beauty is present everywhere, in one form or another: in human cultures, in civilisations, and in simple round huts made of straw in primitive societies.

Yet during the last two or three centuries we have seen the eclipse of the importance of beauty in Western society, and also in Western philosophy. One of the reasons has been that the tastes and styles in art have been changing so rapidly that both, artists and philosophers could not make sense of the changes — while applying the traditional concept of beauty. They could no longer appraise the validity of arts through the yardstick of beauty, which was so often the guiding criterion of the value of works of art. The demise of the traditional forms of art inadvertently brought about an eclipse of the idea of beauty. The trends were changing so fast that they left behind the traditional conception of beauty.

This was one reason. The second reason was subtler and more hidden. While science and technology were flexing their muscles, they wanted to diminish the importance of all phenomena and forces, which were outside of their domains. They did not have any special quarrel with beauty, for beauty was such a subtle phenomenon — not to be easily measured with a scientific yardstick. Well, for this reason alone it was not so favourably received.

But there was something else. Science, and especially technology, wanted people to appreciate things in terms of utility, efficiency, our capacity to control them. These utilitarian, mechanical criteria of the worth of things were pushed forth,

promoted, advocated...at the expense of things beautiful. The mechanisation of consciousness has led to the barbarisation of the human mind and of human sensitivities; and indirectly to the suppression of beauty. The overwhelming process of the mechanisation of consciousness is a fact. And the fallout of this process is the withering of our appreciation of the importance of beauty — in our lives and in the Universe at large.

In more recent times, during the last fifty years or so, especially through rampant abuses by commercialisation, beauty has received a battering from new quarters. In the orgy of incessant advertising, language has been twisted and washed out to an amazing degree. Words, especially pertaining to beauty, have been used indiscriminately and frivolously — until they have lost their original meaning and power. Language has been made powerless by its continuous abuse. This has caused problem to everybody who intended to talk about beauty, and other things spiritual and profound. So one of our tasks will be to renew the language, to charge it with new energy and enduring power, so that we are not swamped with the worn out cliché of the marketplace.

Yet another peril to the well-being of beauty emerged in the most recent artistic and philosophical trends. Post-modernism equalises everything. Everything is equally important; and equally unimportant. Ugliness is as important as beauty. Moreover, there is no way of distinguishing ugliness from beauty, that is to say, in the world in which everything is 'equal rubbish.' In this 'intellectual' climate, art has lost its head and succumbed to the notion that ugly is as important and beautiful, and that indeed the ugly should be celebrated as beautiful. Such absurdity!

Chaos in the mind leads to the chaos in art; and to the chaos in lifestyles. The result is that the barbarous, the brutal and the violent are aspiring to be the norm. This is further evidence of the

barbarisation of the human mind of which we have spoken earlier. Yet, amidst the fractured and nihilistic 'comings and goings', we need to resort to our inner clarity, and with a deeper insight reach for beauty again. Let us try to do so.

The time for beauty is always. The time for life is always— as long as life breathes. When it breathes elegantly, it breathes with beauty. For beauty is but a culmination of life when it reaches its apogee. Beauty is a daughter of life. Evolution is its mother. Human sensitivities are its nurses. Human mind is its father. When life breathes beautifully, it breathes with health and radiance.

Beauty is an expression of Joy. And Joy is an expression of beauty. Beauty and Joy are different. But they participate in each other's being. Joyless beauty would only be sad and unnatural. Yes, there is also austere beauty. But under the surface of austerity, a subtle smile of Joy is hidden. An appreciation of the austere beauty so often leads to wonder and amazement — which are acknowledged with a smile of Joy.

Joy without beauty would be a superficial thing, easily slipping into vulgar fun. Yet Joy does not wish to be just a superficial diversion. It wants to touch the ineffable, the transcendent and the miraculous. For this purpose, it needs beauty. When Joy emerged as the first God, it was already dreaming of its sister — Beauty. For Joy and Beauty are divine entities. They infuse us, and all existence with the sense of glory.

Evolution does not create spurious things. When it created beauty, it created an organ of its own blossoming. Whenever beauty flowers, evolution blossoms. Whenever beauty smiles, life is enhanced. Whenever beauty dwells in us, grace and happiness follow. For beauty is the flowering of evolution, and of life and of God.

Why is beauty a necessity of the human condition? Because when beauty withers in us, we wither. Because when we flourish

with radiance, with joy and beauty, life in us flourishes and rejoices in its being. Beauty is not an artificial flower attached to a pretty dress. It is part of the rhythms of our heart. It is part of the essence of our soul. For this reason, it shapes the quality of our being. Beauty is not only 'psychic oxygen', which nourishes our heart and soul. It equally guides our mind and reason. In the absence of beauty, when our minds are cluttered with trivia and ugliness, they create ugly lives and ugly environments.

Beauty is an important source of the energy of our life system. It is as invisible as the oxygen we breathe. And equally important. When we are deprived of oxygen, we suffocate and die. When we are deprived of beauty, we also suffocate and eventually die; although more slowly and from a different kind of death.

What I am saying is probably known to each of us. Yet we seem to have forgotten these important truths. We have lived in the strange somnambulistic dream of forgetfulness. We need to wake up, and in a truly Platonic fashion re-remember. The Greeks called this process anamnesis. May we awaken to the true reality of our being and see clearly the glory of the human condition.

THE HISTORICAL PERSPECTIVE ON BEAUTY

Beauty is like light and love — very natural for the human. The experience of beauty is obvious for everybody, just like the experience of Light or love. But catching in words this experience and the phenomenon of beauty itself is very difficult. Beauty is so close to us. When we try to define it, we look for it in far away places.

One of the first who took up the subject of beauty in Western philosophy was Pythagoras. Pythagoras was in love with numbers. He thought that the essence of the world could be expressed through numbers. Everything according to him is a matter of relationships, proportions and of harmony.

Harmony itself consists of right symmetries and symmetries are right proportions.

The same holds for the phenomenon of beauty. And for the objects which we call beautiful. Their beauty consists of symmetry, of the right orchestration of parts, of proportions and measures, which together compose harmony. *Beauty is objective*. It resides in the objects themselves; that is to say, the objects which are symmetrically and harmoniously composed. According to Pythagoras and some ancient Greek philosophers, mathematical relationships are able to precisely describe the well-composed objects, both in musical and visual arts.

This concept of beauty was cherished by Plato, Aristotle and a whole host of thinkers until the Roman times. Needless to say, different metaphysical systems of Plato and of Aristotle led to the treatment of beauty in different ways. The reason is that the idea of the form is understood differently in Plato and in Aristotle. The form, as we remember, is the key element. It determined the nature of things in which it is embodied, and therefore shapes the idea of beauty according to the understanding of the idea of the form. In spite of the nuances, and subtle differences between Pythagoras, Plato and Aristotle, the core is the same, namely that beauty consists in symmetry, in the harmony of elements, in the right relationships and proportions. Hence great art in the classical period was but a repetition of the known canons of beauty.

In the Hellenistic period which followed the classical period— in fact already in the classical period, starting from Sophists and Protagoras (Man is the measure of all things) — there emerged a new concept of beauty: 'Beauty is conditioned by human perception.' Beauty is in the mind, not in things. This is the subjective concept of beauty. Our mind and our senses together make things beautiful. From the Hellenistic period these two

concepts of beauty: objective (beauty resides in the structure of things themselves) and subjective (beauty resides in the structure of our mind and of our perceptions) have co-existed with each other, and not always harmoniously.

Plotinus introduced another concept of beauty. Plotinus was very dependent on Plato; so much so that for a long time he was indistinguishable from Plato. However, in the realm of beauty, he opened a new chapter. For Plato beauty existed in the world of imperishable forms. When the form of beauty inhabits an object, the object becomes beautiful. But beauty itself dwells in a trans-physical world.

Plotinus, on the other hand, also recognised physical beauty or sensuous beauty. For Plato, beauty can be apprehended only by the mind. For Plotinus — only through the senses. For Plotinus, although the origin of beauty is in a trans-physical reality, it manifests itself through the senses. He expressed his idea in the following way: "Beauty is a flash (reflection) of trans-physical reality in the senses."

This was a significant point of departure in Western aesthetics. For it showed that beauty is a *participatory phenomenon*. It needs an anthropocentric framework to manifest itself. Beauty needs the human to reveal itself. It is not by itself, and by its own self. There is no beauty without human agency. Beauty for the butterfly is quite different from what it is for humans. This is not a proclamation of subjectivism, which announces that beauty resides in the senses and is 'created' by man. Beauty is 'reflected' in the senses (and sensitivities); but itself is a flash of trans-physical reality.

It has been traditionally contended that Plotinus's is a spiritual concept of beauty; furthermore, that Plotinus anticipates the Christian idea of beauty, as derived from God. When Plotinus and Plato were lumped together, they appeared to be predecessors

of the Christian concept of beauty, according to which beauty comes from God.

The concept of beauty proposed by Plotinus perfectly harmonised with the Christian system of beliefs, which was to come. Beauty derives from God, descends from above and is an attribute of divinity. The spiritualisation of beauty fitted the conviction of the divinity of beauty. For many centuries the Christian world did not have any problem with beauty. The reflection of the trans-physical world in the senses, which was seen as beauty, was a manifestation and an evidence of the flash of God in the physical world of the humans. This concept of beauty held well as long as the Christian system of beliefs held together. But when the Christian belief system was undermined and the whole paradigm of Christian faith collapsed, both the Plotinus's and Plato's concepts of beauty were questioned and torn to shreds.

By questioning Christian ontology and denying that God is underlying all existence, we have undermined the ground for Plato's forms. But we have also undermined and actually dissolved all deistic forms of understanding of beauty, including Plotinus's: "Beauty is a flash from a trans-physical reality."

The average reader, sensitive to beauty, but not necessarily well-read in the philosophic literature, may ask: "How do all these considerations, although interesting in themselves, help us to live? How can they help us make our lives more harmonious and more beautiful?" This reader may also say: "We understand the problems with defining beauty. But we also understand, we ordinary people, that without beauty our life shrinks and becomes...a little hell. What is the way out of this quagmire?"

We shall precisely attempt to answer this question. However, we shall plead a little patience from the reader until we complete our historical survey and create a framework for a reconstruction.

We need to deliberately go slow because the subject is complex, its roots are intermingled together and its branches lead into different directions. Thus it is sometimes confusing to know where we were, and where we are.

It is important to realise that it requires philosophical reflection to understand why in spite of our physical riches, we suffer spiritual poverty. Why our bold and invincible science has led us to the destruction of the environment, and also to the degradation of beauty and the impoverishment of our individual lives? All these phenomena are connected. We are thus repeating what we have already said: *as we understand*, so we act, so we are; so we treat beauty, *so we treat spiritual life*.

Thus we allow ourselves a few words of recapitulation. Plato's answer was an insight of a genius: everything that is important and beautiful is divine. Divinity itself, by definition, is beautiful. It is from the divine that beauty derives its vital powers. This is magnificent theological shorthand. However, when the entire deistic theology, including Platonic is questioned, the whole foundation of beauty is undermined.

In the Renaissance period, this led to the resurrection of the subjective concept of beauty: "Man is the measure of all things", a motto which was very much feted in Renaissance. In the post-Renaissance period, beauty was further replaced with such terms as 'grace', 'sublimity', and 'nobility'. In the twentieth century it is weakened further. The eminent Polish philosopher, W. Tatarkiewicz finally remarked: "Beauty is today in decline."

What is the way out of the dilemma? How can we rescue beauty? Our question is really much deeper: How to resurrect beauty as the foundation of human life — without returning to Plato or to traditional God? How do we embrace beauty, cherish it, and live by it — without the mystification of beauty and its deification, as it happened both in the Platonic and in the Christian traditions?

Of course, we can relativise beauty, as we have done it during the last century: beauty is a predilection of the human mind. Whatever we wish to consider as beauty, it is our privilege to do so; even ugliness. This, needless to say, leads to intellectual anarchy and aesthetic nihilism. The final existential result is chaos of thought and a slow suffocation in the fumes of ugliness.

We can hear a reply from a post-modernist: "And why not ugliness? It prevails in our present world and is an obvious fact." The shortest possible answer is: because ugliness is carcinogenic. It disintegrates us. It undercuts our vitality, hope, clarity and the cohesion of our life. Thus ugliness is not 'an obvious fact', but pathology.

Simply stated, without beauty, we wither. What is then the road to the rehabilitation of beauty? And through it to the rehabilitation of the vitality of the human condition? I will try to outline such a road in the briefest possible manner.

THE EVOLUTIONARY CONCEPT OF BEAUTY

Between the lofty but untenable absolutism, which imagines that there are ready forms of beauty in some Platonic heaven, and the rapacious and devouring relativism, which considers beauty to be a mere figment of our subjective desires, there is the third way, which transcends both — absolutism and relativism — which, nevertheless, incorporates some insights of each.

What I wish to propose is the *evolutionary conception of beauty*. Beauty is neither absolute nor relative. But universal: universal within a given species and a given culture. Within a given species beauty is universally recognised and shared. Beauty is species-specific. A given species does not change from day-to-day. But it undergoes evolution. Even its dominant characteristics evolve. There are therefore no absolutes. Nothing is absolute in this

evolving Universe. Pythagoras and Plato imagined that there are some unalterable absolute constants. Heraclitus contended, on the other hand, that everything flows and changes. Evolution has proved Heraclitus right.

The evolutionary idea of beauty is a new perspective. We shall need some time to absorb its content. It will require several steps before we shall be able to show how beauty — with its compelling glory and shining radiance — could emerge from below, from the bowels of the evolutionary process, like a lotus rising from the mud. We shall now retrace this arising, by looking at the various steps of the unfolding evolution especially at the steps which lead to the articulation of beauty.

When we look at the ascent of life, we see the formless acquiring a form, we see the incoherent becoming coherent, and we see the inarticulate becoming articulate. The grandeur of life comes through the articulation of 'structure'. Structure is the key to understanding the evolutionary concept of beauty. From the structures of inorganic life, evolution builds the structures endowed with life, and then it builds the structures of beauty through the process of continuous transcendence. Ultimately, structure becomes a ladder to heaven. At this point, life acquires spiritual characteristics. It now presses forward to make itself more divine. Let us see how this process manifests itself in evolution.

The articulation of structures is a sea endlessly rolling for eons of times. Out of this process of rhythmic rolling came all the forms of life, including human life, and the forms of architecture humans created. The continuous waves of the oceans created the shell — on which the imprints of its rhythm are so visible. The shell is the original geometry of the Universe. In the beauty and exquisiteness of the shell — its serenity and symmetry — we witness the anticipation of future temples of beauty.

It is a part of the same evolutionary rhythm — from the shell to our ribs, and then to the columns of the Parthenon, one of the greatest temples of all times. In creating the shell, evolution was already toying with the idea of the temple, and was already creating a rudimentary paradigm of beauty. Temples are among the most significant structures evolved by human beings. They embody and express the great rhythms and symmetries of life.

The secret of structures and their greatness lies in their 'symmetry'. We find these symmetries fascinating and irresistible because deep down it is evolution in us that responds to its evolutionary epic. Thus we have the key to understanding beauty in evolutionary terms: the objects of beauty are those, which are invariably based on intricate rhythms and symmetries. Pythagoras was right in emphasising the importance of symmetry. But he did not see that all symmetries are of an evolutionary origin. These rhythms and symmetries are life-enhancing. For this reason life in us responds to them so readily. We ourselves are part of this stupendous evolutionary epic, and our lives are based on and carried through endless cycles of rhythms and symmetries.

Even before the oceans became the cradle of the amphibian and mammalian life forms, the driving force of the evolution of the Universe had chosen symmetry as its basic modus operandi. All scientific laws (as we have conceived of them) bear exceptions and therefore none is absolute or ultimate. Except the law of symmetry. Only the law of symmetry holds universally: to every element there exists a contrasting element, which holds the original element in balance. This is astonishing and awesome in its simplicity. Balance and harmony are based on symmetry. This is the root of our experience with beauty.

The primordial symmetry is then woven into life-enhancing rhythms, which form the basis of life-enhancing structures.

The rhythm and symmetry may be altered, modified and played with — as they are in the great works of art and in life itself, particularly those forms of human life which are lived to the brim. In brief, the beauty of man-made structures and Cosmos-made structures has its explanation in the life-enhancing qualities of the rhythms and symmetries of the Universe itself. We do not need the heavens above to explain the ascent of beauty. The evolutionary process itself is sufficient. Furthermore, it is inconceivable in our day and age to explain beauty outside the evolutionary process. Evolution is the maker of life, of things of beauty, of things divine.

The radiance of life is the coherence and endurance of structures which are not only capable of withstanding various stresses of life but are also capable of an astounding variety of performances of which early biological life could not dream. When the range of these performances is so enlarged that the human structures blossom forth with the religious significance (through temples and religious rituals), through the objects of art, and poetry (for poetry represents unique structures of the Universe), and through other specific human structures, then human spirituality arrives and beauty becomes a vehicle of the sacred and the spiritual.

Beauty is a unique force of the Universe, one of the astonishing wonders which the Cosmos has created. It is not a necessary force but a contingent one. It did not have to be brought into being. But once it came to existence (and was articulated by subtle human sensitivities), *the Universe was never the same*. Indeed, it is difficult for us to conceive the coherence and meaning of the Universe without the idea of beauty lurking at the background. All meaningful descriptions rely on the criterion of coherence, which is nothing else than a form of harmony — which, in its

stead, is a form of beauty. Deep down, beauty is a shining beacon of clarity, luminosity, sense, order and coherence.

Because of its extraordinary nature, we easily call it 'divine'. For this reason it was natural for Christianity and for Plato to conceive of it as coming from heaven. But the origin of beauty is evolutionary. It comes from 'below', like everything else, we can therefore say, in a somewhat pedantic and discursive manner:

Beauty is but a collective term, summarising all those processes through which structures have gradually acquired more coherence, endurance and capability — until they shine through with new qualities: aesthetic, religious, artistic and ethical.

The incomparable Plotinus, whom we have already discussed, has said:

"The More Beautiful a Thing is
The More Intensively does it Exist."

This is a stunning expression. Our first reaction is: 'Yes.' But until recently we have been unable to find a satisfactory explanation why it could be so. We have now arrived at a rational, evolutionary explanation of Plotinus's dilemma. Why is it so that the more beautiful a thing is the more intensively it exists? Because it possesses more evolutionary life in it; because it manifests the triumph of the evolutionary unfolding. Beauty represents evolutionary radiance — coherence, articulateness and performance born of the relentless zest of life to make more of itself. Beauty is the result of an upward process of relentless transcendence.

Thus, a more beautiful object exists more intensively (in comparison with a less beautiful one) because it literally contains more life in it; more life in the evolutionary sense, more life in the sense of radiance which the process of creative unfolding has brought about.

Our entire discussion directly applies to human lives. The more beautiful the life of a human the more intensively does it exist: by incorporating the richness of the evolutionary life-flow, by partaking in a variety of life-enhancing forces, by affirming and celebrating life.

The break up and disintegration of beauty is the break up of the coherence of human life. The loss of beauty — in our times — is tantamount to a loss of meaning, which follows the loss of coherence. The violence done to beauty has been violence done to our souls and lives. The loss of spirituality is one of the consequences.

Beauty, meaning coherence are the links of the chain. Beauty is not a luxury but a necessity of human life. As oxygen is indispensable to our lungs so beauty is indispensable to the inner coherence of our lives. Beauty is not fiction but an extraordinary blessing of evolution. Beauty strengthens and fortifies our life because it is a vital force. Beauty makes us aware of the meaning of divinity. Great works of art are impregnated with beauty and significant energies of the Cosmos, which is in turn, received by sensitive humans. Beauty is an indispensable link connecting life with joy and divinity.

Plato was right to connect beauty with divinity. But he got the whole process backward. He assumed that beauty comes 'downwards' — from the Platonic heaven, instead of seeing that beauty and divinity arise from 'below', grow from the bowels of life; are the stuff of life; are the acts of life, allowing it to blossom with a new radiance.

Beauty is not only an aesthetic description of objects but also an 'evolutionary' description, a recapitulation of the process of transcendence, an acknowledgement of this stage of life when it reaches such an extraordinary coherence and radiance that it shines with the blush of divinity.

The Importance of Beauty

The two ancient conceptions of beauty have fallen to the wayside. One was objective — beauty comes from the ideal source above, and dwells in objects. The other was subjective — beauty is in the eye of the beholder; the human mind makes things beautiful.

We are now entering the period of evolutionary understanding and evolutionary conception of beauty. Beauty is species-specific; it is inter-subjective. Particular individual minds recognise beauty as such because individual minds partake in the mind of the species. The qualities of the species have been imprinted on our minds and on our sensitivities. For this reason our perception of beauty is inter-subjective.

Our sense of beauty is anthropocentrically conditioned. We have to use human senses and sensitivities to recognise beauty and to create it. Our senses and sensitivities are not our individual properties. They have been shaped and developed by the species and the whole evolution. Hence our conception of beauty is inter-subjective, evolutionary and cosmic.

Beauty is a product of evolution. It exemplifies such forms and structures of life which achieved an unusual degree of coherence, clarity, integration and luminosity; and through which it shines with inner powers. Beauty is the glory of being which has transcended its early limitations. Beauty is this form of unfolding, which shines through — with its energy and with its accumulated life force.

As life develops, it creates more coherent and enduring structures. As these structures become more and more versatile, they blossom forth as symbolic structures of art, of religion, of human spirituality. The structures of great temples epitomise the spiritual ascent of evolution. The physical has been subtly transformed into the symbolic and spiritual. Seen in the evolutionary ascent, beauty is the structure of coherence, of endurance, of life-giving, of radiance.

The age-old dilemma — why more beautiful objects exist more intensively than the less beautiful ones — is now resolved. Because there is more evolutionary life in them. Beauty means life. The more intensive form of beauty contains more layers of life. When beauty atrophies, human life atrophies. A crisis of beauty is a crisis of man. A culture, which has lost its sense of beauty, has lost its sense of purpose, has lost its sense of spirituality.

Beauty does not exhaust the sense of the spiritual, but is an important aspect of it. Spirituality and beauty are hymns to the Divine, are parts of the music of the Divine. The Divine manifests itself through the structure of beauty. Beauty is an outward appearance of the Divine. But this appearance is not accidental. It is essential to the existence of the Divine — as long as it manifests itself through the human mind and soul.

In our journey of the reconstruction of the meaning and vital powers of beauty, we have discussed Plato and Plotinus. Plato cannot be ignored because he looms large over the entire history of philosophy. We need to transcend this shadow in order to be able to see and experience for ourselves. For all his greatness, Plato did not have an inkling of evolution. Hence his obvious limitations. Plato is magnificent — both for his insights and his mistakes.

Plotinus is magnificent for another reason. His agenda is open. His views are a bit cryptic and under-defined, and yet so potent. He suggests rather than dogmatically stating (like Plato). At the time of Plotinus (five centuries after Plato and seven centuries after Pythagoras), it became clear that the views on beauty of his predecessors were inadequate. Thus Plotinus constructs his own path. In the process he unknowingly paved the way for the evolutionary idea of beauty.

The process of the rehabilitation of beauty, which we undertook, required perseverance. Throughout history, beauty had been veiled in different cloaks. To bring beauty to its true

radiance and to its cosmic significance, we had to demystify it. We had to release it from the tentacles of Pythagoras and then of Plato. We had to release it from the overbearing dogmas of Christianity. And then from the pernicious and crippling influence of subjectivity, and finally from the claws of destructive relativism and nihilism.

Beauty is one of the cosmic forces. The Cosmos takes care of its offspring. Because of the great importance of beauty to the well-being of the species, and to our individual lives, it is bound to bounce back and shine. Beauty is too strong and too cosmic to be suppressed by the misguided prophets of darkness and their superficial gibberish. Yet beauty is tender. It can be easily mutilated. Great care and sensitivity on our part are required to cultivate it. But it reciprocates handsomely. Those who cultivate it become tender and beautiful themselves.

Our sanctity will prevail over our insanity. Have no fear. Beauty will never leave you. Beauty is embedded in the structure of all coherent life. You are a structure of exceeding beauty. You are a paragon of complexity and coherence, which evolution has worked on for eons of time. The cosmic symmetries are underlying your entire being. Your mind is charged with subtle sensitivities, which enable you to read the Universe. You react to beauty in a spontaneous way because cosmic cycles of beauty are circulating in you.

Awake to being a piece of beauty. Awake to being an integral part of cosmic beauty. The cosmic structures of beauty, embedded in the rhythms of the shell, in the columns of the Parthenon, and in your own body are strong and enduring. They will prevail over the unseeing age to shine again and again.

TRANSCENDENCE — A MAJOR COSMIC FORCE

TRANSCENDENCE AND CREATIVITY

Our story of creativity, Light and evolution continually helping each other in the unfolding destiny of the Cosmos is far from finished. In the previous chapters, the word 'transcendence' appeared from time to time, not as a main factor but in the background. It is time to bring out transcendence to its full glory — as one of the cosmic forces shaping the destiny of the world, in all spheres of existence, including human life. It is through the force of transcendence that we can explain this relentless drive of evolution to always go forward, as well as the relentless thrust of our individual life to go forward.

This imperative of transcendence is built into the nature of the Cosmos, as a kind of cosmic necessity. Transcendence is a part of the Nature's evolution and of the Cosmos itself. Let us say it more adequately. Transcendence, creativity and evolution are not

separate forces, each working on its own, but parts of the cosmic team, helping each other and defining each other.

We have already established that creativity is the essence of the unfolding Cosmos. Yet we know that creativity can burst uncontrollably in various directions. It can exhaust and spend itself in chance and whimsical experiments. Why does, in the overall scheme of things, creativity not fizzle out in ephemeral or chaotic epicycles? Why is evolution continually unfolding itself and the Cosmos continually unfolding? Precisely because it works hand in hand with transcendence. Transcendence and creativity are inseparable from each other, are twin sisters. Together they the are divine cosmic forces shaping, moulding and ecstatically driving the Universe to its higher glory. This aspect of being twin sisters also means that transcendence cannot work alone, without the aid of creativity. For unaided, transcendence could very well burst into continuous chaos. It is precisely through creativity, *which gives form, coherence and meaning*, that transcendence goes somewhere — in organised patterns and orders.

There is something inexorable in the phenomenon of the unfolding of life which out of necessity must continually transcend itself. Bacteria could have very well settled in their evolutionary niche and stayed there forever. It is such a 'nice' form of existence. But they had to go beyond. There is something extraordinary and sacred in this spectacle. Brian Goodwin is right when he describes living forms as engaged in a sacred dance generated by the interaction between organisms and the field in which they are embedded. Chemical explanations cannot do justice to this phenomenon. Physical explanations, through the four basic forces, are even more mute, and unsatisfactory.

Transcendence has not only driven bacteria and lower forms of life forward and upward, but has also been driving human beings to make something of themselves, far beyond what

they were before. We cannot understand our own life unless we accept that it is driven by something much larger than our comfort and material satisfaction. There is something inexorable in human life, which makes us continually go beyond all previous accomplishments, that makes us transcend all previous stations. This is felt in all human beings. Even ordinary humans grope for something larger, long for wider horizons — which is exactly a response to this larger call of the force of transcendence.

There is something inexorable in art, which makes it continually transcend all previous horizons and accomplishments. Artists are supremely sensitive to the calls of transcendent destiny. They simply cannot perfect the idiom and repeat it over and again. This would be a betrayal of the divine spark, which is felt within and which calls them to go beyond and beyond.

We are slowly bringing the reader to the realisation that transcendence is of such major importance in the evolving and unfolding Universe that without it, the Universe would hardly move. Therefore it is quite clear that without recognising the force and the imperative of transcendence in the story of the Universe, it is hardly possible to understand what has happened and what is going on; in particular, it is not possible to understand why the Universe did not go backward or disintegrate altogether.

Furthermore, why should any form of being, any form of life move forward? Why should life evolve higher forms of consciousness? Why should we try so valiantly to go beyond? If the force of transcendence did not guide the whole process? But it does! In this sense, transcendence is the force that underlines all forces.

Once we accept transcendence, all is clear and coherent. It becomes clear why artists are driven by the divine spark to go beyond; why early forms of life were engaged in the sacred dance to transcend their early limitations; why cosmic dust

transformed itself into galaxies and then the first molecules of life. There is something inexorable in the way the Cosmos has 'chosen' to unfold. There are subtle balances in the composition of matter, space and density — all regulated by what is sometimes euphemistically called 'cosmic constants.' The proper name for these 'constants' and for all the propelling forces of the Cosmos is transcendence.

If we do not postulate transcendence as a living force, then any sense of self-perfectibility, any idea that life evolves and goes upward, is a complete enigma and a mystery. With the idea of transcendence, we have the background through which we can explain: this sense of the divine spark among artists which drives them on and on; this sacred dance within life forms; this awareness among humans that they must go forward and upward.

The omnipresent force of transcendence could be conceived as a kind of vector, a sharply pointed arrow, which drives the whole process. The vector of transcendence is manifest in all the evolving stages of the Cosmos, including our spiritual life. We should be really aware that the force that has driven the Universe through eons of time cannot be proven in a scientific laboratory in which we screen blood tests for possible diseases. It cannot be proven in any scientific laboratory. The question of scientific proof is simply out of the question. We have to have the courage of our simplicity and declare with Einstein that we are seeking the simplest possible theory, which makes sense of all the manifest Universe, including our own life in it.

It is time that we connect these deeper underlying currents, the forces which are invisible, but which guide all visible phenomena. We have already emphasised that evolution is a creative phenomenon. But evolution has not worked by itself. Without the presence of transcendence we would have not known the meaning of evolution. For everything would be a messy

change; perhaps devolution, perhaps disintegration, perhaps just 'going in circles'. But life has broken through so many of its limitations to flourish in ever new forms.

Transcendence is a wild force. Its energy is inexhaustible. For this reason, it needed to be 'tamed'. Hence the necessity of creativity, which organises the bursts of transcendence into distinctive forms and patterns. The pursuit of evolution, and of all evolved forms of the universe is the pursuit of 'structures', through which the successive dramas of the Universe are played. Creativity is thus an exquisite artist, which moulds and forms the energy of transcendence into structures of coherence — which become structures of performance, of beauty, of understanding.

As we said before, the three realms — evolution, transcendence, and creativity are not separate from each other, but overlap each other, co-define each other.

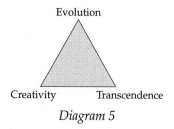

Diagram 5

SCIENCE, EVOLUTION AND TRANSCENDENCE

In the seventeenth century, mechanistically inspired science created the picture of the universe in the image of a clock-like mechanism. Science has not yet liberated itself from this picture. It is still there, in the middle of the square box, which it has helped to create. Now this picture has been abandoned by the new physics. But the mechanistic ethos of science has not been abandoned. The engrained metaphor of the world as a clock-like mechanism is still strong and dominant. Part of the ethos of science is the reductionist

attitude: you must try to reduce everything to ultimate atoms. Whether they are solid bits of matter or some invisible quarks. The old ghost is still haunting the edifice of science.

For this reason science has so many problems with its identity. One of the problems is the meaning of evolution itself. On the superficial level, science accepts evolution. After all, Darwin was a scientist. Darwin discovered evolution. Therefore science would take credit for the discovery of evolution. The logic used here is a bit primitive. But this does not bother science — as long as it can take credit for the discoveries we are proud of.

Actually, the attitude of science towards evolution is more alarming and superficial than hitherto suggested. It wants to recognise evolution. But only as long as it can squeeze it into scientific boxes; which is to say, as long as it can 'reduce' the evolutionary process to either deterministic necessity or pure chance. Thus science is content to accept evolution when it can be handled by molecular biology. Molecular biology, as we remember, attempts to explain all evolutionary processes through their molecular sub-structures, thus through chemical and physical processes alone. What finally triumphs in molecular biology is not the explanation of the exquisite and the complex in life structures but physics and chemistry.

Now, evolutionary biology looks at this whole matter differently. It contends that the evolutionary process is creative par excellence, in the primary sense of the term 'creative'. The two disciplines, molecular biology and evolutionary biology, have been at loggerheads with each other for quite a while. The scientific world (or shall we say, the prevailing ethos of the scientific world) has been subtly supporting molecular biology as more scientific.

An eloquent case in point is the book, *Chance and Necessity*, written by a Nobel Laureate, Jacques Monod. This book has attained the status of a classic. The scientific interpretation of

evolution consists of the claim that all that happens in evolution is the result of either chance or necessity. There is no room for creativity or transcendence. Why should this interpretation of evolution be considered scientific? Actually, neither the term 'chance', nor the term 'necessity' are 'scientific' terms. They do not have any well established meaning in the scientific language. They do not belong to any of the established scientific disciplines. The term 'chance' is really ambiguous, if not meaningless. What does it mean to say that things in evolution happen by chance? We simply do not know. The situation is not much clearer even with the term 'necessity'. 'Necessity' does not have any clear scientific meaning. It is a term borrowed from philosophy...or perhaps theology. In brief, the so-called scientific interpretation of evolution, through chance or necessity, rests on shaky ground indeed.

DOES SCIENCE UNDERSTAND EVOLUTION?

Let us now come to a more serious problem of science vis-à-vis evolution. The point is that science has never understood the meaning of evolution. It has used evolution as a hatchet against religion. The discovery of evolution was viewed, in the second part of the nineteenth century, as a blow against religion. Yet, and this needs to be emphasised, science has never thought through the deeper meaning of evolution. If all life is evolving, if continents change their nature and place and are evolving, if knowledge itself is evolving, what is the main conclusion of all of this for science? Simply to understand that the truly significant knowledge of the Universe is evolutionary in character, because only then can it understand the nature, the peculiarities and genius of the evolving Universe. This understanding would require changing the entire frame of reference of science. Existing science assumes that the Universe is static and frozen. And it tries to photograph this unchanging Universe, fragment by fragment,

atom by atom, through its static concepts. The point is that the Universe is moving and evolving all the time. What we need is not separate shots of its frozen structure, but a moving film — showing 'how' things are changing and 'what' is responsible for the changes. We need dynamic evolutionary concepts (not static ones), which would reveal the nature of the evolving world. Such concepts would have to be based on the *logic of becoming*; not on the static logic of being, on which the concepts of present science are based. These new dynamic concepts, married to evolutionary logic, would inevitably lead to new forms of understanding, to a new landscape of knowledge — evolutionary knowledge, with vast consequences for the understanding of the Universe and of our own life.

And here is the main point. Science has never understood this aspect of evolution, has never conceived of the idea that evolution requires evolutionary thinking. Specifically, it must apply evolutionary thinking with respect to all the phenomena it studies. It has been stuck in its mechanistic grid. Instead of broadening its categories of thinking along evolutionary lines, it attempts to reduce evolution to its mechanistic precepts.

Any comprehensive model of anything, let alone that of the Universe, is a philosophical model. The theories or models of everything, which claim to be scientific, are not; they constantly borrow their ideas and concepts from philosophy and theology, usually not being aware of it. They constantly make claims and assumptions beyond the jurisdiction of science. In addition, they are based on some trans-rational 'idols'. These idols are mystic character. They are never proven for their scientific worth. But curiously, very often are considered a part of the proof. Among the idols of present *theories of everything* are 'particles', 'consistency', and 'mathematical equations'. They have a divine status in present theories. They are beyond any discussion or doubt.

They are the untouchables. They are the hidden metaphysics of the present physical models.

Yes, consistency is nice. But why should the Universe be consistent? And consistent according to whose mind, and assessed by which criteria of consistency? Mathematical language is a beautiful thing. But where is the proof that we can 'adequately' describe the universe by mathematical equations? The dream of Pythagoras and of Galileo is but a dream. We do not mind dreams among those who search for the ultimate architecture of the Universe. But let them not pretend that their dreaming is a scientific proof! They must not claim that they know *the truth* — while they are only dreaming.

ALICE IN WONDERLAND

This whole enterprise of capturing the Universe in a mesh of mathematical equations, is an 'Alice in Wonderland' project. The mathematical physicists are on the other side of the mirror. They dream about the perfect consistency of the entire world. We human beings are on this side of the mirror. And we want to understand.

The fundamental thing is about understanding. What do you understand if you do not understand the meaning of evolution within the Cosmos and within your own life? What do you understand if you do not understand the meaning of creativity in the Cosmos and within your own life? What do you understand if you do not understand the meaning of transcendence, the force moving the entire Cosmos and quietly guiding you?

Understanding is species-specific, and not a category specially reserved for mathematical physicists. Yes, you do understand something by mapping reality on the coordinates of the four basic forces of physics. But what you leave out is so enormously important. That is how mathematical models,

purportedly expressing theories of everything, represent only a caricature of understanding. We possess this understanding, which we possess. And we require knowledge, which is species-specific — for a given time of history.

There is an order of understanding in 'Alice in Wonderland.' And it is a deliciously funny order. But it is not an established, historically developed order of human understanding. Understanding is a noble and ancient subject. Some great minds of various cultures have grappled with it for millennia. And they left behind impressive reflections and theories. Suddenly, mathematical physicists propose that they have a monopoly on it. And their understanding of the meaning of understanding should become a new canon. Behold gentlemen! This game is going too far.

I myself am not immune to the charm and elegance of mathematical equations. I have taught symbolic logic at the university level in the past. For a spell of time, I thought it would be a good idea to have mathematical models expressing the essence of everything. As I looked deeper into the limitations of these models, I became disenchanted with them. For they do not represent the true understanding of the human species what is presently called human knowledge. They are dreams on par with the reality in *Alice in Wonderland*. The author of the story of Alice was a mathematician (interesting, isn't it?). But he was aware that he was describing an imaginary reality, not a genuine one.

Now, I grant you that nowadays it is a real problem to distinguish which are imaginary and which are genuine models of the world. It is indeed so. However, not every consistent fiction deserves to be called a model of reality. What are the necessary criteria that we must use for distinguishing the genuine models from the fictitious ones? This is another good question.

This question, again, should not be decided either by mathematicians or by scientists.

TRANSCENDENTINO ENTERS THE STAGE

There was a time when I played with the idea of introducing to physics a new particle, which would convey the meaning of transcendence, and which would complete the existing Standard Models. Well, I thought to myself, if physicists can postulate invisible (and perhaps not detectable) particles called 'gravitons', why can't I think along similar lines? The idea just emerged in my mind — why not introduce transcendence as a would be particle, or perhaps as the fifth force of the Universe? I called this particle 'transcendentino'. I am aware that my postulated particle does not have any physical dimensions; and it is unlikely to be traced in these huge super accelerators, which hunt for rare particle. But these things do not worry scientists any more. They postulate particles for whose existence we have never found any evidence in any 'physical' sense. They do so for computational convenience, or to put it in a simpler language, because these particles make their models more coherent; make the whole thing fit together — according to their accepted assumptions.

But then such is my case. My transcendentino, or the fifth force of the Universe which I call transcendence, fits in my evolutionary-transcendent model. Moreover, I can legitimately claim that all other models, which do not include transcendence and creativity as the essential underpinning of the Universe, are nil and void. In my opinion, the evidence of the existence and importance of transcendence is attested by the stupendous unfolding of the whole Cosmos. Thus the evidence is overwhelming.

I played with the idea of transcendentino for a while. Then I caught myself playing the same reductionist game as

the physicists. I had been trying to 'reduce' the enormous cosmic force of transcendence to some particle. I started to laugh at myself. What a charming naïveté, I thought. But I also became immediately aware what a powerful and seductive force the present physical models are. They try to suck you in and dissolve you in their language and assumptions.

This whole thing of pretending that we can understand through reductionism is simply not working. The entire idiom of our understanding must be changed — away from the mechanistic grid and static categories. Understanding is a subtle and profound thing — dynamic, evolutionary and creative. Reducing it to the moronically simple, represents moronic understanding.

There have been some distinguished scientists who attempted to release themselves from the straitjacket of atomistic reductionism and who acknowledged the role of evolution and creativity. Among them are Illya Prigogine and Roger Penrose. Prigogine emphatically insisted that evolution is all-important and that the real story of the Universe is one, which concerns unique unrepeatable events, and which happen only once. Among such events were the beginning of the Universe, the beginning of life and the birth of human consciousness. Roger Penrose, on the other hand, insisted that true science shall be one, which will be able to explain the meaning of history, the meaning of love, and the mystery of the human mind.

This is the way of the future. Sooner or later science will recognise its mechanistic tentacles and, in the process, gain indepth comprehension. Sooner or later science will no longer be called 'science'. Many have noticed that the present image of science is worn out and its meaning is tarnished. Yet, we do possess a perfectly good term, 'knowledge,' which existed before science came on the stage and which may very well be used after science has relinquished its imperial claim to knowing

everything best. We thank science for what it has done for us. We are on the way to further cosmic transcendence. We shall transcend the limitations of science and its present modes of thinking. For such is the imperative of the transcending Cosmos.

TRANSCENDENCE AND RELIGION

In religious discourse, transcendence has a well-established meaning. It is a noble term. It designates a process of ascension from the earthly realm to heaven, according to the conception of heaven of a given religion. Transcendence usually signifies a spiritual process. The process of transcendence, or the one of reaching God is at the same time a process of spiritual purification. So far so good. Yet, as time has gone on, the meaning of transcendence has been peculiarly narrowed to signify the religious transcendence.

We need to liberate the meaning of transcendence from its excessively narrow religious connotation. For transcendence is truly a *cosmic process*. The legendary prophet and sage of ancient Egypt, Hermes Trismigistos, was aware of the cosmic dimensions of transcendence when he summarised his teaching by: Transcend. Transcend. Transcend!

Transcendence is an unending drama of ever-new unfoldings on the way to the ultimate self-realisation of the Cosmos. The rhythm of the Universe, punctuated by the spasms of becoming, which are the bursts of transcendence, is holy. Truly, religious transcendence is a holy process. But then, all transcendence is a holy process. It is just magical and amazing that things can change their nature to such a degree that they can entirely transmogrify themselves and become what they were not before. This cosmic rhythm of transcendence embraces everything. Religion is a part of this rhythm as well.

Actually, religion has been very sensitive to the rhythm of cosmic transcendence. So much so that *it has appropriated the*

whole process as its own. Here lies the answer why religion and transcendence seem to be so closely knit together. By creating specific filters (as a unique way of connecting the human with the Divine), religion has incorporated the meaning of transcendence into its own filters. And this is the reason why, in traditional discourse, we cannot liberate the meaning of transcendence from the meaning of traditional religions. But, we can do so on a higher cosmic level. Simply because cosmic transcendence is much larger than religious transcendence. Cosmic transcendence has given rise to religious transcendence; and not the other way round. Cosmic transcendence had been performing wonders for eons before organised religions came into existence. And it will continue to perform its wonders after institutional religions cease to exist — by being dissolved into higher forms of transcendence.

We shall not begrudge institutional religions when homage is due to them. Religious transcendence is a game worthy of a candle. It is undoubtedly a cosmic quest. To seek God, to divinise the Universe, to make our frail beings into divine creatures, to touch heaven in our mystical states are manifestations of humans as cosmic beings.

Transcendence is a precursor of all religions. Out of the primordial intuitive instinct that things are unfolding and ascending to some more refined states of being, there grew the longing for the infinite, for the immortal, for God. All great longings and ideals of humanity have their sources and roots in the very meaning of transcendence.

What was the first burst of transcendence? It was the original fireball known as the Big Bang, or whatever name we want to call it. This first split-second after the Universe came into being was when it started to give birth to itself. In truth, the Universe has not yet been born. *It is still in the pangs of birth.*

The continuous fire of transcendence of the Big Bang is still with us. The Big Bang was the beginning of transcendence. To understand the meaning of the Universe is to understand the meaning of transcendence. To understand the meaning of transcendence is to understand the first split second of the big fireball.

The Universe is not yet fully born. Yet we need to understand its self-devouring nature. The self-consuming nature of the Cosmos is essential to the mission of transcendence. Lower aspects must be devoured, thus transcended, so that higher aspects can arise. The self-consuming nature of the Cosmos has two possibilities: dissolution into ashes and destruction; or self-devouring on the way to re-birth through transcendence. It is the latter possibility that is all-important to the existence of the unfolding Cosmos.

All the miracles of creation are miracles of transformation; miracles of transcendence and miracles of 'transgression'. This transgression, by going downward leads to destruction; by going upward leads to continuous re-birth. What else is there but a continuous re-birth, continuous arising from the ashes like a phoenix? This is the heart of art, of all creation, of all life — this continuous change through new metamorphoses.

Existence is not some Platonic heaven, resting on unchangeable ideal forms but a continuous fire of transformation and transcendence. Let fire be with you — as it has been from the beginning of time. When this fire ceases, when the flame of transcendence becomes extinct, the time for the creation of the Universe will arrive again.

What is the innermost meaning of all meanings if not transformation? What is the meaning of transformation if not transcendence? That which is eternally static and unchangeable is meaningless. That which is transforming but not transcending

betrays its own destiny. Transcendence is this subtle rhythm, which is beating through all the dramas of creative art when the sparks of new meanings are flying, through all the dramas of human life when new destinies are forming themselves and then triumphantly blossoming. Listen friend, listen to the heartbeat of transcendence. You will hear the rhythm of the Big Bang. You will hear the rhythm of the waves of primordial oceans nursing new life for the first time. You will hear the rhythm of your own heart.

TRANSCENDENCE IN HUMAN LIFE

Transcendence is hope. Transcendence is the redemption of unfulfilled dreams. Transcendence is compassion. Transcendence is the energy of our future dreams. It is a vehicle to travel to lands unseen, which are calling us. Transcendence is a guarantor of new social contracts, which will provide humanity with cohesion and harmony.

Why would there ever be hope if we did not feel that the Universe has in store for us not only disappointments and miseries but sunshine and radiance; why hope, if we did not feel that this unfolding glory — which we call the Cosmos — has a meaning and the power to move and sustain everything?

Transcendence is the power which fuels our hopes, which makes sense of our courage to be — in spite of all the vicissitudes of our life — and which propels our will to seek beyond. How many times can we fall and stumble? Many. But as long as there is hope in our soul and the courage in our hearts, we get up and keep going — reaching further and further; because such is the will of the transcending Universe.

Courage, will, hope and vision are subtle but invisible forces of energy within us. They are the sustainers of our life and our

creativity; but themselves are continuously sustained by the everlasting power of universal transcendence. The more aware we are of this cosmic transcending power the more surely we can draw on the sources of our inner energies. Thus transcendence and hope and love and courage are enormously important in our individual lives.

Transcendence is equally important in the social sphere. We desperately need new social contracts. The present one is worn out and in shreds. There is a multitude of ideas of how to improve and reform the present system. But these schemes move in circles. They do not propose anything new. They are platitudes, moving on the same plateau of impotency and superficiality. Present social thinkers are laughable in their indolence and their paralysis of vision. What we need are entirely new perspectives, ideas which take society seriously, which take the human being seriously, which take transcendence and creativity seriously; in short, which take our cosmic endowment and cosmic destinies seriously.

We cannot tinker with details any more — how to reduce unemployment, how to increase productivity, how to increase welfare, how to increase profit. For all these economic problems are the consequences of a wrong vision — of looking at specific details while the whole structure is collapsing. The old strategy — profit above everything else — must go. The old mechanistic precept — technology invents and man conforms — must go. The old mechanistic philosophy — happiness through material consumption — must go. A lot of things must go because they are, separately and even more so together, the causes of the disease. They have undermined the old social contract and made its useless and decrepit.

Now, while designing a new social contract, we cannot go item by item, by trying to replace the decayed and dysfunctional

elements within the system, and at the same time preserving the old structure as it was. We have to replace the whole structure, in toto, and all sub-structures within it. The task may appear daunting and difficult. Let us not disempower ourselves by saying that it is impossible.

We just need to make a leap of transcendence. Transcendence is exactly the right term. The process of transcendence, the right vehicle. A new social contract must come out not of tinkering but of transcending; not of reforming but building anew; not of improving the old but of changing the whole vision, the underlying values, the raison d'être for our life.

This process of social transcendence will have to be spiritual in nature. In its ultimate meaning, all transcendence is spiritual. We need to truly transcend our decrepit politics, which drags everybody down and benefits nobody. If transcendence in politics does not mean spirituality, it is Machiavellian machination. Transcendence or disintegration; transcendence or numbness; transcendence or amnesia — such are our alternatives.

Politics, which is meant to help us realise a good life must be based on a harmonious social contract. This contract must have spiritual foundations. The guarantor of the spiritual nature of the contract is the force of transcendence. Thus transcendence is the underlying current of all social contracts. For each of them emerged on the wings of transcendence — as human imagination, combined with human will, to attempt to change and indeed transcend the old unsatisfactory conditions. We can discern a chain of the following relationships. Genuinely good life (both social and individual) must be based on a harmonious social contract; which in turn must be based on a transcendent vision of life. This transcendent vision itself must include the recognition of the spiritual nature of life and of the Cosmos. This chain, viewed from the roots upward, looks as follows:

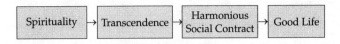

| Spirituality | → | Transcendence | → | Harmonious Social Contract | → | Good Life |

Diagram 6

We should be perfectly aware that new social contracts cannot come about without active and fierce participation of people in the process of change. People too often are inactive, docile, or lazy. They have the tendency to blame the institutions for the apparent shortcoming of social systems. They often have a quixotic idea that systems can change for the better without people participating in the process. Indeed, it is one of the most difficult things for any people to admit that their institutions do not work because of the smallness of their own minds and visions. Social institutions are conceived of as being mere instruments regardless of who we are. These institutions are a shadow of who we are.

We blame our institutions for our plight. Why? Because it is very hard for us to admit that we have the institutions we deserve, that we are responsible for these institutions, that they reflect our inner selves, that is to say, our inner worth. At times, we are not very happy with our inner worth. We keep the awareness of this unhappiness to ourselves; and we hope and trust that our inner self has nothing to do with our outer life.

I am aware that the kind of statements I am making are not welcome. Often they are ignored as annoying. Why? Because they pose too much of a challenge to ourselves. Yet, if these statements reveal the truth, then the conclusion is: do not blame institutions for what they are. Blame yourself for what you are. And do not hide. Hiding accomplishes nothing. Are you prepared to change yourself? No. Therefore, do not expect institutions to change. The institutions only reflect who you are, including your indolence and lack of responsibility.

Do not expect politicians and even political scientists to help you, for they are completely conditioned by the past and possessed by the collective un-wisdom of our time. They think that by putting you in the cast of your smallness, you are comfortable there. Deep down you are not. Let us call the poet Wolfgang Goethe as our witness. He said:

"To treat man as he is, is to debase him.

To treat man as he ought to be, is to engrace him."

Politicians and social scientists want to treat us as we are, constantly reducing us in our stature and possibilities. Yet, we celebrate our humanity by aspiring to what is best in us, by attempting to become what we can potentially become — highlights of the Universe. Only then do we give testimony of who we truly are.

CHAPTER 13

DIALOGUE AT A
LOTUS POND

DAY ONE

The scene is southern India, near Chennai, in a coconut grove.
I am sitting on a granite bench in front of the Buddhist temple.
The temple and I are separated by a lotus pond.
Three lotus flowers are in full blossom.
At the other end of the bench I feel a presence.
I hear the words:

Voice: So you think that you can figure out all the truths necessary for finding the golden path to human salvation?

HS: (Almost automatically I say to myself) And why not?

Voice: This is what Aristotle tried to do — to comprehend all truths.

HS: (I am now quite surprised and say aloud) Yes indeed...

Voice: And he ended up as a dry stick and an analytical pedant.

HS: (I smile back and say) I know that. Well I suppose I want to

address myself to a new generation of seeing beings who want to go beyond the dogmas of patriarchal religions and who want to take evolution seriously — as part of their unfolding being; and as part of the unfolding Light of the Cosmos.

Voice: Intelligent humans are nowadays all hooked to computers and they believe in the virtual reality.

HS: Perhaps the computer-mania is only an intermediary step, which may ultimately lead to a liberation from old dogmas. This is, at any rate, my belief.

Voice: Good luck. But it will be a hard task. Nobody listens to intellectual arguments any more. They have no moral force in them. They do not bring light. They do not illumine. You should also know that the only way you can spiritually inspire other human beings is by yourself being so spiritually attuned that you emanate through your being. You must take a clue from this coconut palm. You see how tall and straight it is? But ultimately nobody cares how deep its roots are; what soil it gets its nourishment from; how it pumps its water up; and how it transforms the minerals taken from the earth. What we care about it is what kind of 'fruit' it ultimately yields.

HS: But I know that.

Voice: So what is the problem?

HS: One problem is that old religions do not deliver. They have burnt themselves out. They do not address themselves to the world and the Cosmos we have recently discovered. They cannot help us in finding our place in the new Cosmos. Consequently, we are lost and drifting. They cannot help us in finding new imperatives for action, new ethics, which would straighten our life in the new Cosmos and which would also help us to maintain peace with

all creation. All religions that originated during the last 3,000 years suffer the same ossification. Their view of the Universe is so constrained. Their view of God so exclusive (except for Buddhism), their notion of the human crippled and limited. The human is not given creative powers and freedom to cooperate with the Cosmos and God. And this is what our present situation requires.

Voice: So this is your new theology. Which actually is not so new. Why aren't you more successful in making people see your new truths?

HS: Yes, these are ancient cosmic truths which we have still preserved in our bones but which have been muffled and suppressed; distorted by traditional religions.

Voice: This is interesting. Why you do not have enough stamina and perseverance to make your truths ring loud and be heard?

HS: I do not want to shout. There is too much shouting and aggression in our world. I do not believe in gurus and guruship...although this may have been a good vehicle. I do not believe in gurus chiefly because I hold creativity and freedom to be the most important values of our new cosmic ethics. To make people empowered with creativity and freedom you must not teach them too much; if you do, then they only follow. And this undercuts the wings of their creativity and limits their freedom.

Voice: But people do not want to be so free and creative. They want dogmas and creeds. They want to be saved. They want to be led.

HS: That is only part of the truth. They want to be free as well. Surely the time will arrive when we shall become mature. We shall then cooperate with God and be co-responsible with God for the state of world. I am suggesting that the

time is now. Otherwise our future may be so dark that there might not be a future.

DAY TWO

I am again sitting on the granite bench in the morning
in front of the lotus pond. After a brief meditation, the Voice speaks.
And this is to happen for the next following days.

Voice: You are still writing and writing, hoping that in this manner you will find your path to the summit of Light.

HS: Writing for me is a path to discovery. It is elucidation and articulation. And articulation is a form of creation. Besides, writing for me is therapeutic.

Voice: It may very well be therapeutic. But is it the best you can do while searching, especially for the Big Light? You remember the story of Ananda, the favourite disciple of Lord Buddha and his attendant. The Buddha was gently remonstrating Ananda that he was only reading and reading and not achieving enlightenment. The Buddha suggested that it is through meditation that one achieves enlightenment, not through reading. For if one reads with the same mind and the same consciousness one stays at the same level, on the same plane. For one can only acquire that much which one's consciousness is capable of receiving and absorbing. It is similar with your writing. You move on the same plane. You articulate and re-articulate the same ideas, or should I say the same quality and depth of ideas. And you cannot go any further, any deeper towards the Big Light which you desire. Enlightenment is achieved through silence and meditation.

HS: For me writing is meditation. And silence is always meditation.

Voice: But this meditation is not deep enough, not liberating enough, not transforming enough.

HS: Possibly so. But I want to use lucid Logos as the vehicle of further transformation. For me Logos is a divine instrument; no, a divine force: a form of Light carrying you to further Light. I do not want shock therapy through meditation. For me, via contemplative is really via 'divina', it is a gentle gradual process. It is a road through Light to further Light. Always Light.

Voice: You might just as well ally yourself with some of the worthy mystics and follow their path. Plotinus would be a good choice. He was lucid, Logos oriented, deep and far-reaching.

HS: Yes, he was stupendous. He came on the scene in the third century AD — already in the Roman times. The climate of Rome was not very conducive to high philosophy. Admittedly he was born and shaped in North Africa and worked out his ideas and visions there. Well, the problem with Plotinus is that he has not sufficiently liberated himself from the shadow of Plato. And there is something else. His solutions are too effortless, too swift. Following him is breathtaking. And yet there is something suspicious and unsatisfactory in these breathtaking solutions.

Voice: How can you say all these things while you call Plotinus stupendous? Was he a shadow of Plato? Who is not? You may recall these words of Plotinus: "Each one must become God-like and beautiful who cares to see God and beauty." He not only anticipates some of your philosophy but expresses it so clearly that it is truly amazing.

HS: How right you are! But one cannot become a true disciple of Plotinus in our times. Finally his solutions are forcing one to accept too much of Plato's philosophy, with its acceptance

of the pre-existence of forms and all that. There is another danger as well. The mystical legacy of Plotinus has been appropriated by the Christian tradition of mysticism, to such a degree that many of his fundamental insights have been re-translated into the Christian language so that the original Logos and spirit of Plotinus is lost. Plotinus was not a Christian mystic. His high ideas are flames of fire. They can hardly breathe in the confinement of the Christian framework.

Voice: Why so harsh on tradition rather than go along with it? After all, this tradition has existed for 1,500 years, it has enlisted and used some of the most brilliant minds that have existed — at least within the Western tradition. Who are you to challenge this tradition? Who are you to be so arrogant as to think that you can do better than this tradition?

HS: This tradition has indeed used and enlisted so many brilliant minds. But many of them would not have served it — if they were not compelled. This tradition has shown an amazingly coercive power in its history. To the point that at the height of its power, nobody would even allow himself to start thinking independently.

Voice: But it is all different now. Everybody can think as he wants to such a degree that there is a complete chaos in our thinking.

HS: The problem is not only with the Christian dogmas, although they have been and still are crippling enough. The problem lies much deeper. The whole patriarchal mindset is a problem. This patriarchal mindset has pervaded all our thinking, including all traditional religions. And including all Western philosophy. Plato's thinking is patriarchal. And so is the thinking of Plotinus. If you look deep enough,

you will see that in Plato, and then in Plotinus, and then within the church, there is always a return to the source. And it is the Father or the Form, which is a typically patriarchal construction. To this Father, everything must return. From this Father, everything originates. Even when Plotinus explicitly says that: "Each must become God-like and beautiful who cares to see God and Beauty;" thus even when he clearly postulates an evolutionary philosophy which starts from the roots and admits the creative role of the human in God-making, when it finally comes to a crunch, he (Plotinus) goes back to the Father image. This whole thing is so warped. And consequently all of our thinking is lopsided and distorted.

Voice: You have a big problem in front of you.

HS: I am seeking liberation, which is fundamental, even the deep mystical philosophies of the West did not envisage this kind of liberation. For they were controlled by the patriarchal mindset. The new philosophy of the third millennium must liberate itself from the tethers of patriarchal thinking.

DAY THREE

Voice: So you are going to write a set of books explaining your new philosophy which nobody is going to read — as your words will be drawn in the sea of meaningless gibberish. Is that your ultimate desire?

HS: I do not want to write another set of philosophical books. Or create yet another philosophical system. The point lies elsewhere — to create a system of thought which will be so vibrant that it will infuse people with new energy and will inspire them with new dreams, aspirations, transcendent yearnings.

Voice: This is precisely what so many mystics have tried to do; and many present gurus; as well as many worthy preachers.

HS: That is not what I have in mind. But rather a renewal of thought, of the entire human logos, a recreation of philosophy in such a fundamental way that it will become a gushing source of reality, vitality, energy and Light. Not just for day-to-day living. But for sparking off these dormant evolutionary springs in which our destiny resides. Through this inner light, which dreamily waits to be awakened, we need to create the sense of our destiny which is God-like, which self-realises itself by reaching the Highest Light. We are so divine that it paralyses our will and action to realise that. By enacting our cosmic destiny, we shall make sense of our life, make peace with ourselves, make peace with all creation, make peace with the Divine. This is not some kind of theological scheme. This is a practical idea for living on this earth with dignity.

Voice: And this you call philosophy?

HS: This I call the new philosophy. You may call it what you will. I am merely saying that the human mind is so divine and human destiny so extraordinary that we must find for it a proper vision and outlet. Otherwise we shall be dwarfing ourselves. We are not meant to foul our nest. We are not meant to deny our cosmic origin. We are meant to merge with the larger schemes of things.

Voice: This is not how Western philosophy has developed. It has not tried to be a nanny, stroking man's ego. That role has been reserved for religion and all kinds of spiritual groups. Philosophy in the West has been a love of wisdom of a more abstract kind. We might even say, that in the West, philosophy has been man's love affair with his reason.

HS: Only sometimes. Philosophy at the beginning was a cosmic quest to understand a deeper matrix of the Universe and man's place in it. Such was the philosophy of Pythagoras, Heraclitus, Anaxagoras. Also of Socrates and Plato. Philosophers were not only thinkers but also sages, and healers.

Voice: But Aristotle onwards, this path ends, or mostly ends...

HS: Yes, for some strange reasons. After Aristotle, philosophy becomes drier, more brain oriented, until it becomes very dry, analytical and cerebral.

Voice: And you are saying that this is not all there is to philosophy and not all which is most significant in philosophy.

HS: Exactly, philosophy has had many obstacles on its way, and somehow it has derailed itself. The first obstacle was Aristotle. A pedantic classification of things was elevated to be a collective name for philosophy. The second obstacle was Christianity, which appropriated all philosophy into its domain. Philosophy was supposed to be a handmaiden of theology. How to live life and be happy and harmonious was decided by the church, and not by philosophical reflection and quest for wisdom. The third obstacle was the emergence of science.

Voice: Wait, you are going too fast and lumping together so many different things. After all science was a reaction to Christianity, and was meant to liberate the human lot from the tethers of orthodoxy and from the tethers of the dogmatic precepts of the church.

HS: Quite so. But there was a paradox in this liberation. Scientists and secular thinkers were so adamant in getting out of the clutches of orthodoxy and of the rule of supernatural agencies — God's dicta and the church's interpretations of them — that they banked everything

on reason. In the process, they elevated reason to a dominant position. And this reason led to the development of empirical philosophy, one which is obsessed with facts, data, physical explorations of the world, at the expense of the spiritual, the ethical, the tender and the human.

Voice: So we have a rather grim picture. Philosophy is first battered by the church, then by empirical sciences which put on us horse blinders — to make us look at the Universe in a very restricted way. In this fashion, philosophy has lost its cosmic outreach.

HS: Yes, philosophy has been battered. No question about that. But the situation is not entirely grim even amidst crippling Christian orthodoxy, mystical schools and visions flourished. These were the visions upholding the freedom of man from the confines of the church. This was the capacity of man to reach the Divine through mystic ecstasy. This was a celebration of the Light within us, which can guide us to the Light Extraordinary.

Voice: Admittedly these mystic schools were persecuted and the mystics themselves exterminated by the thousands.

HS: Yes, what a loss for humanity! Yet their teaching, nay, their Light is still lingering around.

Voice: How can you say that while the present world is completely dominated by crass materialism and darkness.

HS: Nothing is lost in the Universe, particularly in the sphere of the spirit and Logos. Logos has its own sphere which is impenetrable by materialism. Besides, this materialism is a facade, a veneer. Deeper down a more sublime Light is burning.

Voice: But during the last four or five centuries, in the Western world, the mystics who could have maintained and sustained this Light have been rare.

HS: They were, although they did not call themselves by this name. There was Pascal and there was Spinoza. There was Blake and there was Goethe.

Voice: Yet Western philosophy followed another more abstract path. And became a monument of the cerebral capacity of man.

HS: Yes, at its own peril, and by making itself insignificant to the point that it is sometimes ridiculed for bearing the name 'philo-sophia' — the love of wisdom. But let us not dwell on its past mishaps. Philosophy must regenerate itself to become holistic and integrative, an inspiring torch of Light, which leads Logos and life to their highest expressions. Philosophy is destined to re-weave life into a larger cosmic context, whereby both gain on lucidity and power — the Cosmos and the human. Above all this means re-connecting ourselves with the Great Light, which nourishes all. We are all subtle artifacts of this Light. The unfolding Universe is the journey of Light and life itself is but Light structured in ever more exquisite patterns. Logos itself is a form of Light. And intense Logos may be a form of fire. It can burn and inspire the mind. It can also burn antiquated dogmas to ashes. It can make fresh trails for thinking and living. Logos is a trailblazer of our destiny. Philosophy is an articulation or Logos in the sphere of our knowledge and in the sphere of our life. It was never meant to be a mere mental exercise, playing with concepts and the logic of language. It was meant to be a lucid thrust forward of life articulating itself.

DAY FOUR

Voice: This business of Light troubles me. It is so large. So much beyond our comprehension. It seems to be some kind of miracle-maker.

HS: It is true. Yet, deep down we somehow understand it. We understand that all is made of Light; we are made of Light and our journey is one of Light. These ideas give us a sense of joy. Because somehow they explain it all. Although vaguely.

Voice: Yes, rather vaguely. Why so vaguely?

HS: Well, one of the main reasons is that institutionalised religions have monopolised our access to Big Light. They have become jealous guardians, which do not like humans to be in touch with it directly. Religions have controlled this Light rather ruthlessly. We know it and feel crippled.

Voice: And the kind of philosophy you call for, will it consist of the unblocking of our cosmic connections, renewing us at the roots?

HS: Exactly. This last point of renewal at the source, at the cosmic roots, is very important.

Voice: And how do you see the individual contributing to this process? How can he be a part of it? Do we have to become gods before we gain access to the Big Light?

HS: Not quite so. We are little spiders weaving a huge net. It is a Divine net. And we are Divine spiders. While we are on this net, we are Divine beings.

Voice: And where does this net lead? To heaven, to God?

HS: This net itself is heaven, a God-like being. We are weaving it ourselves. It is the most extraordinary handiwork that we and the Cosmos together have ever endeavoured. By being within it and contributing to it, we are co-creating divinity, fragments of God. We are co-creating with God and the Divine. In this holy work of creation, God needs us as much as we need God. These are actually the words of Meister Eckhart, a medieval mystic. He also said that

the human eye looking at God is the same eye with which God looks through the eye looking at Him.

Voice: A very new way of looking at divinity.

HS: Maybe not so new. It can be found throughout human history. Admittedly, this view so often has been suppressed by dominant religions. Besides, this view is very natural. Intuitively, almost obvious. If all is divine in the Universe (and we are more and more convinced that this is the case), then *by our understanding of the glory of the Divine, we are morally bound to cooperate and co-create with the Divine.* The very awareness of it being so is a profoundly liberating experience bringing us to a closer union with God. Let me put it differently. All creation is articulation. An amorphous piece of marble out of which Aphrodite of Knidos was carved, was not a sculpture — until it was carved into its finished form, until it was articulated. Before it was articulated, it was a potence of a sculpture, not a sculpture itself.

Voice: Do you mean to imply that it was similar with the Divine and even with God?

HS: Yes. God and the Divine could only come to their articulated existence after the appropriate sensitivities, appropriate Logos, appropriate symbols and icons, were developed and articulated by human beings. The human race has been endowed, or simply entrusted, with developing these sensitivities and powers of imagination which could seize and express the Divine. We have been evolving our sacred nature simultaneously with the Cosmos. We are fragments of the divinity of the Cosmos. Through us this divinity is articulated. We are truly one. We and the Cosmos are one. We and the source are one; we and God are one. We are part of the crystallisation, of articulation and actualisation

of God. And God rejoices in this articulation. Without our sensitivities, our Logos, our imagination, God would still be only a potential God, like a statute of the Aphrodite, hidden in the amorphous chunk of the original marble. We are God-makers; although we, ourselves, came from the cosmic dust. There is a paradox and a mystery in this view. We have to live with it. The Cosmos is a mysterious being.

Voice: Yes, it is a strange view that you are presenting — this Divine net on which we are little Divine spiders. But this net surely must lead somewhere; it cannot just dangle in the void. It must go upward to more divinity and ultimately to God. Otherwise, it is a very unsatisfactory solution of the wholeness and beauty of the Universe.

HS: Yes, it goes upward, towards greater divinity, and towards further articulation of Godliness in us and in the Cosmos. But we should not rush to judgement too fast. Otherwise we shall find ourselves in the traditional scheme, namely that God created this net, and by being on this net, we are reaching to God and thus returning to the source. The realisation of God within the Cosmos is a stupendous process. We are in the middle of it. What the ultimate nature of God's divinity will be at the end of time, we do not know and we cannot know at present. We are in the infancy of our understanding of these divine matters. We have been grappling with the divine nature of the Cosmos and of ourselves since a very short time. We must have more humility. This is what all religions advocate.

Voice: How is all of this is going to help you and others? It still is philosophy, words. We are bombarded by words, insignificant words, twisted words. Words are such a cheap commodity nowadays.

HS: True. But the point is not to end with words. Words are only a means, a passage to deeper realms.

Voice: What are these deeper important realms, which you want to lead us to?

HS: First of all, we need to realise that we are important beings in the Universe, not cheap dispensable straw-puppets, or cogs in the wheel of some machine. We are part of the natural magic. We do not need miracles of science. We are a miracle. When science brings about its own 'miracles', so much pollution and destruction follows. Secondly, we need to realise that we live, work and think in an envelope of lucid Logos. It is a creative Logos. We are the recipients of its creativity and we are a part of its creativity. The Universe is pulsating with vibrant creative forces — all around us. We are part of this creative vibration. To grasp this whole picture and embrace it, is a source of joy. And also a great source of empowerment. This act of the acceptance of the creative Logos of the Universe entirely changes our situation and status in the present disempowered world. Thirdly, guided and inspired by lucid Logos we can create philosophies more life-enhancing than hitherto known, philosophies which are woven into great cycles of life and of cosmic becoming, which serve the Divine because they themselves are an expression of the Divine. At this point, words, which express and articulate our merging with the Divine will not be cheap commodities but points of Light charged with energy and glow.

Voice: And you think it will be easy?

HS: I am not saying it will be easy, but necessary. Let me continue with my discussion of lucid Logos. Fourthly, from a right cosmic philosophy, we shall derive a right ethics, which we might just as well call cosmic ethics.

Voice: Again, you think it will be easy to evolve this kind of ethics?

HS: Again, I am not saying it will be easy but necessary. Actually in some quarters this ethics is already being articulated — sometimes more consciously and boldly, sometimes less. There is a search for a new ethics going on throughout the entire world. We have understood by now that we have fallen to a low place by allowing ourselves to be devoured by nihilism, radical subjectivism and other moralities which are not friendly to the human species. A new ethics is required. This is almost universally understood. And lo and behold! At this very moment, Light is articulating itself to demonstrate that it possesses, within its bowels and structure, universal ethics, which can guide and support all humanity and all creation. This is the ethics of giving, generosity, altruism, compassion, solidarity and a quest for a spiritual transcendence.

Voice: And how does God figure in this scheme?

HS: Prominently. This entire scheme is pervaded by God, is God-like, is divine.

DAY FIVE

Voice: Where did this Big Light idea of yours come from? Why not use the conventional term, which is God? To all intents and purposes your Big Light is another name for God. Why not stick to the original terminology?

HS: You are going backward not forward. Big Light is not another name for God.

Voice: But it is — as you have explained.

HS: It is not. The Big Light is much more ancient, much more profound. It is the source of all sources. Out of this source in very ancient societies, the first rituals explaining the

ecstasy of life were born. Yes, it was the time when people were unconsciously worshipping elements, especially fire and the sun. Out of this original source came the first rudiments of what we call spirituality. And then later, more crystallised forms of this spirituality in the form of Arian gods (sky-gods). Out of these gods emerged the image of the all powerful hierarchical God (sometimes called Jahve, sometimes Brahman). God is a late arrival in human history, and especially in evolutionary history. It represents one of the embodiments of the Big Light. By no means the first. Not the only one. And not the most lucid and beneficial one.

Voice: This is not how religions represent it. They think that it is the other way round...

HS: We all know the story, which religions have pushed on us. We have all been fed and conditioned by the story. Sometimes browbeaten into submission by the story. But the story of religions is only one story. The story of the mystics, of shamans, of medicine men is another story.

Voice: So all these are only stories...

HS: The story of the Big Light is the real thing. It contains all other stories. It explains all other stories. The story of traditional monotheistic religions is tremendous in the power of its imagination — of weaving everything around one central axis. But it is a defective story. It wants to thrive at the expense of other stories. It tries to impose itself on us as the only story. I have explained the reasons of this imperious design. Monotheistic religions have attempted to monopolise the Big Light as their property. Then they established themselves as the only guardians and as the only ones with access to this Light. In this manner religions have become powerful filters — filtering from the

Big Light only that part which fitted their (monotheistic) designs. Yet the Big Light is so tremendous that it makes all religions puny.

Voice: You do not mean to say 'puny,' do you?

HS: Well, how do I say it when I maintain that the Big Light has been the repository of the great cosmic forces over millions and billions of years; and when I point out that organised religions have existed for barely 3,000 years; and when, in addition, I suggest that they have created consequences far from the desirable.

Voice: You are then saying that both religion and science have failed us.

HS: Well, yes. I am maintaining that neither God nor science has been capable to provide us with a comprehensive picture of reality or a convincing story of our nature and our origin. The religious picture continually mystifies us through its dogmas. The scientific picture continually depresses us through its unwarranted simplicity. Science has been inherently unable to explain that which is most significant in the human and why the Universe is ravishing and beautiful. Far too often we have been squeezed into cage-like images of the Universe within which we felt diminished and robbed of our humanity. Science and religion alike have succeeded in diminishing us. We need to create a new picture of the Universe into which we (humans) fit naturally. We need to comprehend the Universe with our human faculties — because the mind was created by the Cosmos to understand the Cosmos.

Voice: I have also asked you about the origin of the idea of the Big Light, as the source of all sources. Surely some ancient Greek philosopher should have stumbled upon the idea that all is Light. They were so imaginative and so daring.

It just strikes me that there should have been a Greek philosopher who had anticipated your idea. After all, your idea of the participatory mind and of participatory reality was anticipated by Parmenides who said: "No mind no world." Was there no Greek philosopher who anticipated your idea that God is Light?

HS: Indeed this is a fascinating question. I quite agree with you that there should have been a Greek philosopher who had anticipated my design...well, I bite my tongue when I say 'my design.' This design can be seen as implicitly manifesting itself in so many ancient and pre-historic cultures. I have searched for such a philosopher among the early Greeks. But I have not found him. Heraclitus comes quite close — with his idea 'everything flows' and with his obsession with fire as the most important element. But he was a bit stuck within the prevailing cosmology, namely that there are four basic elements: water, air, earth and fire. He did not see beyond the four elements.

Anaxagoras was also a likely candidate to have seized the idea of Light as the source of it all. He postulated that Logos or more precisely *nous* (mind) is at the source of it all. He moved beyond the four elements. *Nous* or Logos was recognised to be a manifestation of the Big Light. But the Big Light is much more primary, much more fundamental, much more encompassing. It clearly outlines the odyssey: from life, to creativity, to divinity. No Greek philosopher possessed such an encompassing evolutionary understanding. There are glimmers of this idea in Plato. Particularly in the allegory of the cave. What we see in the world are shadows, whereas the Light outside is the real source. But the main thrust of the allegory is to emphasise shadows — not Light itself as the

source of it all. What I had expected was to find among Greek philosophers statements like the following: *To fos ine Pandemiurgos* — the light is the pan-creator of all. In Greek it sounds quite all right.

Voice: But it is not the term they used then. You are inventing what they would have said about Light as being Pandemiurgos.

HS: You are right. But my idea is expressed with the kind of simplicity and terseness the ancient Greek language relished. In the Greek version, the emphasis is not on the idea that Light is God. The emphasis is rather that *it is a creator of it all*, including the process of creativity. Yes, 'Pandemiurgos' also conveys divinity, but it especially emphasises the active source of creativity and all creation.

Voice: Am I right that what appeals to you most is the creative aspect, the active idea of creation? Tell me why they (the Greeks) could not have conceived the idea *to fos ine Pandemiurgos*? After all the Greeks were so inventive, so free in their imagination.

HS: I suppose they were conditioned by their views of what is possible. They did not understand evolution as transforming it all, as the real source of a new becoming. Somehow they could not see that at the beginning Light was the source of all sources.

Responding to the first part of your question. Yes, indeed, 'Pandemiurgos,' conceived as an active and creative divinity, is immensely attractive. In this evolutionary and unfolding Universe, a true creator cannot be a static being, unchanging and petrified in its perfection. But it must be a continually creative force — itself evolving with the entire Cosmos.

Voice: Yet again, how does your Pandemiurgos differ from the biblical God? Pandemiurgos is creator. And so is God.

HS: There is a difference. God created the world in six days. On the seventh day he rested. He seems to have been resting ever since. Some have suggested that God has been on a permanent holiday since the creation of the world. He created the world, and has been doing nothing ever since. Pandemiurgos, Light in all its dimensions, is continually and ceaselessly transforming itself and us in the process. This creative process is sometimes smooth, sometimes it is not. Creativity is a mysterious process. Most of the time it involves a partial destruction of what was so that the new can emerge. Sometimes the creative process may be violent.

Voice: Yes, it has been violent at times. How can you explain this? Why not a continual peaceful process of unfolding?

HS : We are part of the unfolding Light, which always acts through us. We are not always wise and capable enough to keep right balances, particularly at the times of stress. Yes, we are evolving towards more Light and compassion. But our evolutionary history still contains some remnants of the darker and rougher aspects of our being from the past. When these remnants of darkness meet each other— on the opposite side of the barricade (whatever the barricade is), it's best to be careful.

Voice: Tell me now, if Light is God, then what is darkness?

HS: Let me put it in the simplest possible way. Darkness is failed Light. Darkness and light are not two sources. There is only one: Light. Darkness and evil do not have an independent existence. Evil is distorted goodness. Human nature is essentially good. Only when, through unforeseen circumstances, it departs from goodness, can

it become evil. The act of sliding towards evil is an act of unseeing. Light is essential and necessary for embracing goodness and perpetuating it. When Light is obscured and becomes darkness it may lead to evil. Evil is a form of darkness, which in turn is failed Light. May you have enough light to recognise the primacy and glory of Light and goodness.

DAY SIX

Voice: Some say that there is nothing we can conceive of what has not been anticipated by the ancients. Some say that Zoroaster (or Zarathustra) was a disguised prophet of Light and his religion may be called a religion of Light. What would you say to that?

HS: Well, let me respond in a round about way. The philosopher who put Zarathustra on the map of European thinking was Friedrich Nietzsche. Nietzsche possessed a colossal mind, which was brilliant but mentally unstable. Nietzsche's philosophy is actually split in the middle. The first deconstructionist part of it is magnificent. The second nihilistic part is rotten. Nietzsche was supremely aware of what he was doing. He had moments of great lucidity. In his famous passage he wrote:

> "God is dead. Religious belief is a comforting but debilitating self-delusion. A Christian God can no longer express the highest ideals of Western civilisation. Belief in God is now a burden on the individual and on society. A system of ethics and morality founded on faith is no longer valid; the time has come for a new set of values to take its place, beyond good and evil as religion has until now defined them."

After deconstruction, Nietzsche ran out of steam. Instead of leap-frogging through an act of creative transcendence, he settled for turgid nihilism, and Schopenhauerian pessimism. Nietzsche did not have sufficient depth to imagine what was necessary for creating a new culture and a new religion. Re-evaluation of all values has become a process of lowering of all values to the relativistic and nihilistic common denominator. Furthermore, Nietzsche's philosophy is not a true rendering of Zarathustra's legacy. It is a debasement and distortion of Zarathustra's intent. There is too much of the nineteenth century pathology and too little Light in Nietzsche's Zarathustrianism. Zarathustra's intent was to reach Light, and through it reveal and re-interpret existing moral codes, which had been messy before him. He wanted to create universal ethics, binding all human beings.

Voice: I was wondering whether you would ever return to Zarathustra. So what was Zarathustra's role as a prophet of Light? Was he such a prophet? Or are we projecting on him our more recent understanding of the meaning of Light?

HS: I suppose a bit of both. Nietzsche created his doctrine of, "God is dead" within the context of his struggle with the Zarathustrian legacy, and while writing his famous book: *Thus Spake Zarathustra*. It was meant to be a creative reconstruction of Zoroastrian religion and philosophy. Instead something else happened: Nietzsche's deconstruction of Christian religion led to the erosion of all intrinsic values; then to relativism and nihilism; and then to post-modernist chaos and confusion.

Voice: Would you say that Zarathustra is an ancient prophet?

HS: Zarathustra is undoubtedly the most ancient prophet of all times. Western scholarship has dated his birth in the sixth century BCE. More recent research suggests that he was born in the sixteenth or seventeenth century BCE. He is an ancient prophet to such a degree that he did not call himself a prophet, although he became a prototype of one. His teachings inspired other religious traditions: Judaism, Hinduism, Buddhism and Christianity. Zarathustra's teachings are very ancient indeed. History was not kind to the records in which this teaching was recorded. One of the biggest blows was the destruction of Persepolis, by Alexander the Great in 330 BCE. In the destruction of the city were destroyed all the tablets containing the complete teachings of Zarathustra. Alexander then went to Central Asia and his soldiers destroyed the remaining tablets. Eyebrows are raised; such savagery and thoughtlessness from an emperor raised by Aristotle himself! Because of other vicissitudes of history, not much is left of Zarathustra's original teachings. What is undoubted however is that he taught that goodness and Light will prevail over evil and darkness; that following the path of the good makes one's life harmonious and happy; that the path of the good is universal for all human beings. Zarathustra represents the transition from the early trends, based on sacrifice and unmindful rituals, to the path based on intelligent understanding that righteousness and goodness lead to well-being and happiness; while lying and evil lead to darkness and unhappiness.

Voice: So what is most universal in Zarathustra's teaching?

HS: The new path which Zarathustra outlined attempted to illumine human condition by relating it to goodness and

Light, which were assumed to be universal components of human nature. We are not divided by subjective predilections. We are united by our common goodness and universal Light. This is the teaching, which might be of great value to our splintered world and our confused minds.

Voice: What about his teachings on Light?

HS: Zarathustra did not explicitly formulate his teachings as a religion of Light. It was too early for that. But he was subconsciously embracing Light as the highest divinity. His images of Light as overcoming darkness, and of goodness as overcoming evil, were paving the path for a universal religion based on the primacy of Light and goodness.

Voice: So, finally, what about Nietzsche's interpretation of Zarathustra?

HS: Nietzshe's interpretation of Zarathustra was a butchery. Zarathustra in the Nietzchean interpretation has been turned into an icon of pop culture. A new creative rendering of Zarathustra must follow his deepest intent: to create the world of the humans in which Light and goodness universally prevail.

Voice: Is that not wishful thinking?

HS: Every religious vision is. But in spite of it, and perhaps because of it, humankind has ascended. Never mind our failings and imperfections. These imperfections do not demonstrate the frailty of goodness and of Light, but our own frailty to embrace goodness and Light — and behold them steadfastly.

Voice: Why are you undertaking such a difficult task for something that has been done so sublimely well many times before? Your attempt to outline the path of perfection and divinity is as old as the quest for God.

HS: Every epoch has to do it in its own distinctive way. We are now entering a new epoch, the Era of Light. Besides, the perspective I am presenting continues the teaching of Buddha Sukyamuni and Jesus Christ. They were prophets of Light, of luminous Light. Their teaching embodies and extols love, compassion, altruism and the ethics of solidarity. They were heralds of the ethics of Light, including the understanding that Light is the Universal Mother. Their teachings have been wrapped in cumbersome theologies, which are often inscrutable. The original Light has been muffled by dry theological theories. We need to return to the original source. This source is Light.

DAY SEVEN

Voice: If you allow me, I still would like to explore a bit further the question of the origin of the idea of Big Light. After all, theologies do not appear out of the blue. I will grant it to you that the theology of Light (which you are proposing) is quite a bold structure, of considerable explanatory power. If it is true, then some important consequences follow. Usually theologies have some roots, they are derived from other theologies. They represent a tradition of long reflection on the Divine. Are you sure that your theology is not continuing some important tenets of existing theologies, even if only subconsciously so? What are your roots?

HS: Well, yes. Theologies usually have roots and are related to other theologies. But mine is not that kind of theology. It cannot be. For traditional theologies in the Western world are consciously and deliberately rooted in monotheistic religions and their specific dogmas, except of course, the mystics, who have their own fascinating world.

My theology deliberately wants to transcend the existing theologies because they are a trap, a very contrived and dogmatic way of reading the nature of the Divine — with some magnificent insights, of course, but dogmatic and rigid nevertheless. Any attempt to translate the theology of Light into categories and language of most of the existing theologies would be a kiss of death for theology of Light.

Voice: But there must be some roots nevertheless.

HS: Yes, I was just about to broach the subject. My spiritual quest began with my mystic experience around 1980, perhaps even earlier, when I tried to explore the meaning of the human in my Eco-philosophy, in the mid 70s. This meaning had to include the spiritual dimension. Around this time, actually, in 1976, I started to write meditations (later published in a book form). The very first line of these meditations read: "Submerge ourselves in the sacred, which is of our own making." After I sorted out, so to speak, the relationships between humans and Nature (in Eco-philosophy, 1981), these questions immediately imposed themselves on me: what about heaven? What about the Divine? What about God? I tried to answer these questions — first in a monograph entitled *Eco-Theology* (1985), then in the book entitled *A Sacred Place to Dwell* (1993); and then I gave a series of lectures in New Zealand entitled "The Journey of Evolutionary God" (2000). And finally came this book.

Voice: So many steps...

HS : Not too many actually...

Voice: Indeed, there cannot be too many steps when one attempts to reach God. Tell me about the nature of your eco-theology. Was it some kind of return to Spinoza and his pantheism claiming "Nature is God and God is Nature."

HS: Something more than that. Spinoza lived in the world in which evolution was not discovered, or not fully discovered. Evolution was not part of the general vision of things and of the Cosmos itself. In the second part of the twentieth century, we witnessed an extraordinary plethora of new views on the evolving Cosmos. Cosmology has become a fascinating subject, with the probing of the questions: when did it begin? How? Through what forces? The evolution of the physical Cosmos is quite an enthralling phenomenon.

Voice: But this is not what you mean by eco-theology, surely? Present astro-physics can do very well without eco theology. It has its hands full as things stand at present.

HS: Do not be so impatient. Everything is connected in this mysterious Cosmos. Astro-physics has its own story to tell. By itself, it is not free of theological speculations, which creep into its domain every so often. But this is not my story. As I had been watching the mind of the twentieth century unfolding, I had been quite intrigued and sometimes agonised by the general discussion of the meaning of evolution — its consequences, its reach, its language...its relationship to traditional religions. I noticed that we have moved from Darwinism (that is to say, from one version of biological evolution), to evolutionary biology, which has freed evolution from the confines of Darwinism. And then we extended evolutionary thinking to a conceptual evolution: all products of knowledge are evolutionary, are evolving entities.

Voice: But you are still not telling me about the tenets of eco-theology.

HS: But I am. I was watching the evolving scene of evolution, and of evolutionary thinking with a keen interest. I studied with Karl Popper and was impressed when he extended

evolutionary thinking to all knowledge, under the name of evolutionary knowledge. I prefer the name of "conceptual evolution." I have decided that this evolutionary thinking was quite a powerful vision and offered itself as an exquisite vehicle of inquiry. Extending evolution to products of knowledge was quite exciting, but not enough. If evolution is all-encompassing (I reasoned), then surely it must be encompassing all. In my thinking I extended the idea of all-encompassing evolution a bit further, to our thinking about theology. But I could not stop there.

Voice: Why?

HS: Because it would mean that evolution is relevant only to our *thinking about the Divine,* but not to the *Divine realm itself.* There is a difference between thinking about the Divine and the Divine itself; between thinking of God and God itself. As we know, God was supposed to be static and not evolving. The Divine realm was supposed to be beyond evolution. Yet I was relentless. And decided that if evolution is all-encompassing, then *it must include the realm of the Divine.* And that means that God cannot be outside the realm and the bounds of evolution. This line of thinking has finally led me to the conclusion that God is evolving, or that God is an evolutionary being. I further simplified this insight to read: evolution is God. God is evolution. This thinking was expressed in my monograph of 1985 and in the book of 1993. The idea of evolutionary God was then one of the tenets of eco-theology.

Voice: So it was mainly Popper that led you to your evolutionary theology?

HS: He was not the main influence. Popper was one of the inspirations. Far more important for my theological thinking was the influence of Pierre Teilhard de Chardin and Henri Bergson.

Voice: But Teilhard was not a theologian, not in the strict sense. And Bergson was even less so.

HS: Perhaps they were both theologians — in a deeper sense of the term. I consider Teilhard's *The Phenomenon of Man*, to be a seminal book of the twentieth century. It is an evolutionary epic par excellence, steeped in a subtle mysticism. The views and visions expressed in this book are profound and have far-reaching consequences. But Teilhard's opus was left unfinished. In a way I am continuing Teilhard's legacy. Teilhard took evolution seriously. But somehow could not see that it applied to theology and to the phenomenon of God. He did not allow himself to do so, perhaps because he was a Catholic priest; perhaps because the church hierarchy was already intimidating him enough in his lifetime. Anyway, I took evolution as seriously as Teilhard did. Thus I drew the consequences of evolutionary thinking to the realm which traditional theologians would not dare enter by considering God as an evolving being.

Voice: What was then the influence of Bergson?

HS: Teilhard himself was inspired by Bergson and much indebted to him; much more than we usually are aware. In his classic book *Creative Evolution* (1909) he said it all — in the very title. Teilhard accepted the idea wholeheartedly. He showed in his magnum opus how creative evolution worked in minute details in biological life. Teilhard focused on the structure and flow of evolution itself. I concentrated on another aspect. Yes, evolution is creative (I reasoned). But if it is so creative then, *the whole Cosmos must be creative*. I became consumed and fascinated by the phenomenon of creativity. Like Pythagoras, I murmured it to myself: "The whole Universe is creative." A succinct

summary emerged in my mind: creativity is God. God is Creativity. This sounded good. The idea of the creative Cosmos has really motivated and led me further and further. At one point it dawned on me that what we call AP in astro-physics, and what we consider the creativity of life, in biological evolution, is the same creative force of the Cosmos. At this point I knew that I was on some kind of journey.

Voice: And this realisation that the AP and the creativity of biological evolution are merging with each other, are a continuation of the same process of creativity — this realisation occurred to you roughly when?

HS : It has been with me certainly since the mid 90s, or perhaps even earlier.

Voice: Let us return to your story. You stipulated first that God is evolution; evolution is God. Then you proposed that God is creativity. Creativity is God. Which of the two gods is more important to you?

HS : This is a good, incisive question. At a certain point I realised that I needed to go deeper, to a more fundamental source—beyond Nature, beyond evolution, beyond creativity. Searching relentlessly for the source of all sources, I discovered that this very source, I was searching for, was Light itself — evolving and immensely creative. Thus, Light is all. Theology of Light 'could' emerge because I took evolution seriously, because I took creativity seriously, because I took Light seriously. The conjunction of these three divinities (if I can call them that) merged together to create my Universe.

Voice: This is a fascinating journey. But may I ask you a mundane question: how is this new philosophy going to provide bread and butter?

HS: This is a wrong question. God or divinity is not here to provide bread and butter; nor is it here to provide us with electronic gadgets, cellular phones and other gizmos. God is here to provide Light for proper understanding and radiant living. From right cosmic understanding everything follows. From wrong myopic understanding only distorted views follow. And then what follows is unnecessary destruction and misery.

Voice: What is the main truth that you want to share with me?

HS: We are the children of God who have become mature and who can now assume the responsibility for creation. We are also beings who can assume the responsibility for our own lives. We are divine spiders advancing upward on the divine web of cosmic becoming. Now I think we have talked enough. Let me bid you goodbye.

Voice: Wait a moment. What more specific teachings would you care to share with others?

HS : When you wake up in the morning, remember, you have awoken in the universe of Light. While getting up, embrace this Light; be mindful at the same time that Light is embracing you. As your feet are touching the floor — smile. Try to keep this smile on your lips for the rest of the day. As you brush your teeth — do not rush. Do it with the smile of Light. As you begin your breakfast, bless it. Bless the Light contained in your food. Eat with joy, for there is so much Light in your meal. As you select your shirt or dress for the day, be mindful — you are not dressing for show, but to enhance and celebrate this Light of yours. Wear your garments with ease and with quiet dignity.

As you enter the world, be aware that it is full of pitfalls and agonies. You cannot avoid some of these agonies.

But you can bear them with more equanimity when you maintain your dignity and your inner light. You cannot teach people how to behave. But you can influence them with your own behaviour. Everybody responds to the Light shining from within, bright but gently. You may be ruffled during the day — by bad smells, or by bad energies of people. From time to time withdraw into yourself, breathe deeply and say to yourself: this Light within me cannot be tarnished so easily. When circumstances allow, go deeper into yourself and reflect on the glory of all Light.

Do not be upset if other people find you a bit aloof. You need to be a bit detached to preserve your inner peace. Always respond to people with your gentle Light. And a gentle smile, if you can. When at night, in your meditation, go back to the Big Light. Serve Light well. While serving Light, you are serving this beautiful Cosmos.